Art & Design

in Europe and America
1800 - 1900

Art & Design
in Europe and America
1800-1900

Introduction by Simon Jervis

E. P. DUTTON NEW YORK

Published in the United States by E. P. Dutton,
a division of NAL Penguin Inc.,
2 Park Avenue, New York, N.Y. 10016.

Library of Congress Catalog Card Number: 87–71373

ISBN: 0–525–24610–X (cloth)
ISBN: 0–525–48352–7 (DP)

First published in Great Britain 1987 by The Herbert Press Limited
Designer Pauline Harrison

Printed in Great Britain by Jolly & Barber Ltd, Rugby

10 9 8 7 6 5 4 3 2 1
First American Edition

Frontispiece Marquetry table (detail), made by
Edouard Kreisser, Paris, 1855 (*see* pages 94–5)

Foreword

Contributors

Entries have been written by the following:

SA	Stephen Astley
MB	Malcolm Baker
HB	Hilary Bracegirdle
MGC	Martin Chapman
RE	Richard Edgcumbe
JH	Jean Hamilton
PH	Paul Harrison
MH-B	Mark Haworth-Booth
WH	Wendy Hefford
RJCH	R.J.C. Hildyard
SJ	Simon Jervis
LL	Lionel Lambourne
JVGM	J.V.G. Mallet
AREN	A.R.E. North
JHO	Jennifer Hawkins Opie
AFR	Alicia Robinson
NR	Natalie Rothstein
MWT	Margaret Timmers
ET	Eric Turner
VJV	Vicki Vinson
CW	Clive Wainwright
RW	Rowan Watson

The Victoria & Albert Museum in London is both a national and an international institution. Its collections range from the Middle Ages to the present day, and from Japan to America. Some of its galleries are devoted to materials, such as silver or glass, others to techniques, for example lace or prints. But perhaps the most memorable, and the most attractive to the general visitor, are those in which the whole range of objects produced in a particular area and period are shown together to present an integrated account of art and design.

This book commemorates the most recent gallery of this latter type, opened in 1987, and devoted to art and design in Europe and America from 1800 to 1900. It should be made clear that in this instance Europe excludes England (and for this reason the book's introduction illustrates English comparative examples). The Victoria & Albert Museum has had a gallery of English nineteenth-century art and design for some twenty years. This new gallery thus represents the Museum at its most international. It is the first gallery of art and design at the Museum in which America is included, and some important recent American acquisitions are among the 570 objects on view. The geographical scope is remarkable: there are also objects from France, Germany, Italy, Spain, Austria, Hungary, Bohemia, Russia, Holland, Belgium, Denmark, and Sweden. The range of material and function is equally wide, including furniture, tapestries, tiles, stained glass, paintings, posters, photographs, sculpture, books, porcelain, pottery, enamel, silver, iron, pewter, and ormolu.

The style of display adopted in the gallery is at once innovative, functional, and historicist. Its colours are derived from the Victoria & Albert Museum's Cast Courts, opened in 1873.

Its showcases are made after designs published by the Museum in 1877. Its electric lights are copied from those used in this part of the Museum when it opened in 1909, but incorporate modern dimmers. It has air-conditioning, but this is concealed in Victorian-style plinths, with security barriers derived from those used in the Museum in the 1860s. But it is the rich, dense, and varied mix of objects which lends the gallery its distinctive character.

Many of these objects were acquired by the Victoria & Albert Museum, or rather the South Kensington Museum, as it then was, from the great international exhibitions, such as those held in London in 1851 and 1862, Paris in 1855, 1867, and 1878, Philadelphia in 1876 and so on, and were intended as models for English manufacturers, designers, and craftsmen. It seemed appropriate, therefore, to devote the introductory essay to the relationship between English and foreign design in the nineteenth century. The main body of illustrations, arranged chronologically, represents an anthology of the gallery, a handbook to its contents, and an episodic survey of nineteenth-century art and design in Europe and America. The commentaries have been written by a large number of colleagues throughout the relevant departments of the Victoria & Albert Museum, and thus represent a wide variety of approaches. The illustrations are the work of many members of the Museum's photographic section. Both gallery and book are team efforts. Special mention must, however, be made of the work of Stephen Astley and Vicki Vinson, who did much to assemble and organize the materials for both, and of David Herbert and Erica Hunningher, publisher and editor, who processed the book with remarkable dispatch and efficiency.

SIMON JERVIS

Introduction: Europe, America, and England

'In England much more attention is generally paid to the perishable instruments of the stable than to the lasting decoration of the house.' In the introduction to his *Household Furniture and Interior Decoration* of 1807 Thomas Hope endorsed a perennial image of the English as philistine, unsophisticated, and insular. A cultivated and cosmopolitan scion of a Scots-Dutch banking dynasty, Hope was concerned to raise the standards of English design. His book illustrated the furniture and decorations of his own London house in Duchess Street, which he had opened to the public in 1804. He recorded that he had had to procure models and casts from Italy and that he had failed to find in London English craftsmen capable of executing his designs. Hope also paraded his friendship with Charles Percier, the French architect and designer who worked extensively for Napoleon. Percier's *Recueil de Décorations Intérieures*, issued from 1801 in collaboration with his partner Pierre François Léonard Fontaine, was the recognized manual of the neo-classical language of ornament which was the *lingua franca* of design in Napoleon's Empire.

Many other examples could be adduced of an enthusiasm for foreign design and designers among the élite of English patrons. William Beckford, the millionaire votary of the sublime, bought silver designed by Jean-Guillaume Moitte and Jean-Jacques Boileau. The Prince Regent was a great collector of French furniture, bronzes, and porcelain produced under the *ancien regime*, and even in his exile in Calais Beau

Pier-table, gilt wood with bronze medallions
This table was made in about 1800 for the Flaxman Room in Thomas Hope's London house in Duchess Street, of which the centrepiece was John Flaxman's monumental sculpture of Aurora and Cephalus, commissioned by Hope in 1790. The table is close to French examples of the same date.

Brummell 'had quite an old dowager's passion for buhl furniture'. But the general impression which emerges from Hope's introduction — of an England backward in design — was in 1807 a half-truth at best. Hope's own bibliography includes James 'Athenian' Stuart's *Antiquities of Athens* (1762) and Robert Adam's *Ruins at Spalatro* (1764), works which had inspired neo-classical designers all over Europe, and Hope praised the works of John Flaxman, a sculptor with a European reputation, who was also active as a designer of porcelain and silver.

Foreign comments are even more telling. In 1800 Charles Moreau, a distinguished French designer who was a pupil of Jacques Louis David, published *Fragments et Ornemens d'Architecture*, a pattern book of Roman ornament. In its preface he noted that Sir William Hamilton's sponsorship of volumes illustrating his collection of vases, published in 1766–7 and 1791–5, had had the intended effect of encouraging English design and industry to the detriment of France. And in 1786 the first issue of the Weimar magazine *Journal des Luxus und der Moden* stated that England had become a dangerous rival to France, for so long the sole arbiter of taste. England's new influence was partly the result of innovation and efficiency in manufacture and of aggressive marketing. Ceramics from Leeds and from Josiah Wedgwood's factory, English pianos and English cottons, artificial stone by Eleanor Coade, metal ornaments by Matthew Boulton, English furniture and English coaches, all were widely exported. But English taste in design was also praised: the *Journal* contrasted English simplicity, practicality, and comfort with French luxury, impracticality, and formality.

English influence was particularly marked in Scandinavia, Germany, and Austria and it was of course dominant in the newly constituted United States of America. But even in Paris the production of Wedgwood-style wares at the Sèvres porcelain factory and the foundation of factories to produce transfer-printed creamware on the English model flattered by imitation. In about 1815 the English designer and design impresario, George Bullock, was a pioneer of the use of native woods combined with bold, part naturalistic, part neo-classical inlays in dark wood or brass, a form of decoration that anticipated the Parisian style of the 1820s. The English designer John Buonarotti Papworth complained in 1824 that he had been widely plagiarized in Paris. In the mid 1820s the architect and designer Benjamin Dean Wyatt began to work for his aristocratic clientele in a rich rococo revival style far in advance of the rest of Europe. At the same time the Meissen porcelain factory in Saxony was producing new versions of its hitherto outmoded rococo patterns specifically for the English market.

Much of the neatness, ingenuity, and practicality of English design

Introduction: Europe, America and England

Cabinet, veneered in maple and ebony
This cabinet is attributed to the London manufactory of the designer George Bullock; its ornament closely resembles that of a documented Bullock cabinet of 1817 at Blair Castle in Scotland. The decoration looks forward to French furniture of the 1820s.

of the first thirty years of the century is epitomized in the *Encyclopedia of Cottage, Farm and Villa Architecture and Furniture* of 1833 by John Claudius Loudon, a Scottish autodidact polymath. The *Encyclopedia* and Loudon's other writings were aimed at a self-improving middle-class market. Their influence was enormous in America where Andrew Jackson Downing and Alexander Jackson Davis, respectively the leading New York design pundit and designer of the 1840s, freely borrowed from and paraphrased Loudon. A crucial ingredient of Loudon and of English taste in general was the cult of the picturesque. This might be expressed as a liking for asymmetric or informal groupings, be it in town planning, architecture, or room arrangement, as a predilection for the romantic styles of the past, particularly Gothic, in whose revival England had led the rest of Europe, or for the exotic styles of China, India, and Islam, and as an inventive and undoctrinaire pursuit of the surprising oddity and the interesting juxtaposition. The principal vehicle by which the concepts of picturesque design were disseminated was the English garden, which enjoyed a remarkable dominance from the banks of the Hudson to the plains of Hungary. The foreign English garden was often, admittedly, a trim and contrived caricature of the original, but the influence was nonetheless unmistakable, ubiquitous, and acknowledged.

One field in which England lagged behind many of its foreign competitors was state involvement in the promotion of design and

industry, and design education in particular. Since Louis XIV's take-over of the Gobelins factory in the 1660s the French state had taken the lead in the direction and patronage of luxury industries, and other absolutist states followed the French example. Porcelain factories at Sèvres, Meissen, St Petersburg, Capodimonte, and Buen Retiro were all under state protection. The reforms introduced by Joseph II after his assumption of full power in 1780 included a new emphasis on design education for craftsmen throughout the Austrian dominions. From 1798 regular exhibitions of French industrial products were held in Paris, and similar exhibitions later took place in Stuttgart (from 1812), Munich (from 1815), Leipzig (from 1816), and elsewhere. In the field of publication many original initiatives came from abroad. It is often forgotten not only that Rudolf Ackermann, whose *Repository of Arts* (1809–28) was the leading English design magazine of the early nineteenth century, was a German, but also that his *Repository* followed a specifically German format. In Berlin the state linked initiatives in design education and publication: from 1821 a series of model designs, many by the great architect Karl Friedrich Schinkel, were published under royal patronage, and by 1835 the main promoter of the state encouragement of industry, Peter Christian Wilhelm Beuth, had established twenty technical schools all over Prussia.

In England the picture was very different. Much of the success of English industry had been based, it seemed to contemporaries, on a freedom to trade, absent elsewhere. The guilds, restrictive and reactionary forces in many countries up to the end of the eighteenth century and, in some, beyond, had in England long lost their power. There had been little tradition of state patronage or promotion of English industry and design. The Dublin Society (founded in 1731), the Society of Arts (founded in 1754), and the Edinburgh Trustees Academy (founded in 1760), all included design education among their aims, but their impact was fitful at best. Some major and enlightened manufacturers, such as Wedgwood and Boulton, seem to have provided a measure of design instruction for their workers, and there were many private drawing schools for artisans run by designers and teachers, including Richard Brown and Peter and Michael Angelo Nicholson. But of their nature such initiatives lacked permanence and consistency, and the quality of teaching was variable.

So when the Select Committee on Arts and Manufactures began to sit in 1835 they had to look abroad for working prototypes of state-sponsored design education. France, Bavaria, and Prussia were particularly influential. Nonetheless, the first fifteen years of the London School of Design (founded in 1837) were marked by repeated conflicts

Introduction: Europe, America and England

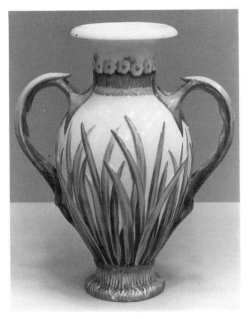

Vase, porcelain with painted decoration
This vase was designed by the painter and designer Richard Redgrave for Summerly's Art-Manufactures, a set of model designs commissioned by Henry Cole under the pseudonym Felix Summerly. This particular example was made especially for the South Kensington Museum by Mintons porcelain factory in about 1865.

on aims and methods. These have never been fully resolved, but when Henry Cole took full control in 1852, his energy, administrative ability, and political skills ensured the development and expansion of a system which numbered 85,000 pupils in eighty schools by 1860. In about twenty years there had thus emerged from nothing an official design establishment, powerful at home and influential abroad. Its headquarters were from 1857 at South Kensington, where the Royal College of Art and the Victoria & Albert Museum stand as its living memorial. In 1863 the Union Centrale des Beaux-Arts Appliqués à l'Industrie, a private association of designers and manufacturers, was formed in Paris specifically to counter the threat offered to French trade by improved English standards of design, and in 1864 the Austrian Museum for Art and Industry was founded in Vienna as the first foreign museum on the South Kensington model.

The South Kensington venture was financed on the profits of the enormously successful Great Exhibition of 1851, promoted by Henry Cole and his royal patron Prince Albert of Saxe-Coburg-Gotha. Prince Albert, who married Queen Victoria in 1840, demonstrated a consistent and energetic involvement in the development of design up to his sadly premature death in 1861. He was a competent amateur designer himself, working in a simple and mildly sentimental naturalistic style, reflecting contemporary German taste and close to the dominant manner of Summerly's Art-Manufactures. This venture was a series of model designs commissioned by and executed for Henry Cole, under the pseudonym Felix Summerly, in 1847. Prince Albert's own art-adviser at this period, a decorative painter from Dresden named Ludwig Gruner, had a considerable influence in the Cole circle. Gruner himself designed: several of his designs were shown in 1851. But he also published extensively on Italian Renaissance ornament of about 1500, and helped to encourage the adoption of an Italian Renaissance manner as the principal South Kensington style. In 1849 Gottfried Semper, another influential German, came to London. Semper, a political refugee from Dresden, was already an accomplished designer, committed to a sophisticated and synthetic Renaissance style. In London he was active as a designer and taught at the School of Design, but also had time to develop his own theoretical position on the basis of style, which identified materials and techniques as determinant factors in the development of forms. In his later years, in Zurich and Vienna, Semper's Renaissance manner enjoyed a remarkable degree of dominance in German-speaking countries.

Informed English manufacturers were fully conscious of a dearth of native designers with an assured grasp of Renaissance ornament (the

principal exception, the sculptor Alfred Stevens, was an awkward employee). France filled the want. Antoine Vechte came in 1848 and stayed until 1861; his pupil Léonard Morel-Ladeuil arrived in 1859. Both worked for Elkingtons, the Birmingham electroplate manufacturers. Léon Arnoux became Art Director of Mintons porcelain factory in 1849 and continued to advise them until his death in 1902. Under his aegis Émile Jeannest and Albert Ernest Carrier-Belleuse also worked for Mintons and others. Buying design talent from abroad might have had a depressing effect on English design. Indeed in 1851 and at the Paris 1855 Exhibition it was evident that many of the most sophisticated and accomplished English manufactures were designed by Frenchmen. But this was less true at the London 1862 Exhibition and still less at Paris in 1867. French designers had become involved in English design education and the force of their example had had a salutary influence on English design expertise.

The mouthpiece of Henry Cole's campaign for design reform, the *Journal of Design and Manufactures*, which ran from 1849 to 1852, was, like Ackermann's *Repository* before it, essentially German in format. In 1851 the *Journal* included a set of six principles of good design, the first being: 'The construction is decorated; decoration is never purposely constructed.' Many discussions with Henry Cole and others went into their refinement and expansion, and when their author Owen Jones published the final set of principles in his great *Grammar of Ornament* of 1856 the number had swollen to thirty-seven, including: 'All ornament should be based upon a geometrical construction.' The French designer Victor-Marie-Charles Ruprich-Robert claimed he had anticipated Jones's ideas. The implied accusation may be ill-founded, but it contains a kernel of plausibility, for Jones shared a French fascination with polychromy, and a French appetite for rationality and theory. His great work on the *Alhambra*, published from 1836 to 1845, was based in part on researches shared with his friend Goury, the French architect who had earlier worked on Greek polychromy with Semper. And Jones's triumphant decoration of Paxton's Crystal Palace of 1851, a combination of the primary colours and white, had its theoretical basis in the researches of the French scientist Michel Eugéne Chevreul.

After the Great Exhibition Jones was part of a small committee charged with spending £5,000 on acquiring exhibits for the nation. Another member of that committee was the architect, designer, and propagandist Augustus Welby Northmore Pugin. Pugin, the son of a French emigré architectural draughtsman who produced a series of important works illustrating Gothic architecture and ornament, was

Introduction: Europe, America and England

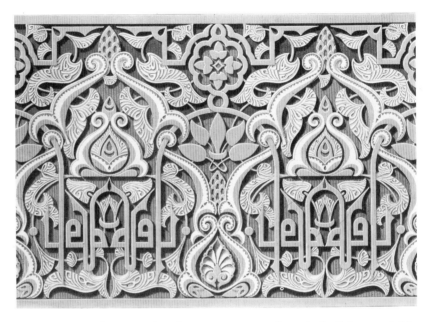

Ornament from the Alhambra, chromolithograph.
This illustration is taken from Owen Jones's *Plans, Details and Sections of the Alhambra*, published from 1836 to 1845, one of the great early achievements of colour lithography, and a major stimulus to the use of Islamic flat pattern by designers.

steeped in Gothic. In 1835 he was converted to Catholicism and his *Contrasts* of 1836 presented his uncompromising creed that Gothic was the only possible Christian style. All over Europe collectors, antiquaries, and designers were rediscovering Gothic and the styles of the succeeding centuries represented in England by Tudor, Elizabethan, and Jacobean. However, English publications on the past seem to have carried more conviction and authority than most published elsewhere. Thus plates from Henry Shaw's *Ancient Furniture* of 1836 were copied in Paris in 1844, and illustrations from Joseph Nash's *Mansions of England in the Olden Time*, published from 1839 to 1849, served as the basis for interiors in Bohemian castles. It is symptomatic of this English enthusiasm for the past that the great engineer Isambard Kingdom Brunel, like Pugin the son of a French emigré father, was a collector in this antiquarian mode. But Pugin took things further. His love of Gothic was not merely an extreme development of the English taste for the picturesque, but also a crusade for structural honesty.

Pugin's Mediaeval Court was the great English success of the 1851 Exhibition, but he was by this time tired and ill. His opposition was uncompromising when he discovered that the purchasing committee had decided in his absence to buy a Renaissance-style shield by Antoine Vechte. This incident can only have speeded his premature death in 1852, worn out and disappointed. Although his *True Principles* were republished in Bruges in 1850, and his furniture designs were copied in Germany and America, there were few signs abroad of any

profound response to his radical originality. In England matters stood differently. Pugin had helped to build up new manufactures of Gothic furniture, encaustic tiles, metalwork, wallpaper, textiles, and stained glass. A new generation of architects was at once inspired by his doctrine of honesty and possessed of the confidence to explore new prototypes and to go beyond archaeology.

The new language of Gothic developed by architects as different as George Edmund Street, William Butterfield, and William Burges had a tendency towards the abstract, the geometric, the blunt, and the muscular. In 1844 Gilbert Scott had demonstrated English Gothic expertise by winning a competition for the rebuilding of the church of St Nicholas in Hamburg with a design in a revived German Gothic style. The new post-Puginian Gothic triumphed in Europe with the Lille Cathedral competition of 1856, when the design of Clutton and Burges was placed first and that of Street second. This Gothic was far from provincial: French thirteenth-century models were often preferred, and Italian and Spanish Gothic also served as wells of inspiration. Nor was there any lack of scholarly contacts abroad. Burges for example was in close touch with the French scholar Adolphe Napoleon Didron, and freely recognized his own debt to the scholarly writings of the French architect Eugène Viollet-le-Duc. But Viollet-le-Duc's restoration of the great medieval castle of Pierrefonds, which began in 1858 and only came to an end in 1884, after his death, lacks life for all its archaeological expertise when compared to Burges's inventive restorations of Cardiff Castle and Castell Coch for the Marquis of Bute. On the mainland of Europe Gothic often carried nationalistic, reactionary, and Catholic overtones. Viollet-le-Duc, a rationalist republican, was an exception. In England Gothic was a broader church in which High Churchmen like Butterfield, moderates like Scott, and atheists like William Morris could feel equally at home. Some of the credit for this wide appeal belongs to John Ruskin, whose eloquent writings linked the love of Nature with the love of Gothic, and added a new social dimension to its claims to moral authority by stressing the creative contribution of the individual craftsman, as opposed to the modern 'degradation of the operative into a machine'.

Although it was in the 1850s and 1860s the main focus of innovation, Gothic never dominated English commercial design. The South Kensington Museum continued to promote Renaissance and exotic ornament, and to buy elaborate and refined examples of foreign, predominantly French, design to serve as models for manufacturers. Abroad England had ceased to be quite the dominant industrial and trading power of earlier years. In America design influences from France and Germany

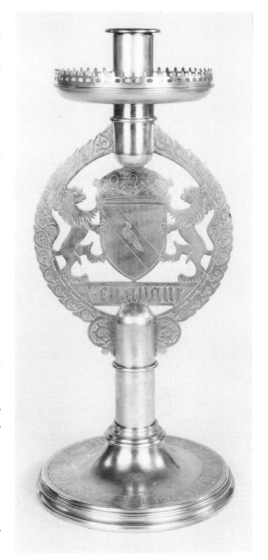

Candlestick, gilt brass with engraved decoration
This candlestick, one of a pair, was designed by A.W.N. Pugin for his own use and made by John Hardman & Company of Birmingham in 1844 or 1845. It is engraved with his arms. Similar candlesticks were shown at the Great Exhibition of 1851.

Introduction: Europe, America and England

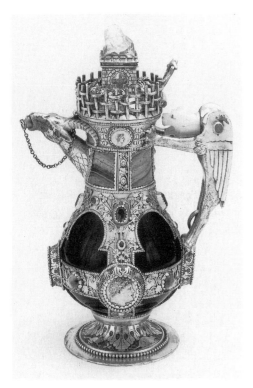

Decanter, green glass mounted in silver set with crystal, jade, Greek coins, and cameos
This decanter was first sketched by William Burges in 1858, and made by R.A. Green for James Nicholson in 1865–6. Two similarly rich and inventive decanters were made about the same time for Burges's own use.

became much more important. In France a new neo-classical style of ornament called Néo-Grec had evolved. It was characterized by imaginative polychromy, by extreme refinement of execution, and by a highly original and mannerist combination of forms and motifs derived from Greek, Etruscan, Roman, and Egyptian sources, often lent extra pungency by daringly geometric elements. Although one of the most accomplished Néo-Grec ceramic designers, Marc Louis Emanuel Solon, worked at Mintons from 1870 to 1904, and much of the work of Owen Jones and his follower Christopher Dresser may be seen as an English equivalent of Néo-Grec, the style never really became acclimatized in England, by contrast with America. Significantly one of the finest 'English' designs in this manner was an elaborate suite of furniture designed in 1884 by the Dutch-born painter Lawrence Alma-Tadema for the New York maecenas Henry G. Marquand. English manufacturers were more at home with the more directly historicist revived 'Louis XVI' style, or its English equivalent, the 'Adams' style.

In the late 1860s a younger set of Gothic architects, led by Richard Norman Shaw, William Eden Nesfield, and Edward William Godwin, began to explore a wider range of models. The 'Queen Anne' style of architecture that emerged from their experiments was characterized by red-brick variations on late-seventeenth- and early-eighteenth-century themes, with a stress on asymmetry and flexibility. Interiors tended to be informal in planning and eclectic in contents, which might include English vernacular furniture, Spanish lustre pottery, Chinese blue and white porcelain, and William Morris wallpapers and fabrics. Japanese motifs and bric-à-brac were common. The 'artistic house', to adopt a phrase used in 1882 by Mrs Haweis, author of the *Art of Decoration* and other manuals of taste, rapidly turned into a caricature of itself, a subject which George du Maurier made his own in a series of *Punch* cartoons published from 1873 to 1882.

The art movement had its superficial aspects, but it also produced a fresh language of design with an ideological base in the structural honesty of Pugin's Gothic, with strong moral overtones derived from Ruskin and Morris, but with a new sense of freedom from commitment to any particular stylistic vocabularly. Its protagonists enjoyed some international fame. Charles Locke Eastlake's *Hints on Household Taste*, first published in London in 1868, went through seven American editions from 1872 to 1886, and Eastlake gave his name to an American style of commercial art furniture which often flouted his precepts. The designer Bruce Talbert's *Gothic Forms Applied to Furniture* (1868) and *Examples of Ancient and Modern Furniture* (1876) were also reprinted in America, in 1873 and 1877 respectively. His influence extended to

Germany and Sweden, but his crowning achievement was at the Paris 1878 Exhibition when his Juno cabinet won the grand prize; it combined the ebony and ivory virtuosity of many earlier French prize winners with the new English style.

Anglo-American artistic relations were sometimes close. The Philadelphia architect Frank Furness designed furniture and buildings

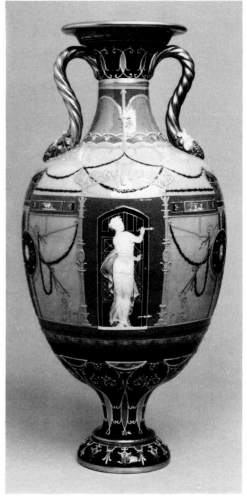

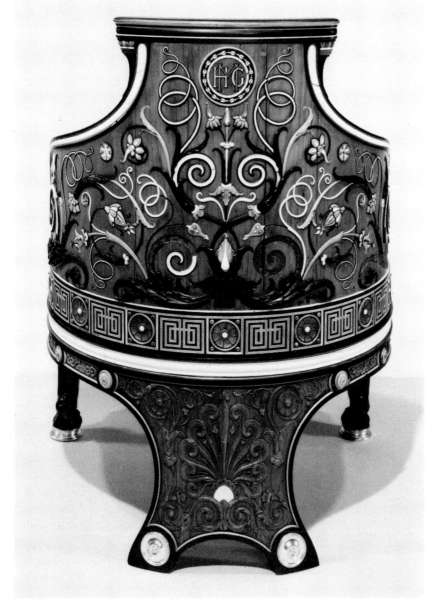

Vase, porcelain with *pâte-sur-pâte* decoration
Designed and modelled by Marc Louis Emanuel Solon for the Minton porcelain factory, this vase was shown at the Philadelphia Centennial Exhibition of 1876 and then purchased by the South Kensington Museum for £52 10s.

Armchair, cedar with inlays of ivory, ebony, sandalwood, and abalone shell
This armchair was designed by Lawrence Alma-Tadema in about 1884 for the Music Room of Henry Gordon Marquand's New York mansion, as part of a large suite including a grand piano. It was completed by Johnstone, Norman & Co. of New Bond Street, London, in 1887.

Introduction: Europe, America and England

from the 1870s in a tough Gothic style much indebted to England. Henry Hobson Richardson's Watts Sherman house in Newport of 1874 was directly influenced by Richard Norman Shaw, and his great Trinity Church in Boston, consecrated in 1877, contains stained glass by Edward Burne-Jones and Henry Holiday. But it should not be overlooked that artistic nationalism was an important new factor from around this date. In America the Philadelphia Centennial Exhibition of 1876 helped to stimulate a nationalistic hankering for Colonial artefacts, which tended to satisfy Queen Anne taste. In Germany the Munich 1876 Exhibition signalled the coming ascendancy of German Renaissance and other local styles and the supersession of Semper's Italian Renaissance manner. And developments in England no doubt contained a strong if rarely strident element of nationalism.

In about 1883 the architect and designer Arthur Heygate Mackmurdo, a disciple of Ruskin, designed a chair whose back was filled with undulating floral and foliate fretwork which strikingly anticipates Art Nouveau ornament: indeed the design was copied by Fred Miller in 1899 in the German design magazine *Der Moderne Stil*. Also in about 1883 Mackmurdo founded the Century Guild 'to render all branches of art the sphere no longer of the tradesman but the artist'. In 1884 the first volume of the Century Guild's *Hobby Horse* was published, an elaborately designed and finely printed magazine, the predecessor of *Van Nu en Straks* (published in Brussels from 1893), *Pan* (published in Berlin from 1895), and *Ver Sacrum* (published in Vienna from 1898). The Century Guild was essentially a design firm, while the Art-Workers' Guild, founded in 1884 on the initiative of a group of pupils of Richard Norman Shaw, was a forum for discussion among designers and craftsmen. The first guild proper was the Guild of Handicraft founded by Charles Robert Ashbee in 1888, and in the same year the first exhibition of the Arts & Crafts Exhibition Society provided a showplace for the work of all those who were concerned to put into practice the ideas of Ruskin and Morris.

The formal innovations of advanced English designers were widely influential in Europe and America. From 1893 a new magazine, *The Studio*, disseminated information on and illustrations of English design: its first issue included articles on Aubrey Beardsley and by Arthur Lasenby Liberty, and illustrated designs by Anning Bell, Herbert Horne, Selwyn Image, Heywood Sumner, C.F.A. Voysey, and others. English designers received foreign commissions. In 1897, for example, Baillie Scott designed two rooms for the Grand Duke of Hesse, and in 1895 Siegfried Bing ordered paintings from Frank Brangwyn, as well as selling fabrics by the Liberty and Morris firms and metalwork by

Tapestry, *Angeli Laudantes*, coloured wools and silks
The tapestry was made at the Merton Abbey works of the William Morris Company, and purchased by the South Kensington Museum in 1898 for £225. The figures were designed by Sir Edward Burne-Jones, and the border and background by J.H. Dearle.

Angeli · Laudantes ·

Introduction: Europe, America and England

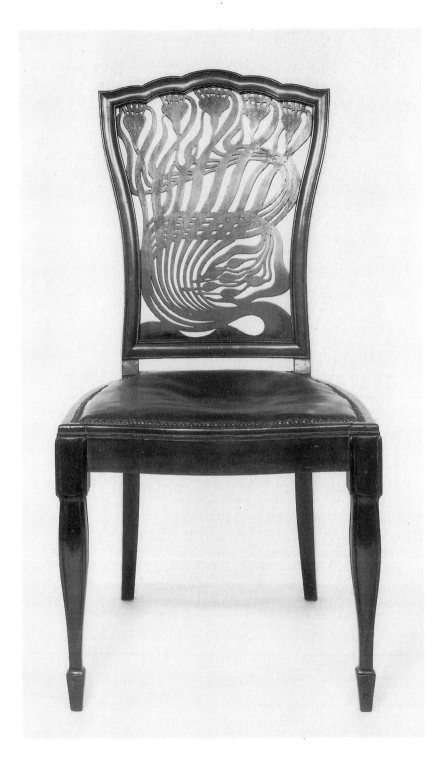

Chair, mahogany with painted decoration
This chair was designed by Arthur Heygate
Mackmurdo in *c.*1883 and made by Collinson &
Lock. Its use of the 'whip-lash' curve is a remark-
able anticipation of Art Nouveau ornament of the
1890s.

18

W.A.S. Benson. In Vienna Arthur von Scala bought English furniture for the Trade Museum from about 1890 and for the Museum for Art and Industry from 1897, and at the Paris 1900 Exhibition Justus Brinckmann acquired the Kelmscott Press *Life and Death of Jason*, bound by Cobden Sanderson, for the Hamburg Museum. And from 1896 Hermann Muthesius was in London reporting back to Germany on English progress in architecture and design.

Ruskin and Morris were paid almost universal lip-service as the prophets of the new movement, but any profound understanding or application of their teachings was rare; Frank Lloyd Wright was exceptional in taking them very seriously. Much Art Nouveau ornament, especially that which the French sculptor and designer Carabin called the 'macaroni style', was superficial and dishonest in Puginian terms. Commercial design of this ilk was not without influence in England: the facile pewter designs made by Hugo Leven for the Kayser factory at Krefeld inspired Archibald Knox's pewter designs for Liberty's. However, the English design establishment strongly disapproved of such foreign developments. A dramatic demonstration of this attitude was the condemnation by Walter Crane and other English pundits of the French furniture from the Paris 1900 Exhibition given to the South Kensington Museum by Sir George Donaldson. It is significant that Charles Rennie Mackintosh, whose creative relationship with Josef Hoffmann and other Viennese designers continued beyond 1900, was an essentially formal innovator based in Glasgow.

In 1900 there was thus a strong tendency among English designers towards an insular detachment, although, ironically, English influence was then at its height after a century of ebb and flow. In 1800 English practicality, neatness and comfort had been admired by foreign commentators. For Adolf Loos, the Austrian architect and writer who was the scourge of self-conscious designers such as Josef Hoffmann, these remained the essential English virtues in 1900. Many English designers would have agreed but, unlike Loos, they were nurtured by a native tradition of design and design theory which, though evolved in the nineteenth century, still remains a force not only in England, but also in Europe and America.

SIMON JERVIS

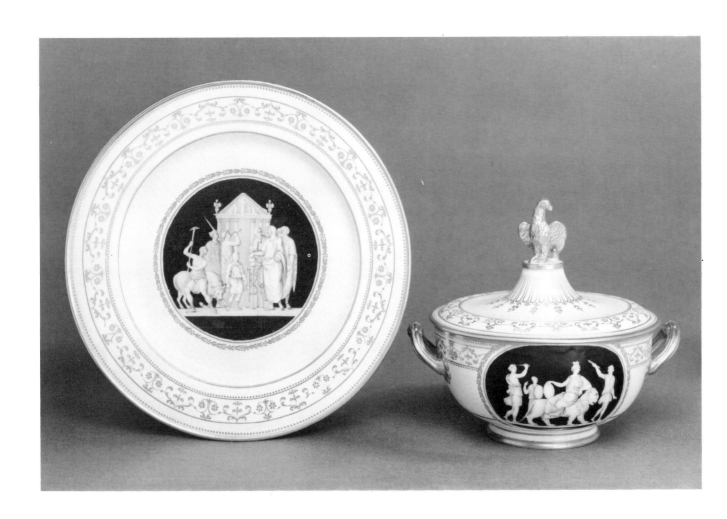

Broth-basin, cover and stand

Manufactured by the Real
Fabbrica Ferdinandea
Italian: Naples, c.1800
Soft-paste porcelain, enamelled
and gilt
Broth-basin and cover
h (overall) 16.5 cm (6½ in.)
Stand *diam* 22.5 cm (9 in.)
Marks: N under a crown
impressed; 6 incised
12A and B—1869

Though in essentials similar to mid-eighteenth-century porcelain broth-bowls, both the shape and decoration of this piece show neo-classical touches; reminding one that the Neapolitan factory that made it was, like the excavations being conducted on nearby Roman sites at Pompeii and Herculaneum, under the control of the Bourbon King of Naples, Ferdinand IV. The Roman-looking eagle on the cover; the upward-sweeping handles derived from ancient Greek pots such as were then daily emerging from the soil, or else from ancient metalwork; the enamelled scenes representing a Roman sacrifice and the triumphs of Bacchus and Cybele, designed to resemble Roman cameos: all these reflect a taste for classical art. Neo-classicism in Naples, however, perhaps because of its close contact with the warm and sensuous classical originals discovered locally, has a spontaneity and charm that is sometimes lacking in the more theoretical neo-classicism of Northern Europe. Porcelain was in any case a material unknown to the ancient world.

Most other factories on the continent of Europe were by 1800 using hard-paste or true porcelain, whose cold glitter and suitability for producing sharp-edged forms resulted in very different effects from those obtainable with the soft-paste used at the Real Fabbrica Ferdinandea, which is notable for its glassy and melting appearance. A similar soft-paste had been used at the earlier, distinct Neapolitan factory at Capodimonte (1743–59), which was removed to Buen Retiro, Madrid, when Charles III of Naples became King of Spain in 1759. His son, Ferdinand IV of Naples, founded the Real Fabbrica in 1771, and it continued as a royal factory until the Napoleonic invasion of Naples, whereupon it was leased to the French firm of Poulard, Prad and Co, under which the quality of the products declined. In view of its royal mark this piece must have been made prior to 1806. JVGM

Cabinet

Designer unknown
Manufactured by Jacob Frères
French: Paris, c.1800
Amboyna with ormolu mounts
and bronze mounts; the top of
Spanish 'Brocatello' marble
h 120 cm (3 ft 11 in.); *w* 145 cm
(4 ft 9 in.); *d* 51 cm (1 ft 10 in.)
Marks: stamped JACOB FRERES
RUE MESLEE
W.9–1971

This elaborate cabinet was manufactured by the celebrated Parisian cabinet-making firm of Jacob Frères which supplied furniture to Napoleon and his wife Josephine. From 1799 the firm was involved with the leading French architects Percier and Fontaine in re-furbishing Malmaison for Josephine. The JACOB FRERES RUE MESLEE stamp was in use only between 1796 and 1803 when Georges Jacob II (1768–1803) was in partnership with his brother François (1770–1841), usually known as Jacob Desmalter.

It is not known who designed this cabinet, though Percier is a distinct possibility; several of the mounts appear on other Jacob pieces and were probably made by the firm of Pierre-Philippe Thomire (1751–1843) who often provided the mounts for Jacob furniture. All three of the large mounts depict Venus, the centre one shows her rising from the sea and wringing the water from her hair while two cupids look on. The source for this mount is Jean Goujon's celebrated relief of the same subject, *Venus Anadyomene*, which dates from the mid-sixteenth century. The relief was for the Louvre which in 1803 Napoleon transformed into the 'Musée Napoleon'. The two other mounts also represent Venus in other manifestations.

On the bottom right and left are two circular mounts depicting Diana the Huntress with her arrows and hunting horn. The two circular upper mounts and that in the centre of the frieze represent the imperial eagle. Interestingly the centre Venus mount is very similar to that on a cabinet now at Fontainebleau which was designed by Percier and made in 1810 by Jacob Desmalter for Empress Josephine.

It is known that this cabinet was part of the Ruspoli Talleyrand collection in the Villa Imperiale in Florence whose contents were sold in May 1969. Some of the objects in this collection had originally belonged to Napoleon's minister, the celebrated Duc de Talleyrand (1754–1838). The elaboration of its mounts and the fact that it is veneered in amboyna, which was far more exotic and expensive than the mahogany usually used by Jacob, indicate that it was made for an important client. Talleyrand is a possibility, of course, though it could easily have come into the Ruspoli Talleyrand collection in the later nineteenth century. The presence of the imperial eagle could indicate that it was made for Napoleon himself. CW

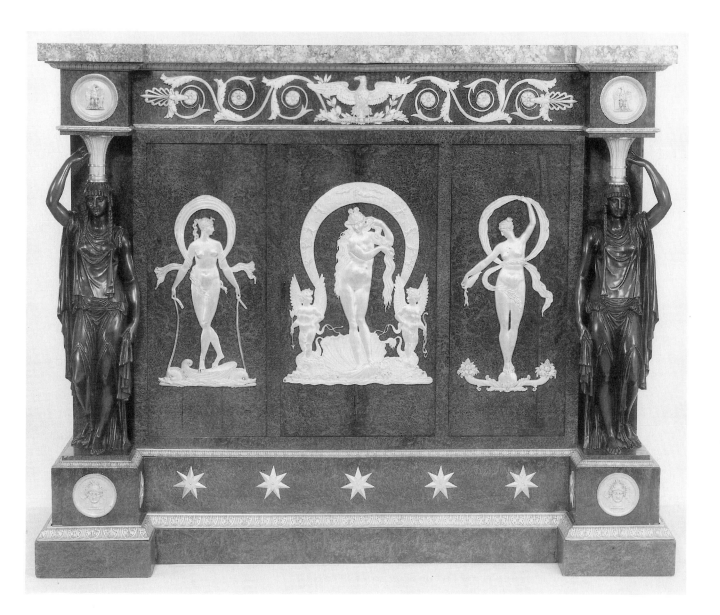

Furnishing panel

French, c.1800–15
Woven silks with embroidered
details
h 56 cm (1 ft 10 in.); w 310 cm
(10 ft 2 in.)
1274B–1871

Literature

Pompeii as Source and Inspiration,
exhibition catalogue, University
of Michigan Museum of Art,
1977

This panel belongs to a set of three valances
or friezes, each of which features a row of
Bacchantes copied from engravings of wall-
paintings at Herculaneum reproduced in the
1757 volume of *Le Antichità di Ercolano esposte*
1755–92, Naples. Published in a small limited
edition by King Charles III of the Two Sicilies,
this series did not become widely available
until about 1770. Although the painted interiors
were known from the mid eighteenth century,
they were regarded as debased in style, prov-
incial in character, and unsuitable for imitation.
Individual motifs, however, were ideal for the
decorative arts, and this silk woven with pairs
of *Bacchantes* may have been intended for

cutting up to provide single figures for chair
upholstery and other decorations. A chair-seat
and back at the Metropolitan Museum of Art,
New York, and a wall-hanging at the Cleveland
Museum of Art, Cleveland, Ohio, seem to have
been made in this way.

Around the turn of the century there was a
new wave of interest in the excavations at
Herculaneum and Pompeii. The Kingdom of
Naples fell into French hands and the work
was re-directed towards thorough recording
and even restoring the sites. This quest for
the holistic view, essentially romantic, was
reflected in a new kind of classicism in design.
In 1800 the dining-room at Malmaison, country

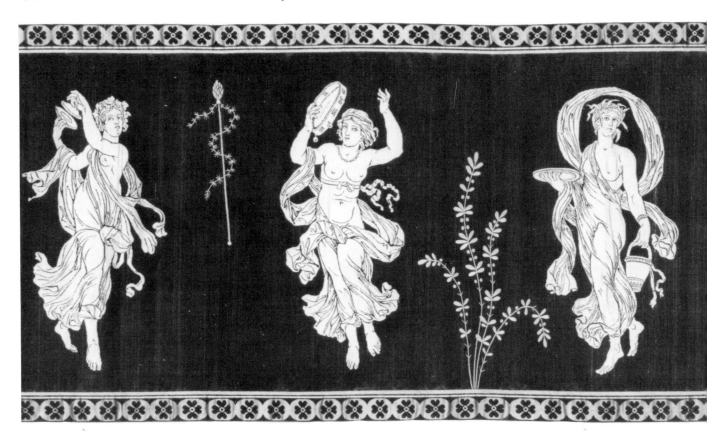

house of Josephine, Napoleon's wife, was decorated with full-sized dancing figures, restoring the original size of the ancient paintings. In 1828 the architect Leo von Klenze designed a Pompeian room for the Maxpalais in Münich, and in 1841 Friedrich von Gärtner built a complete Pompeian house at Aschaffenburg for Ludwig I of Bavaria.

These hangings seem to date from the Napoleonic period. Five pieces of the *Bacchante* silk have been joined together to re-create a type of figured frieze found at Herculaneum. Some of the yellow silk background has a woven pattern of a garland of flowers with a ribbon in an octagonal frame flanked by griffins; the flowers do not fit into the Pompeian style and were concealed by the *Bacchante* silk, but the griffins appear suitably classical and were incorporated into the design of the new hangings. Palmettes and scrolls, foliage and other emblems were embroidered on to the completed hangings.

When these hangings were acquired in 1871, comparable pieces in the Royal Palace at Madrid were thought to have come from Naples. The Victoria & Albert Museum's collections show that classical motifs were extensively used in designs for printed cottons in this period; these panels show that silk-designers too were inspired by antiquity. PH

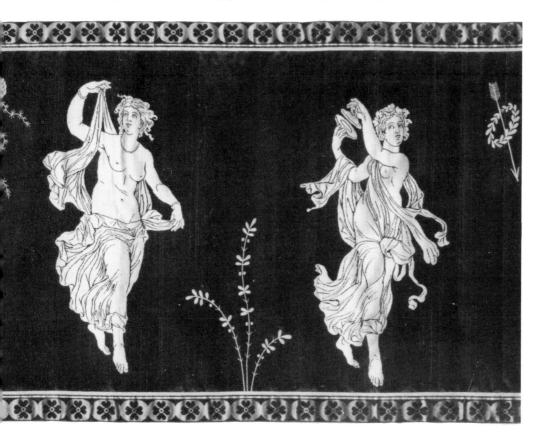

Parade sword

Made in the Manufacture de
Versailles established by Nicolas
Noel Boutet (1761–1833)
French: Versailles, c.1802–3
Mounts of silver-gilt with
applied silver masks, the
scabbard mounted with plaques
of mother-of-pearl, the blade
blued and overlaid with punched
and engraved gold
Signed Ent BOUTET, MF A
VERSAILLES
l (overall) 94.6 cm (3ft 1¼ in.)
486–1870
Acquired in 1870 from a
Mr Davis for £25

Literature

M. BOTTET, *La manufacture de
Versailles An II – 1818, Boutet
Directeur Artiste*, Paris, 1903
J.F. HAYWARD, *The Art of the
Gunmaker*, London, 1963
J.F. HAYWARD, *European
Firearms*, London, 1969
G.F. LAKING, *The Armoury of
Windsor Castle*, London, 1914

In 1793 a special workshop was established within the Manufacture de Versailles to produce presentation arms of high quality. The workshop was under the artistic control of Nicolas Noel Boutet, a gunsmith who had worked for the French Royal Household before the Revolution. The majority of the arms produced were firearms, but a number of luxurious presentation swords were made. These include a sword given by the Emperor Napoleon to Don Manuel de Godoy, now at Windsor Castle, and a sword presented by the Emperor to Joseph Fouché, Duke of Otranto, now at Schloss Elghammer, Sweden. Also at Windsor is a parade sword of virtually identical design to the sword shown here. The Windsor version was acquired for the Royal Collection in 1827 from the well-known goldsmiths Rundell, Bridge, and Rundell. With it was a letter signed by Napolean's packer, confirming that the sword had been worn by the Emperor when he was First Consul. It is thought that these swords were supplied to members of the French Consulat in 1802–3. The members of the Consulat were Bonaparte, Sieyès, Ducos, and later Cambacérès and Lebrun.

Boutet signed many of his works 'Directeur Artiste' and the firearms and presentation swords produced in the Versailles factory are works of the highest quality. The motifs used to decorate these swords were drawn from neo-classicism. Masks, altars, Roman standards, and classical trophies were all incorporated into the design, and the shape of the blade with two long parallel channels is based upon contemporary French military swords. Traces of colour remain on the ivory grip indicating that the grip was formerly stained brown.

As with his production of firearms, Boutet introduced some standardization into these presentation swords. Certain features, such as the silver masks and the monsters soldered to the sides of the scabbard, appear on other Boutet presentation swords.

The high cost of raw materials and the length of time each weapon took to make, led Boutet into frequent financial problems. The factory continued to operate until 1818, but much of its stock and working materials were requisitioned by the Prussians in 1815. This seriously affected its production. Boutet died in poverty in 1833. AREN

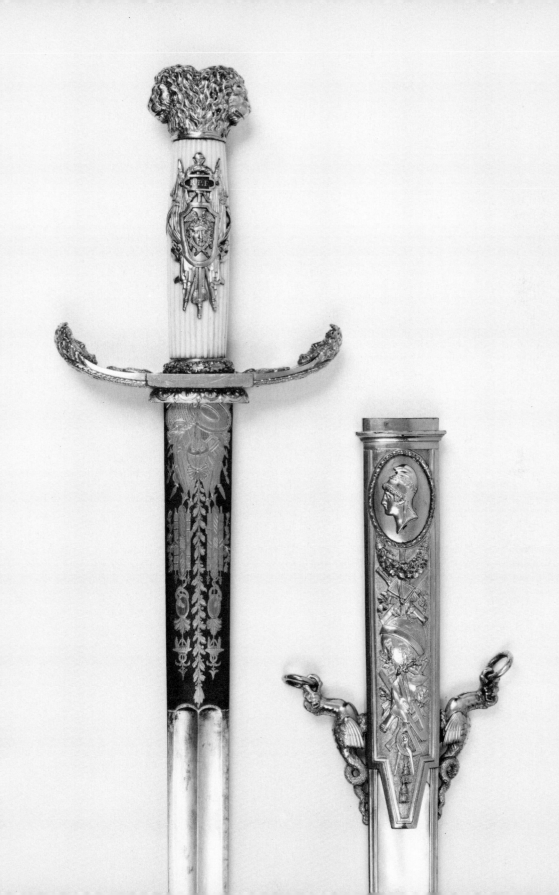

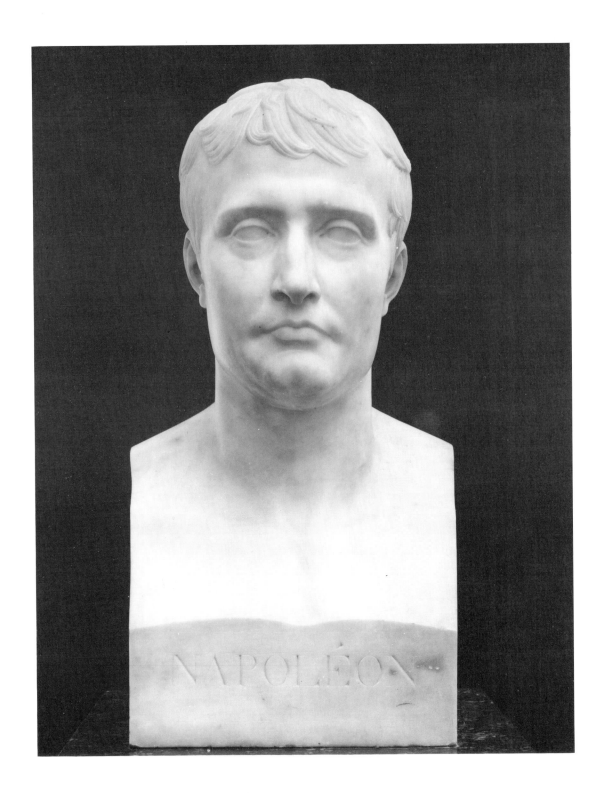

Napoleon I (1769–1821)

From a model by Antoine-Denis Chaudet (1763–1810)
Carved by the Carrara workshops, Italy, 1807–9
Marble
h 58.3 cm (27½ in.)
A.17–1948
Given by Sir Rennie Maudsley, Keeper of the Privy Purse and Treasurer to The Queen

Literature

G. HUBERT, *La Sculpture dans l'Italie Napoléonienne*, Paris, 1964

Chaudet's portrait, for which the plaster model was made in 1799, follows the herm form, the shoulders with straight-cut sides, frequently used by neo-classical sculptors. This severe convention, employed for Roman imperial busts, was considered particularly appropriate for a portrait of the Emperor of the French (1804–15). This was indeed the image preferred by Napoleon himself and became the official portrait, of which copies were placed in public buildings throughout France. The vast majority were destroyed when the Bourbon monarchy was restored in 1814.

The official copies were produced not in France but in Italy, then under Napoleonic rule. Between 1807 and 1809 no less than 1,200 marble versions were carved by the Carrara workshops on the orders of the Emperor's sister, Elisa Baciocchi, who as Duchess of Lucca had control of the Carrara marble quarries.

The production of marble replicas on this scale was only possible through the employment of large numbers of assistants who were responsible for carving and polishing following a model. The increased size of studios and the division of labour within them became characteristic of sculptural practice throughout Europe during the nineteenth century. Similarly, the placing of portrait sculpture in official buildings, though anticipated by the dissemination of images of Louis XIV a century earlier, looks forward to the proliferation of commemorative sculpture in public spaces during the second half of the nineteenth century. This phenomenon was linked with the increasingly important function being played by sculpture in contemporary urban and civic life. Commissions for such public statuary formed a major part of the activity of sculptural workshops during this period. MB

Centrepiece

Manufactured by Thomire
French: Paris, c.1810–20
Gilt bronze
Stamped, THOMIRE A PARIS
h 76 cm (30 in.); w 32 cm (12⅝ in.)
M.135–1929
Given by Mr Douglas Vickers

Literature

D.H. COHEN, 'Pierre-Philippe Thomire-Unternehmer und Künstler', *Vergoldete Bronzen*, II, 1986
J. NICLAUSSE, *Thomire*, 1947

This centrepiece was intended to form part of a *surtout de table*, the elaborate dining service which, in the early nineteenth century, was displayed on a long mirror-lined plateau. This form of *surtout* was developed in France and, in the wake of Napoleon's conquests, it was exported all over Europe. Thomire made many *surtouts*, usually in gilt bronze, for the Imperial family and for many European courts and an example by Thomire survives at Rosenborg castle in Denmark.

The rest of the *surtout* to which this centrepiece belongs has not been identified. The basket of the centrepiece was intended for an arrangement of flowers and it could be fitted with a separate ring of twelve candle branches. The dancing figures, representing Ceres, Flora and a *bacchante*, are gilded in the soft matt finish known as *dorure au mat*. The matt-gilded ornaments are set against backgrounds which are deeply gilded and brilliantly burnished. This quality of gilding and the use of strong contrast in the finish, exemplified in Thomire's carefully executed pieces, is typical of the Empire period.

The firm of Thomire was the most important Parisian manufacturer of gilt bronzes in the early nineteenth century. Though the founder of the firm Pierre-Phillipe Thomire (1751–1843) was trained as a sculptor under Houdon and Pajou at the Academie de Saint Luc, he followed his father into the profession of bronze foundry, becoming a master in 1772. From 1774 Thomire was apprenticed to the celebrated *ciseleur* Pierre Gouthière (1732–1813), from whom he was to learn the sophisticated techniques of chasing and gilding bronze.

Thomire opened his own business in about 1776, with spectacular success, for by the 1780s he was supplying pieces for the court and was employed by Sèvres from 1783 to provide mounts for the porcelains. During the Revolution Thomire's workshops seem to have been involved in the manufacture of arms and he only properly recommenced his trade as a *bronzier* in 1804 when he bought the business of the prominent *marchand mercier* Martin-Eloy Lignereux. Under the name of Thomire, Duterme et Cie, the new firm supplied many commissions for the refurnishing of the royal palaces by Napoleon. In recognition of this work Thomire was granted the title of *ciseleur de l'Empereur* in 1809. After the Emperor's second marriage, Thomire was involved in further commissions, among which was the marriage vase of the Emperor (Versailles) and the two magnificent cradles of the King of Rome (Vienna and Louvre). Thomire provided the heavy bronze mounts for the cradles, in collaboration with the goldsmith Odiot, to the designs of the artist Prud'hon.

Thomire, Duterme et Cie suffered, as other Parisian manufacturers, from the economic crisis brought on by Napoleon's wars and the firm is thought to have become bankrupt in 1811. In order to support it the Emperor granted Thomire a special dispensation to trade with the enemy, allowing the firm to supply bronzes to the Prince Regent in 1813.

Thomire's business survived the political reversals with the restoration of the Bourbons in 1815, despite his close associations with Napoleon. Now called Thomire et Cie, it thrived during the succeeding decades and won medals at the industrial exhibitions held in Paris. Thomire himself retired in 1823, leaving the business to his two sons-in-law. He received the Légion d'Honneur from Louis-Philippe in 1834 and died in 1843. The firm ceased to trade shortly afterwards in 1852.　MGC

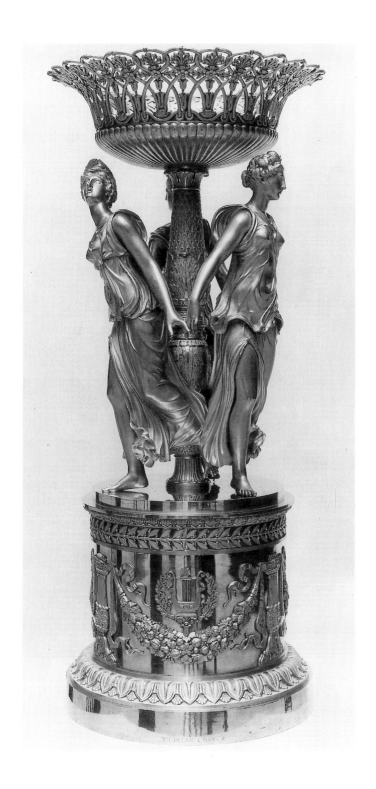

Vase

Manufactured by the
Imperial Factory, Sèvres
French: Paris, 1813
Hard-paste biscuit porcelain
with applied reliefs
Marks: Date-mark TZ for 1813;
AB and (?) J × 6, all incised
h 40 cm ($15\frac{3}{4}$ in.);
diam at lip 32 cm ($12\frac{1}{2}$ in.)
396–1874
Purchased at the Alexander
Barker sale

Literature
G.B. PIRANESI, *Vasi, Candelabri
... Antichi*, Rome, 1778

This vase was closely copied from the celebrated first-century AD Attic marble in the Uffizi Gallery, Florence, known as the *Medici Krater*, which also bears reliefs thought to represent the Sacrifice of Iphigenia. A possible intermediate source may have been the etching contained in G.B. Piranesi's *Vasi, Candelabri ... Antichi* which shows both general views of the *krater* and a flattened out view of the entire relief scene that runs round it. However, many other prints were made of the vase, starting with della Bella's single view of 1656, and three copies had been made for the *Bassin de Latone* at Versailles.

The mark 'AB' stands for Alexandre Brachard the younger, a *sculpteur-répareur* who would have assembled the vase and its reliefs from separate moulds and sharpened up the detail. He was active at the Sèvres factory from 1784–92, 1795–9, and 1802–27.

Although the South Kensington Museum purchased this Sèvres vase at the Alexander Barker sale in 1874, it had earlier belonged to Dr Anthony Todd Thornton, whose daughter gave information that he had bought it directly from the Sèvres factory during the occupation of Paris following Waterloo. This is probably correct, although Dr Todd was apparently told that the piece had been intended as a gift to the Tsar but that, since it became stained during manufacture, handles were never added and the piece was put aside for destruction. However, it seems unlikely that handles were meant to be added to an already fired piece, and in any case Napoleon was at war with Russia in 1813, the date indicated by the incised mark. The pronounced fire-cracks seem a likely reason why the *krater* was left in stock.

The use of a blue ground-colour to set off figures in white relief was probably suggested by the blue jasper-wares of Josiah Wedgwood, which enjoyed great popularity in continental Europe as well as England. Wedgwood's jasper-ware was in its turn influenced by the colours introduced into English interior decoration by such neo-classical architects as the Adam Brothers, whose stucco ceilings often incorporated white figures in relief set against a coloured ground. Wedgwood's jasper-ware, however, was a form of stoneware and not, like this Sèvres vase, a hard-paste porcelain.

JVGM

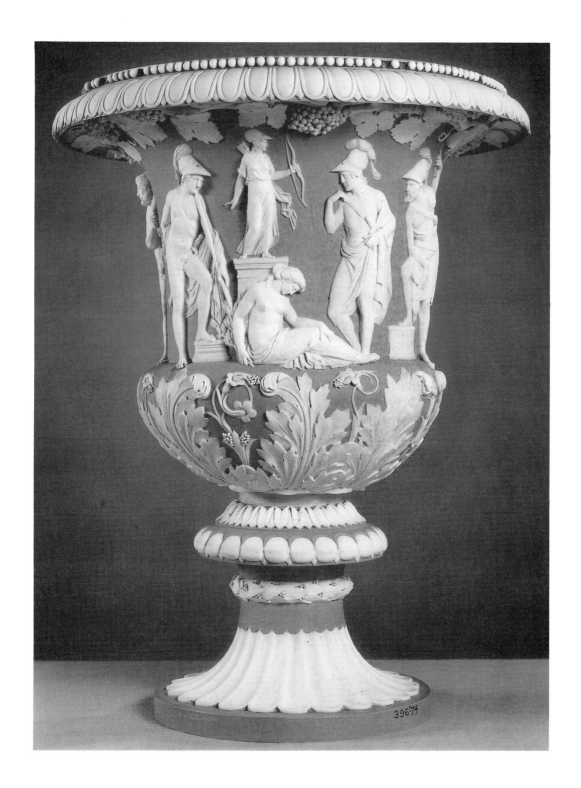

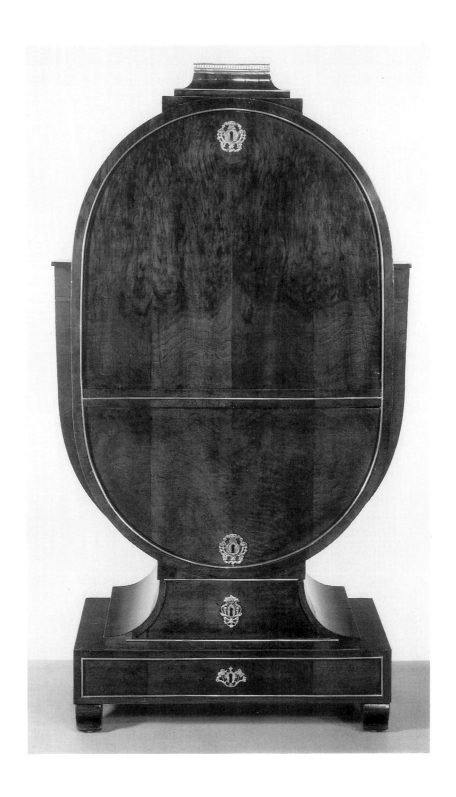

Secretaire

Made by Franz Steindl
Vienna (?), 1814
Mahogany with gilt bronze
mounts, the interior with a
mirror, and with composition
and penwork ornament
h 145 cm (4 ft 9 in.); *w* 81 cm
(2 ft 8 in.); *d* 35 cm (1 ft 1¾ in.)
Signed under a drawer '*Frantz
Steindl 1814 Im 30tm December*'
W.22–1981

Literature
GEORG HIMMELHEBER,
Biedermeier Furniture, London,
1973 (new German edition,
Munich, 1987)

The signature on the drawer of this secretaire may refer to Franz Steindl who was an important cabinet-maker in Budapest from the 1820s onwards. He was probably trained in Pest under the cabinet-maker Anton Sebastian Vogel, and the secretaire could date from this apprentice period. However, the form of the secretaire, a radical abstraction of the antique lyre, seems remarkably advanced for 1814, and Vienna—a major centre of the cabinet-making trade—seems a more likely provenance.

The main body of the secretaire is flanked by curved projections, square in section, which are formalized *cornucopiae*, identifiable by comparison with more elaborately decorated examples. The Steindl projections show signs of having lost some form of terminal ornament, perhaps globes, busts, or vases. The gilt bronze mounts, crisply stamped from thin metal sheet, are typical Viennese products, in contrast to the expensive cast mounts used on contemporary high-quality French furniture. Inside the secretaire, flanking the sets of drawers, are two gilt caryatides formed of composition, another cheap substitute for cast bronze. Composition was popular in Vienna, where Josef Danhauser (1780–1829) based an enterprise—which was already employing 130 workers in 1808—on the production of such ornaments. The penwork on the interior is another inexpensive but effective form of ornament popular in Viennese Biedermeier furniture.

This secretaire stands at the very beginning of the development of the Biedermeier style in Vienna, where it evolved from the idiosyncratic local version of the international neo-classical style known as Empire. It is typical that the sobriety and severity of its exterior, clad in carefully matched and aligned veneers, should be supported on little curved feet which tend to subvert, through ignorance rather than intention, the architectural seriousness of the whole. SJ

Part of a déjeuner (tea service)

Painted by Jean-Charles Develly (1783–1849)
Gilded by Pierre Louis Micaud (active 1795–1834) and others
French: Sèvres, 1814
Hard-paste porcelain painted in enamel colours and gilt
3579–1856

Tray
50.6 × 42.3 cm (20 × 16¾ in.)
Marks: Interlaced 'Ls' enclosing a fleur de lys and 'Sevres', printed in grey [Mark 1]; 'Charles Develly, 1814, signed in the painting 'I Juillet BT' painted; 'IB' and 'QZ' incised; '9 N^{bre} qz' (9 November 1814) painted in gilt; a coronet and 'Galerie de S.A.R. Madame Duchesse de Berry' stencilled in red
Painting: *The Lion goes to War*

Tea pot and cover
h 18.4 cm (7¼ in.)
Marks: [1], as above; 'MR (in monogram) qz 2 aout' in gilt, for the gilder Micaud, 2 August 1814 [Mark 2]; 'Le t' and 'QZ 4' incised; the monogram 'CD' for Charles Develly painted in black in both paintings [Mark 3]
Painting: *The Wolf and the Lamb* and *The Lion and the Rat*

Jug
h 19.0 cm (7½ in.)
Marks: [1] and [3], as above; 'MR (in monogram) qz 1^{er} J^{et}' in gilt [Mark 4]; ?'CS' and 'qz' incised
Painting: *The Fox and Grapes*, and grisaille medallions *The Cock and Pearl* and *The Mountain in Labour*

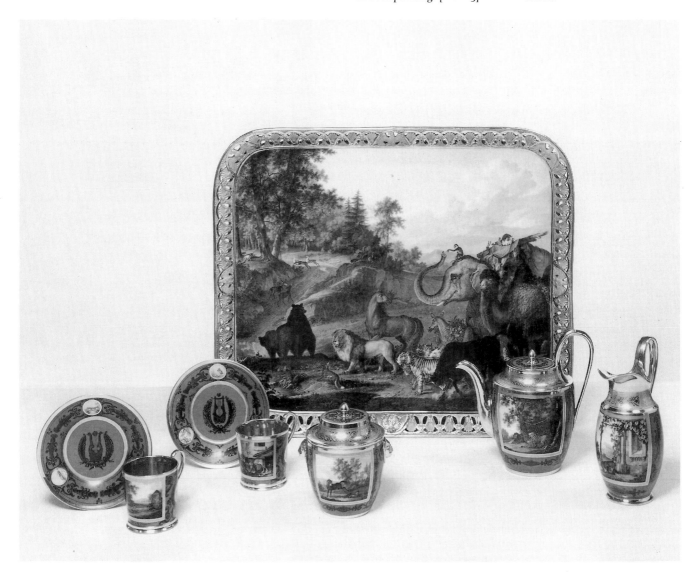

Sugar bowl and cover
h 12.6 cm (5 in.)
Marks: [1], [2], and [3], as above;
'qz 3', 'DL' and 'H' incised
Painting: *The Horse and the Wolf*
and *The Lion and the Gnat*, and
grisaille medallions *The Iron Pot
and the Clay Pot* and *The Bird
wounded by an Arrow*

Cup and saucer
h (cup) 7.8 cm (3 in.); *diam*
(saucer)
14.2 cm (5½ in.)
Marks: on both, [1] and [4], as
above; on the cup, '11 qZ' and
'Le' incised; on the saucer, 'qZ'
incised
Painting: on the cup, *The Wolf
and the Dog* with grisaille
medallions of *The Monkey and
Dolphin* and *The Fox and Bust*; on
the saucer, grisaille medallions of
*The Two She-Goats, The Hare and
the Frogs*, and *The Rat and the
Oyster*

Cup and saucer
Marks: on both, [1] and [4], as
above; on the cup, 'H', 'qZ' and
?'Cv' incised; on the saucer, 'SD'
and 'QZ' incised
Painting: on the cup, *The Hare
and the Tortoise* with grisaille
medallions of *The Fox and the
Stork*; on the saucer, grisaille
medallions of *The Frogs who
asked for a King, The Ant and the
Fly*, and *The Oak and the Reed*

Literature
MARCEL BRUNET & TAMARA
PREAUD, *Sèvres, des origines à nos
jours*, Fribourg, Switzerland, 1978
ROBERT THOMSON, *La
Fontaine's Fables Now First
Translated from the French*, Paris,
1806
Sèvres Archives

The history of Sèvres and of the state are closely linked. Under the *Ancien Régime* the factory belonged to the king himself, but the Revolution brought it into chaos and deep debt. However, in 1800, Alexandre Brongniart was appointed director of the factory, chosen by the Bureau des Arts et Manufactures for his skills both as a distinguished ceramic chemist and efficient administrator. He dismissed surplus workers and sold much of the factory's stocks to raise funds. He also rationalized the internal structure and the payment and accounting systems.

Nevertheless, Sèvres did not regain financial security until it was put on the civil list in 1802, in effect becoming part of Napoleon's expenses. It could now return to the production of prestigious pieces, combining beauty, quality, and technical improvements. Based on work in the chemical research department which Brongniart introduced at the factory, a new hard-paste body, still in use today, replaced soft-paste porcelain from 1804. A wide range of both high- and low-temperature colours was also created. As the director of Sèvres, Brongniart had to adapt to changing political regimes. The various sovereigns treated the factory as their own, frequently visiting to judge the progress of pieces they had ordered.

This *déjeuner*, or tea service and tray, was exhibited at the factory on 1 January 1815. It is typical Sèvres of the period, the painted decoration taking full advantage of the wide palette developed by Brongniart and surrounded by gilt borders to give the whole the appearance of an easel painting. Fashionably heavily gilded, the cups are *doublées d'or*, that is, entirely gilt inside. The border of the tray has been gilded twice, in places directly on to the biscuit (unglazed body) to produce a matt effect, and elsewhere over the glaze for maximum brilliance.

Brongniart wrote in 1815: 'I try never to put on pieces subjects other than those with historical or literary interest, and I avoid where possible insignificant or invented subjects.' The decoration of this *déjeuner* conforms to this ideal, the paintings and the *en grisaille* medallions representing a selection from the fables of de la Fontaine. The Sèvres archives show that the painter of the scenes and ornaments, Charles Develly, was paid 900 francs for the tray, which he signed and dated. It illustrates the fable of *The Lion going to War*:

The Lion form'd some scheme profound,
Held a war council—sent his heralds round,
To bid his subject beasts prepare.
They all in concert joined the toils to share;
The elephant upon his back to bear
The battle equipage, which was not light,
And in his usual manner stand the fight.
The bear was nam'd to scale—
The fox to shift it, when their arms might fail.
The monkey by his tricks to cheat the foe.
But for the ass, they cried, pray let him go,
So stupid—and the hare so full of fear.
No, cried the king, we'll place them in the rear;
Our army otherwise were incomplete—
The ass will blow the onset, and retreat;
And for dispatches, who the hare can beat?

A wise and prudent prince commands
His meanest subjects into use—
And by their merit forms his bands,
For none to men of sense refuse.

The shapes of this *déjeuner* were created between 1800 and 1808. The border of the tray bears eight Imperial eagles. In 1815, during Napoleon's first exile, the factory was occupied by Prussian soldiers who demanded that any pieces which referred to the emperor be brought to them and destroyed. Brongniart gave them only the least significant, saving the rest even if this meant scratching out an inscription or masking a portrait. This is possibly when the Imperial eagles on the tray were covered by silver gilt plaques bearing the Royal (Bourbon) Arms of France. They themselves show signs of having been painted over later, perhaps during another period in French history. One has been left in place.

The *déjeuner*, which originally included two additional cups and saucers, was delivered to Louis XVIII on 26 June 1816, costing 2,995 francs, including box. Later it was allegedly given by Charles X to the Duchesse de Berry, whose inventory stamp appears on the back of the tray. In 1856 it was acquired by the South Kensington Museum for £30. HB

Psyché au bain

Designed by Louis Lafitte
(1770–1828) and Méry-Joseph
Blondel (1781–1853)
Manufactured by Dufour et Cie
French, 1816
Panoramic wallpaper printed in
grisaille from wood blocks
Size of block: 152.5 × 57.2 cm
(60 × 22½ in.)
E.695–698–1937

Literature
CLARE CRICK, 'Wallpapers by
Dufour et Cie', *The Connoisseur*,
December 1976
DOUGLAS POLK (ed), 'French
Panoramic Wallpaper' *Art &
Antiques*, November–December
1980

These panels form part of one of the best-known panoramic wallpapers produced in France in the early nineteenth century. The cartoons for the series depicting the story of *Psyché et Cupidon*, based on Jean de La Fontaine's *Les Amours de Psyché* (1699), were commissioned by Dufour from the firm of Mader *père* in 1785.

The designer Louis Lafitte won the first Grand Prix de Rome in 1791, and after the Restoration became Dessinateur du Cabinet du Roi. In 1817 he exhibited four of the original designs, including one for the scene of *Psyché au Bain*, at the Paris Salon. Possibly due to the political disruption and upheaval of the times, the wallpaper was not issued by Dufour until 1816. In 1819 it was awarded a silver medal at the Fifth Public Exhibition of Products of French Industry.

America provided the largest export market for panoramic wallpapers in the early nineteenth century. *Les Voyages de Captain Cook* (or *Sauvages de la Mer Pacifique*), designed by Jean-Gabriel Charvet, produced by Dufour in 1804, was a favourite. Comparatively few of these papers are found in Great Britain and Ireland. *L'Hindoustan*, an example at Attingham Park near Shrewsbury, was based on the Indian topographic drawings of William Daniel, and produced by Zuber et Cie in 1806.

The popularity of the panoramic wallpapers was at its height between 1810 and 1860 but *Psyche et Cupidon* was re-issued in 1872, 1889, 1905, 1923, and 1931.

The firm of Cowtan decorated a boudoir with this paper in Knole Park in 1901, and hung another set at Tal y Cafn, Bodnant, North Wales in 1933. JH

PSYCHE AU BAIN. *en 4 lés* 8.

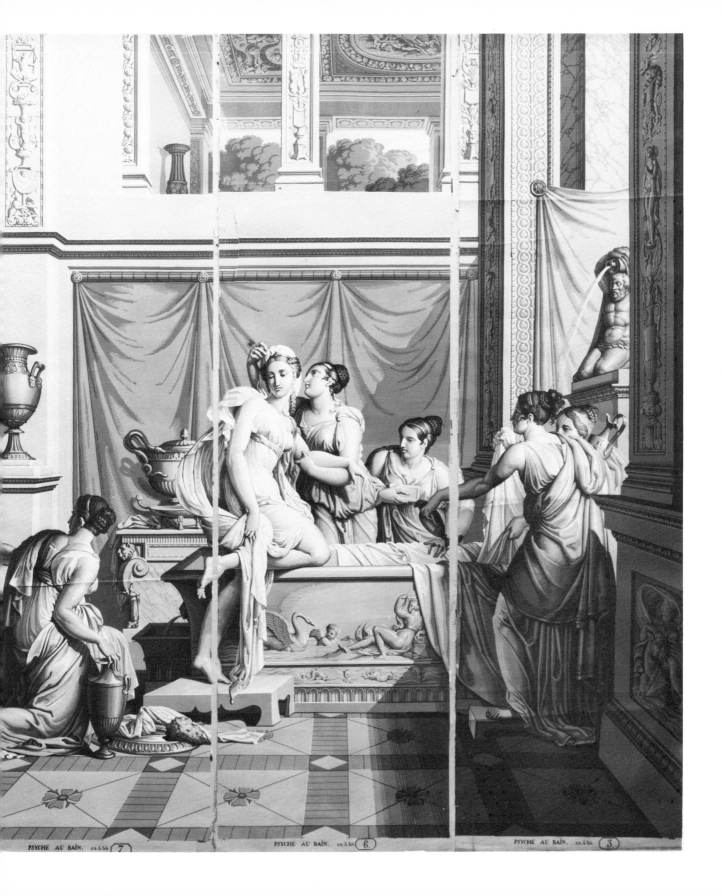

PSYCHÉ AU BAIN. en 5 lés 7 PSYCHÉ AU BAIN. en 5 lés 6. PSYCHÉ AU BAIN. en 5 lés 3

Toilet mirror

Made by Karl Schmid or Schmidt
Painted by Balthasar Wigand
(1771–1846)
Austrian: Vienna, 1821
Oak veneered in mother-of-pearl,
with gilt bronze mounts, the
drawer with sewing and toilet
utensils, the reverse of the mirror
with a painting in gouache
h 66 cm (2 ft 2 in.); *w* (at bottom)
29.8 cm (11$\frac{3}{8}$ in.); *d* (at bottom)
23.5 cm (9$\frac{1}{4}$ in.)
Signed on the carcass: Carl
Schmidt; and dated 1821
W.12–1977

Literature
GUSTAVE E. PAZAUREK,
Perlmutter, Berlin, 1937

The general form of this toilet mirror echoes that of an antique lyre, a favourite motif in Vienna. It may have been made by Karl Schmid who won a bronze medal for mother-of-pearl novelties at the first Austrian industrial exhibition, held in Vienna in 1835, and who was probably related to Anton Schmid, who signed a mother-of-pearl crucifix dated 1793. An alternative candidate is Karl Schmidt, a cabinet-maker born in Soldin in Prussia in 1800, who worked as a journeyman in Prague around 1820 and then in Vienna, where he also attended a drawing school on Sundays. From 1826 to 1830 he studied architecture at the Academy under Peter von Nobile (1774–1854), and he subsequently opened his own drawing school, teaching cabinet-makers and other craftsmen. He was eventually made an honorary citizen of Vienna, and received other marks of official recognition for his services.

Balthasar Wigand, who painted the view of St Stephen's Cathedral in Vienna on the reverse of the mirror, specialized in gouache views of famous sites and buildings in Vienna and its surroundings. The Historisches Museum there owns a mother-of-pearl letter case with four views by him. The mother-of-pearl industry in Vienna goes back to at least the 1760s, but enjoyed its greatest prosperity in the 1820s and 1830s. The main products were small items such as boxes, lightshades and desk sets, but on occasion full-scale furniture was made. In 1830, for example, Johann Tanzwohl is said to have supplied a suite, including table, sofa chairs, and mirrors, to the King of Spain. The mother-of-pearl objects were almost invariably decorated with gilt bronze mounts, usually neat but flimsy. Sometimes, as with a lightshade in the Historisches Museum signed by Christoph Mahlknecht (1781–1851), scenes of Vienna were painted directly on the mother-of-pearl.

An inscription inside the drawer seems to indicate that this mirror was sold by a cabinet-maker named Damm in Paris. It is likely that he was a merchant in small luxury items: many such retailers had shops in the arcades of the Palais Royal. A gothic initial 'P', on the top of the drawer section, is likely to be that of the first owner of the mirror. SJ

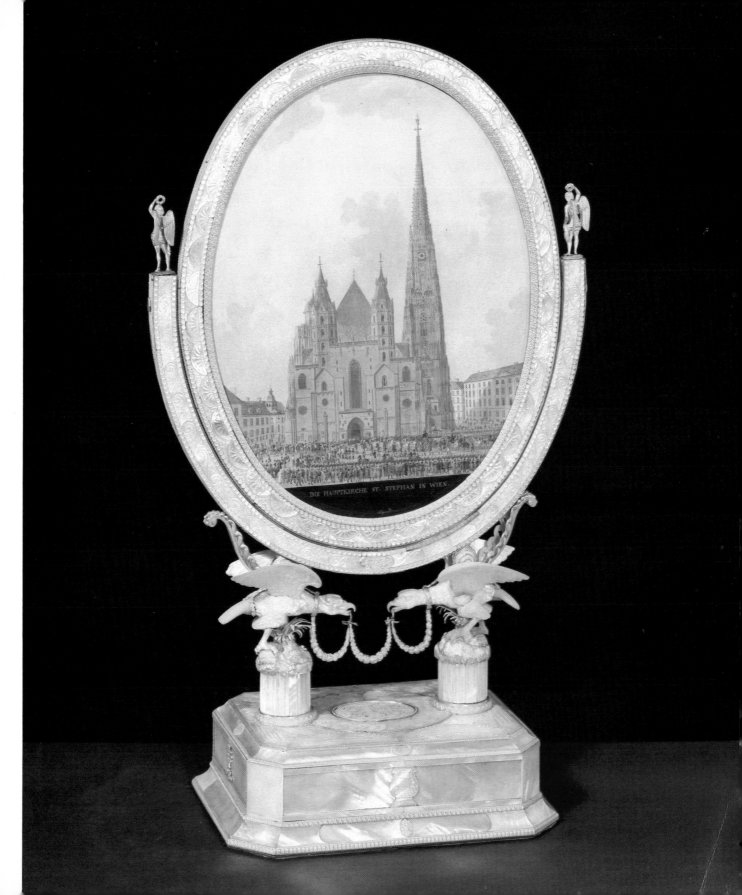

DIE HAUPTKIRCHE ST. STEPHAN IN WIEN.

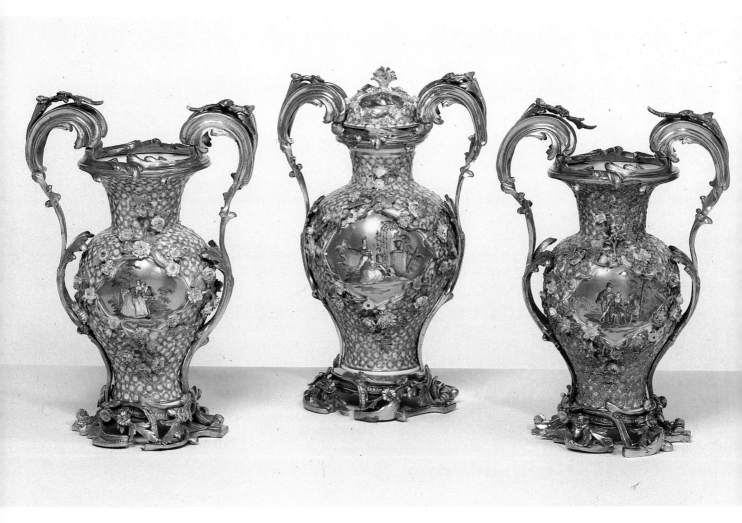

Garniture of vases

Manufactured by the Meissen
factory
German, c.1830
Hard-paste porcelain, gilded and
enamelled, with ormolu mounts
h 30.5 cm (12 in.)
832 to B–1882
Jones Bequest

Literature
Catalogue of the Jones Collection,
Pt.II, Ceramics etc., London,
1924
J. KUNZE, 'Die Bedeutung des
Englischen Handels mit
Porzellanen im ''Altfranzo-
sischen Geschmack'' der Meiss-
ner Manufaktur in der ersten
Halfte des 19.Jahrhunderts',
Keramos No.95, 1982

J.J. Kaendler is reputed to have devised the overall ground of applied guelder-rose (or may flowers), initially to ornament a set of vases made for Louis XV in 1741–2. Garlands of applied, trailing naturalistic flowers, a de-velopment of the later 1740s, were the pre-cursors of the individual porcelain flowers made in France at Vincennes and of the bocage used by English factories. Similar garnitures of Meissen vases are to be found in several collections, notably the Wrightsman, New York, and the Rothschild at Waddesdon Manor, where there is an almost identical set. From the beginning, these seem to have been made for the French market, to be mounted elaborately in ormolu: Charleston quotes from the Livre-Journal of Lazare Duvaux, Septem-ber 1752, referring to the supply to Madame de Pompadour of 'Quatre vases égaux de porce-laine de Saxe à fleurs de relief, avec des cartouches de miniatures, montés en bronze doré d'or moulu.'

In England, the overall Schneeballen type of decoration was much copied, particularly at Derby, establishing a taste which was renewed with the rococo revival of the 1820s, when Coalport, among others, produced vases en-tirely covered with naturalistically-modelled flowers. In about 1820 dealers from London, already engaged in the re-decoration of old Sèvres porcelain, approached the Meissen fac-tory with a request to produce porcelain in the current English taste. Having suffered a decline at the end of the eighteenth century with the advent of neo-classicism, the factory was quick to comply, and to capture the lucra-tive English market with exact copies of earlier models, using original moulds. Pages from a catalogue issued on 10 May 1846 show decora-tive wares 'im Englischen Geschmack', includ-ing similar vases 'mit Blüthenbelege, im Schilde Figuren . . . à la Watteau'.

This garniture formed part of the collection of John Jones, whose bequest of 1882 made him perhaps the greatest benefactor to this Museum. Recent study of the painting style and the ormolu mounts has shown that, al-though Jones acquired them as Meissen products of the mid-eighteenth century, they should now be placed in the second quarter of the nineteenth century. RJCH

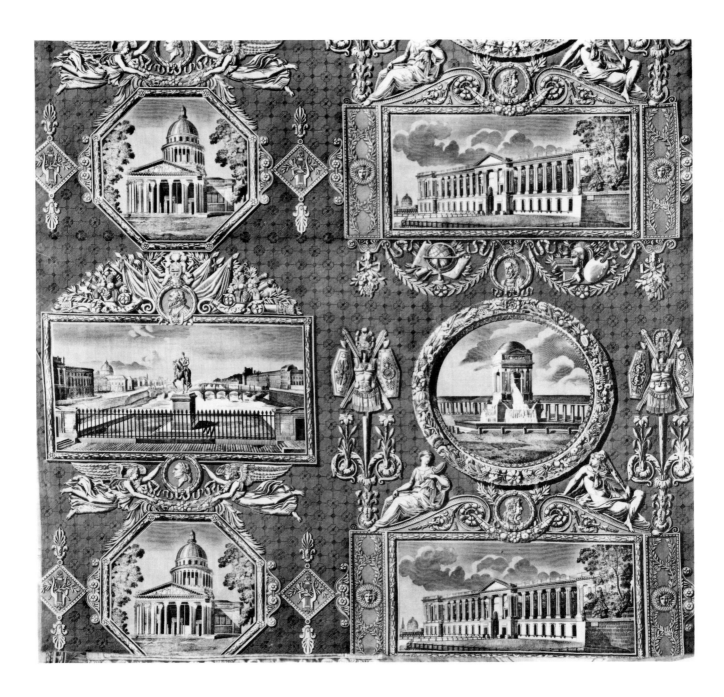

The Monuments of Paris

Designed by Hippolyte Lebas
(1782–1867)
French: Jouy, *c.*1816
Furnishing fabric in
plate-printed cotton, with block-printed background
162.5 cm (5 ft 4 in.) square
T.726–1972
Given by J.B. Fowler

When the Oberkampf works at Jouy resumed printing in 1796 the principal designer, Jean-Baptiste Huet (1745–1811) developed his style of print, introducing classicizing subject-matter and ornament, often setting these on small-patterned grounds. Following Huet's death, designs were obtained from painters such as Horace Vernet, as well as from the architect Hippolyte Lebas.

Lebas had received his training under Percier and Fontaine, authors of the Empire style, and from 1809 he assisted Alexandre-Théodore Brongniart in designing La Bourse, an austere and monumental building intended by Napoleon to reflect the status of the Imperial city. The same glorifying purpose is found in this design, in which Lebas further developed Huet's new style by supplanting classical motifs with modern French monuments in classical style: the Pont-Neuf with the statue of Henri IV; the east colonnade of the Louvre (both in rectangular frames); the Fountain of the Innocents (in a circular frame); and the Panthéon, formerly the church of Ste Geneviève (in an octagonal frame).

The copper plate from which this print was made was an impressive 103 cm (3 ft 4$\frac{1}{2}$ in.) in height, and 83 cm (2 ft 8$\frac{3}{4}$ in.) in breadth. The Jouy workers displayed considerable technical virtuosity in engraving large areas of fine detail in the ground of such fabrics, as well as in the accuracy with which the ground is joined in successive repeats. This design was enhanced by the addition of block-printed shading in yellow which throws into relief the ornamental cartouches. The difficulties of printing small, detailed patterns from large copper plates were overcome soon after the date of this fabric, as the new technique of roller-printing, now feasible on a commercial scale, gradually superseded plate-printing for making the shorter patterns, though copper-plates remained in use for patterns with large repeats and for such special tasks as printing handkerchiefs. PH

Beaker

Engraved by Hieronymus Hackel
(1784–1844)
Austrian: Cilli (in Styria, now
part of Yugoslavia), c.1820
Glass, engraved and polished
h 11 cm ($4\frac{1}{4}$ in.)
Signed *H.Hackel Fabruc Cilli*
C.96–1980
From the Dr F A Phillipps
Collection, formerly Dr J A
Phillipps Collection.

Literature
G.E. PAZAUREK, 'Der
Glasschneider H. Hackel in Cilli',
*Anzeiger des Landesmuseums in
Troppau*, II, 1930 (Festschrift für
E.W. Braun) Braunschweig,
1976.

The revival of glass engraving in Bohemia, which achieved such peaks of perfection during the nineteenth century, began independently at two places: the Riesengebirge, where the loss of Silesia and the death of C.G. Schneider in 1773 had brought to an end the tradition of Baroque glass engraving, and in Northern Bohemia, particularly Steinschonau and Meistersdorf. In the Riesengebirge, Franz and Johann Pohl began to engrave gems, turning their attention to glass in the early nineteenth century, along with Franz Anton Riedl in the Isergebirge. Many glasses of this early period exhibit perfectly executed ornament but demonstrate the inability of the engravers to adapt to the larger-scale figural subjects.

Probably the best example of the early mastery of technique and scale is this documentary beaker by Hieronymus Hackel, which was published by Gustav Pazaurek in 1930, and which is still both Hackel's masterpiece and the key to the attribution of his other work. The style of engraving has been compared to that of the North Bohemian engravers Franz Hansel and Anton Simm, but it is acknowledged to be of even higher quality. The few other glasses attributed with certainty to Hackel are decorated variously with a domestic scene, the Last Supper, a Madonna, a nun, symbols of friendship, and St Simon, the last bearing the signature *alter Hackel hats gemacht*. In addition, Jarmilla Brožová has suggested

that Hackel might be identified with a master hitherto known only as the Master of the Rising Sun. Characteristics shared by the two groups of glasses consist of dotted sunrays, dotted matt areas, polished pebbles and the identical rendering of different species of trees. Given the restraints imposed on artistic expression by the medium, it is only by such small stylistic differences that individual artists may be isolated from the mass of skilled Bohemian engravers.

Hackel is a puzzling figure. It is assumed that he was of Bohemian origin, and the inclusion of *Cilli* on this signed beaker has led to the discovery in Cilli (now Celje) church registers of the entry *Hakl Hieronymus, Glasschleifer, 60 Jahre alt, gestorben 2.Okt.1844 an Schlagfluss in der Stadt Cilli No.29*. Why an engraver of such ability should choose to work in Lower Styria, and why his recognizable output is so small, are questions still unanswered.

The armorials, the initials E, L, and E, and the dedication *Dir O Vater* indicate that this beaker was commissioned, for presentation to their father, by three sons of the Auersperg family of Austria, which had been created Barons of the Holy Roman Empire by Charles V in 1550, Counts by Ferdinand II in 1630, and Princes by Ferdinand III in 1653. Although Spiegl dates the beaker 1835–40, the heroic depiction of the sons in Roman armour would seem to suggest a date closer to 1820. RJCH

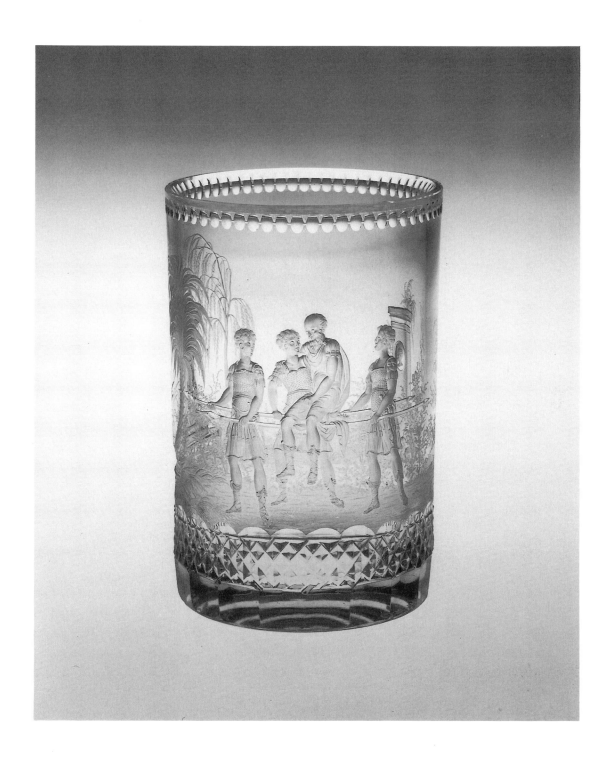

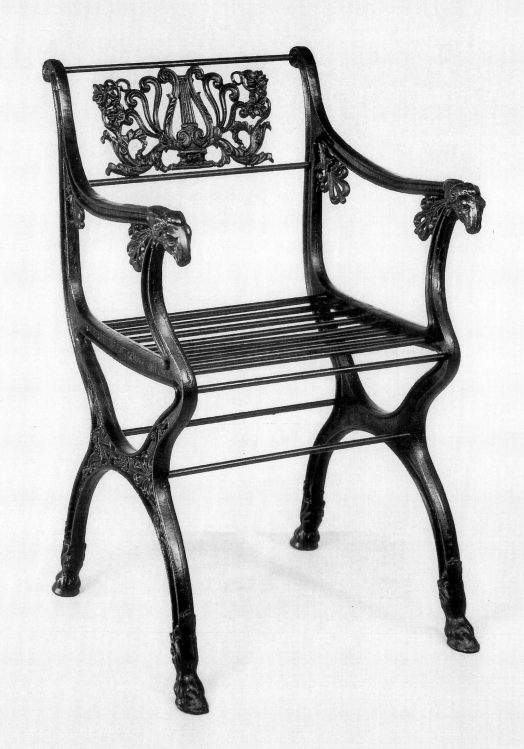

Armchair

Designed by Karl Frederich
Schinkel (1781–1841)
Maker unknown
German: Berlin, first examples
cast *c.*1825
Painted cast iron
h 80 cm (31½ in.); *w* 51 cm
(20 in.); *d* 51 cm (20 in.)
W.10–1986

Literature
Berlin und die Antike (Catalogue
of an Exhibition at Schloss
Charlottenburg), Berlin, 1979

The sophisticated application of neo-classical forms to the design of cast-iron furniture which is demonstrated by this chair is far in advance of anything produced in Britain in the 1820s. It was not until the 1840s that Britain began to produce cast-iron furniture of similar sophistication. Schinkel was also designing a whole range of objects such as urns, candelabra, and tripods in cast iron, both in the neo-classical and Gothic revival styles. Nor did he confine himself to the decorative arts: even before 1820 he had designed his celebrated Kreuzberg war memorial in Berlin. This takes the form of a tall Gothic revival monument reminiscent of an 'Eleanor Cross' made completely of iron. It was the established Prussian expertise in casting in iron to a very high standard, as applied to the casting of the well-known fine iron jewelry, which Schinkel was exploiting.

During the 1820s Schinkel designed a range of iron furniture for use in the parks and gardens of the Prussian Royal Palaces in and around Berlin, including those at Charlottenburg and Potsdam. Chairs and benches to this and similar designs still exist in the gardens of both palaces.

When purchased by the Victoria & Albert Museum in 1986 this chair—like so much surviving iron furniture—had been incorrectly painted white. Cast-iron garden furniture in England was painted to imitate bronze or painted to imitate green patinated bronze. In Germany, however, as well as these two finishes matt black was used and much of the Prussian ironware mentioned above including the jewelry and the Kreuzberg was finished in this way. Schinkel probably used all three finishes for his iron furniture, but the surviving pieces identical to this chair are black so we have used black in re-painting it.

Examples of this design, although never manufactured in large numbers, were made until the 1860s. This piece is unmarked and is thus impossible to date precisely.　　CW

Teapot

By Charles-Nicolas Odiot
(1789–1868)
French: Paris, 1826–38
Silver-gilt in two colours, ebony
h 18.3 cm (7¼ in.); w 24 cm
(9½ in.)
Mark of C.-N. Odiot; first
standard mark for silver, Paris,
1819–38; large excise mark for
silver, Paris, 1819–38, with anvil
mark; restricted warranty mark
for silver in use in Paris from
1838
M.6 to a–1973
Acquired with the aid of the
National Art-Collections Fund

Of the three great silversmiths working in Paris at the beginning of the nineteenth century, Henry Auguste (1759–1816), Martin-Guillaume Biennais (1764–1843), and Jean-Baptiste-Claude Odiot (1763–1850), two are represented in the gallery. A carving knife and fork set (110 & a–1895) reflects Biennais' success as an entrepreneur and the complexity of the trade: the gold bears the mark of Jean Toulon, the silver the mark of Mathieu Carrère, a silver mount is signed 'QUEILLÉ FECIT' (perhaps for Pierre-François Queillé), and the red leather box is stamped 'BIENNAIS ORFÈVRE'.

Odiot is represented by a composite service, including the teapot illustrated, which was probably made up under the *Restauration* (1814–30). The hot-water urn (1798–1809), sugar bowl (1809–19), and the tea-caddy (1819–38) bear the mark of Jean-Baptiste-Claude Odiot. The teapot and the jug bear the mark of J.-B.-C. Odiot's son, Charles-Nicolas, whose mark, according to Beuque, was in use from 1826. It seems likely that a coffee pot would once have been in the service.

The teapot has the animal or bird spout which had survived many changes of style in France during the previous century, but, more characteristic of its period, it bears the applied neo-classical figures which recur frequently on the Odiots' work. Either or both of the infant Bacchus and Amor figures applied to

the teapot can be found on a number of pieces by J.-B.-C. Odiot, including some of those included in the gift of models presented after his retirement to the French nation and now displayed in the Musée des Arts Décoratifs. The Amor figure derives from a sardonyx cameo illustrated in several of the great seventeenth- and eighteenth-century publications, including Philippe de Stosch's *Gemmae antiquae caelatae* (Amsterdam, 1724) and the first two volumes (1731–2) of Gori's *Museum Florentinum*, important quarries for neo-classical designers. In this instance the gem has been copied closely, in others the Odiot figures appear to be more loosely derived. The figure on the jug in the service, a winged woman holding a snake and a bowl, may be a freer adaptation of another Gori gem, while one of Odiot's vases in the Musée des Arts Décoratifs appears to be a tribute to the *Borghese Dancers*, a classical relief which had been influential for nearly three centuries before it was acquired by Napoleon in 1807.

J.-B.-C. Odiot came from a long-established family of goldsmiths. Active before the Revolution in 1789, he served with distinction in the army away from Paris in order to avoid the Terror, while leaving his no less courageous wife to continue the business. At the Exposition des Produits de l'Industrie Française in 1802 he shared a gold medal with Henry Auguste, whose models, tools, and designs he acquired after the latter's bankruptcy. Among many important commissions were toilet services for both of Napoleon's wives and the cradle, now in the Kunsthistorisches Museum, Vienna, which he made in collaboration with Thomire after a design by Prud'hon. His son, Charles-Nicolas, who had experience of working as a modeller at Garrard's, took over the business in 1827. His substantial display at the London Great Exhibition in 1851 earned him a prize medal, but R.D. Wornum found 'something positively vulgar' in the 'mere metallic blaze' of his unoxidized silver. RE

Literature

H. BOUILHET, *L'Orfèvrerie française aux XVIIIe et XIXe siècles*, II, Paris, 1910
S. REINACH, *Pierres gravées*, Paris, 1895

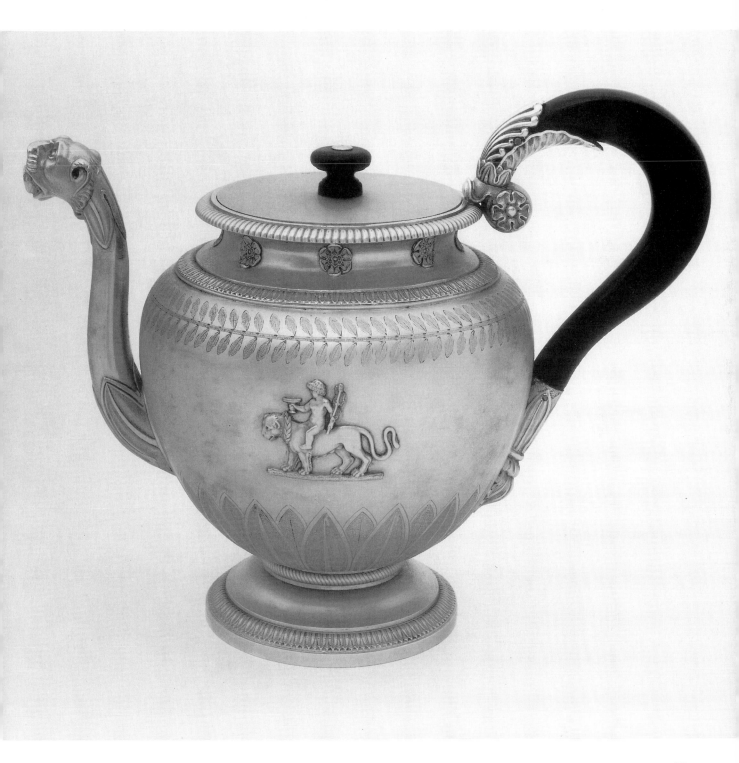

Les Contes du Gay Sçavoir

Text by Ferdinand Langlé
Illustrations and vignettes by Richard Parkes Bonington (1802–28) and Henry Monnier (1799–1877)
French: Paris, Lami Denozan, 1828
h 22.5 cm (8¾ in.)
w 15 cm (5½ in.)
2.12.1869

Literature

JOHN INGAMELS, *Richard Parkes Bonington*, London, 1979
EDITH MELCHER, *The life and times of Henry Monnier*, Cambridge, Mass., 1950
MARCIA POINTON, '"Vous êtes roi dans votre domaine"': Bonington as a painter of Troubadour subjects', *Burlington Magazine*, January 1986

These lively stories in a fashionable gothic idiom were compiled by Ferdinand Langlé, a writer of a number of vaudeville comedies popular in the 1820s and 1830s. One of the illustrators, Henry Monnier, returned to Paris in 1827 from a prolonged stay in London, and there enjoyed a successful career as a satirical cartoonist, humorist, and comic actor. The other illustrator was Richard Parkes Bonington, an Englishman who had been resident in Paris since 1818. Bonington is remembered chiefly as a watercolourist and painter of landscapes and historical scenes, but he was also a painter of antiquarian subjects. As well as tours in northern France to draw medieval monuments, he had made a trip with Delacroix to the Meyrick armour collection in 1825 (a necessary pilgrimage for the serious antiquarian).

The title of Eugène Lami's publication of 1828 refers to the literature of the troubadours, known as *gai savoir*. The stories are quite different from, for example, the *Fabliaux et contes du XII^e et XIII^e siècles* of Legrand d'Aussy, first published with a learned apparatus in 1779, or the troubadour poetry published in 1803 of Fabre d'Olivet who, on the model of Macpherson's *Ossian*, described his own works as translations from the ancient Provençal.

The design and illustration of the book reinforce the neo-gothic quality of the text, where friars and knights are found in places with medieval associations such as Mont St Michel and the *Chateau de Ville Dieu lès Avranches*; reference to historical characters such as Godefroy de Bouillon, the conqueror of Jerusalem on the First Crusade, and inclusion of the poetry of Charles d'Orléans (1391–1465) contribute to an air of historical veracity. The illustrations, all of them lithographs, were pasted on to the page above the text to produce the kind of *mise en page* usual for a fifteenth-century manuscript chronicle with pictures; the printed initials, coloured by hand, contribute to this effect.

The book was said to have been made in imitation of medieval manuscripts, though the decorated architectural frames of the title-page and illustrations were direct copies from those found in late-fifteenth-century Books of Hours printed in Paris. The gestures and poses of the figures seem to reflect study of fourteenth-century miniatures, but the costumes relate more closely to contemporary designs for medieval settings on the stage and to paintings in the *style troubadour* than to medieval illumination.

Lithography, invented by Senefelder in 1798, was beginning to make an impact on commercial printing in the 1820s. Bonington was a master of the medium and had been recruited by Baron Taylor to illustrate the volumes of his *Voyages Pittoresques* for Normandy and the Franche Comté—he had thus taken part in that monument of early lithography which had government support in attempting to record 'all monuments of Antiquity, the Middle Ages and the Renaissance which have contributed so powerfully to the glory and intellectual richness of France'. Monnier's essays in lithography began with his *Exploitation générale des modes et ridicules de Paris et de Londres*, published in 1825.

For small illustrated books such as the *Contes du Gay Sçavoir*, lithography was to be replaced by wood engraving, where the woodblock could be set and printed simultaneously with the type. The sequel to the *Contes*, published by Lami Denozan in 1829 with illustrations by Monnier and his friend Eugène Lami under the title *L'Historiale du Jongleur*, was printed with this technique, as were Charles Nodier's immensely successful work in the same genre, the *Histoire du Roi de Bohême* (1830), the best-selling illustrated editions of *Don Quixote, Paul et Virginie*, and the works of Victor Hugo and Balzac published subsequently. RW

Les Contes du gay sçavoir.

Ballades, Fabliaux et traditions du moyen âge, publiés par Ferd. Langlé, et ornés de Vignettes et Fleurons imités des Manuscrits originaux par Bonington et Monnier. Imprimé par Firmin Didot, pour Lami Denozan, Libraire, rue des Fossés Montmartre, N.° 4.

la veillée des Fileuses.

On chacun sait, qu'alors que fen le roi Jean étoit prisonnier du prince Noir avec les plus nobles et meilleures lances de son armée, tous Comtes, Barons, Bannerets et Chevaliers, chaque comté de France qui n'étoit point ès mains de l'Anglois fut mise à sac et pillage, tant par malandrins on tard-venus, souldoiers fuyards des armées et renieurs de bannières, que par les hommes de la Jacquerie, serfs lâchés et vagabonds; car, vu la dévastation de la guerre, nuls ne pouvoient cultiver champs ou vergers; et de fait les récoltes avoient été brûlées par feux de camps, arbres coupés pour faire piquets,

la Danse Ligie de la fausse monarchie du diable

olà! garçonnet, cria un chartreux monté sur une mule, et menant en croupe une femme qu'au costume on reconnoissoit pour une ursuline; où sommes nous? en quelle seigneurie? et quel chemin nous faut-il suivre?

Vous le dirai volontiers, mon père, et à vous aussi, ma sainte dame, si voulez me promettre votre bénédiction, répondit le manant.

Tu l'auras, ajouta le chartreux; mais dépêche, car nuit est close, et la lune se lève brillante du côté de l'étoile des Mages.

le clocheteur des trepasses.

La Novice [à son prie-Dieu].

Avec sa cloche qu'il agite,
Et sa dalmatique bénite,
Semé d'os et de larmes noirs,
Le vieux clerc de Sainte-Brigite
Se glisse dans l'ombre des soirs;
Il nous demande une prière
Pour ceux qui dorment sous la pierre;
L'Église a prescrit ces devoirs:
Levez-vous, c'est sa voix, ma mère.

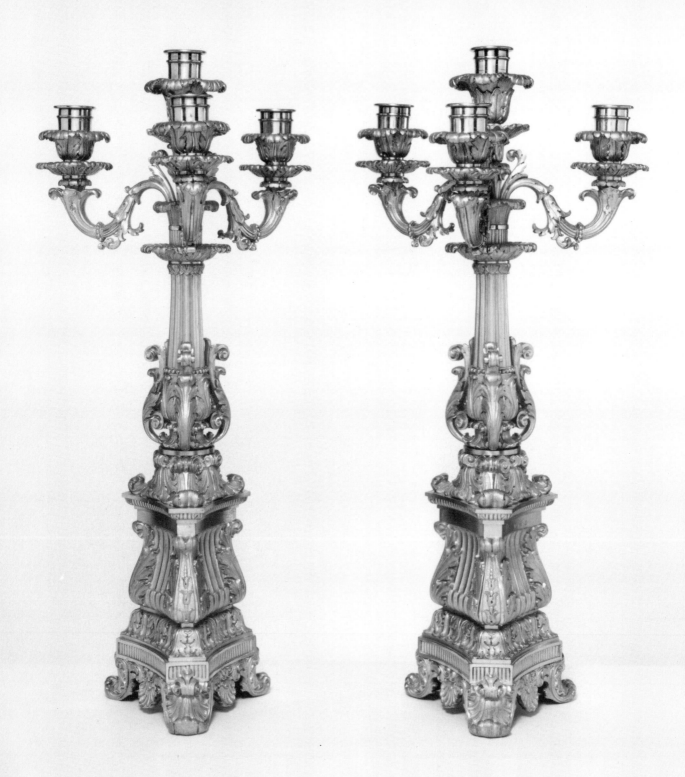

Pair of candelabra

Probably manufactured by
Denière
French: Paris, c.1830–40
h 54 cm (21¼ in.)
Stamped *EU* crowned, *1561,
1562*
M.45 + a – 1982

These candelabra are marked with the stamp of the Château d'Eu, the favourite country retreat of King Louis-Philippe in Normandy. The stamps relate to an inventory taken in 1841 which records that the candelabra stood in the bedroom of Queen Marie-Amelie:

1561 Un candelabre doré, pied triangulaire, 4 lumières, forme Renaissance, estimé 300F
1562 Un candelabre id. 300F

The firm of Denière supplied bronze manufactures for the royal households during the reign of Louis-Philippe (1830–48). Although the commission for these candelabra does not appear to survive, it is known that Denière supplied the chandelier for the queen's bedroom in 1839. After the abdication in 1848 the candelabra remained the property of the king and followed him into exile in England. They were sold at Christie's in May 1853 after the king's death.

The bronze manufactory of Denière was established in the rue de Turenne at the end of the eighteenth century. It traded under the name of 'Denière et Matelin' until 1820. At the Exposition des produits de l'industrie Française in 1819 Denière et Matelin won a silver medal for a sumptuously bronze-mounted cradle (now in the Musée des Arts Décoratifs, Paris) intended for the heir to the throne, the Duc de Bordeaux. From 1820 the business was run by Denière alone, with showrooms at the rue Vivienne and workshops in the Marais. Denière showed at the industrial exhibitions of 1823, 1827, and 1834 held in Paris, where he received further medals and high acclaim for the quality of his workmanship. He held the royal warrant in the 1820s and was appointed '*Fournisseur du Roi, de la Reine, des Princes et des Princesses*' to the court of Louis-Philippe. It was during this reign that Denière achieved his greatest successes when he received commissions from the Tsar of Russia, the Luxembourgeois Order of the Oak and the Légion d'Honneur. In 1844 the business became 'Denière et fils' and it continued in production until 1903. MGC

Jug

Made by the Colonnese factory
(established 1830)
Italian: Naples, c.1830–40
Terracotta with painted
decoration
h 40.5 cm (16 in.)
Mark: *Colonnese Nap.*, impressed
in script
4771–1859

Literature
E. BIAVATI, 'I Colonnese
industriali ceramisti a Napoli nel
sec.XIX', *Faenza* N.5–6, 1976
G. MOSCA, *Napoli e l'arte
ceramica*, Naples, 1908

The origin and interpretation of Greek vases were subjects of continual dispute among scholars and collectors of the eighteenth- and nineteenth-centuries. Since the majority were excavated in Italy, it was widely assumed that they were not imports from ancient Greece, but rather were made by immigrant potters or were native Italian products. Josiah Wedgwood, anxious to associate himself with the new scholarly study of the Antique, named his new factory Etruria, in the mistaken belief that the much-admired red-figure vases were of Etruscan origin. Fuel was added to the arguments by the differing ways in which the scenes might be read, and particularly by the discovery in 1828 of the necropolis at Vulci in Etruria which yielded some 3,000 painted vases, rapidly to be sold by the owners of the land, notably Napoleon's brother Lucien, Prince of Canino.

The decoration of this jug is copied from Tischbein, *Collection of Engravings from Ancient Vases*, Vol.1, plate 2, published in Naples in 1791–5 as the second great collection of Sir William Hamilton, British Envoy to the King of the Two Sicilies 1764–1800. Unlike the first collection, which was acquired by Parliament and deposited in the British Museum in 1772, the second was dispersed, and partly lost with the wreck of the Colossus. The original red-figure Apulian fourth-century vase with this decoration cannot now be traced, although it is certain that the shape would have differed from this jug, which is based on an earlier Attic hydria.

The Colonnese family—Salvatore with sons Francesco and Gaetano, and later nephew Alfonso—established a factory in 1830 in the Via Marinella, where already the firms of Del Vecchio and Giustiniani were making artistic wares. A range of products, from tablewares in the style of English creamware to water-pipes, were made by the enterprising new company, which won medals at the Naples Exhibitions of 1834, 1836, and 1838, and at the London Exhibition of 1862. Since Naples was a major centre for the trade in Greek vases, and a major attraction for visitors, copies of ancient vases were made by several firms in the Via Marinella. Despite the Colonnese factory's attempts to perfect the clay bodies, and even to make a hybrid porcelain, they did not discover the original technique of making red and black vases, which relied on reduction-firing to make the iron-bearing body of the pot black, followed by an oxidizing period just long enough to turn the body red again but not long enough to affect the areas painted with an iron-rich clay slip, which remained black and formed the background of the painting. Instead, this nineteenth-century jug appears to have been painted with black enamel over a wax-resist, the fine details being added after removal of the wax. RJCH

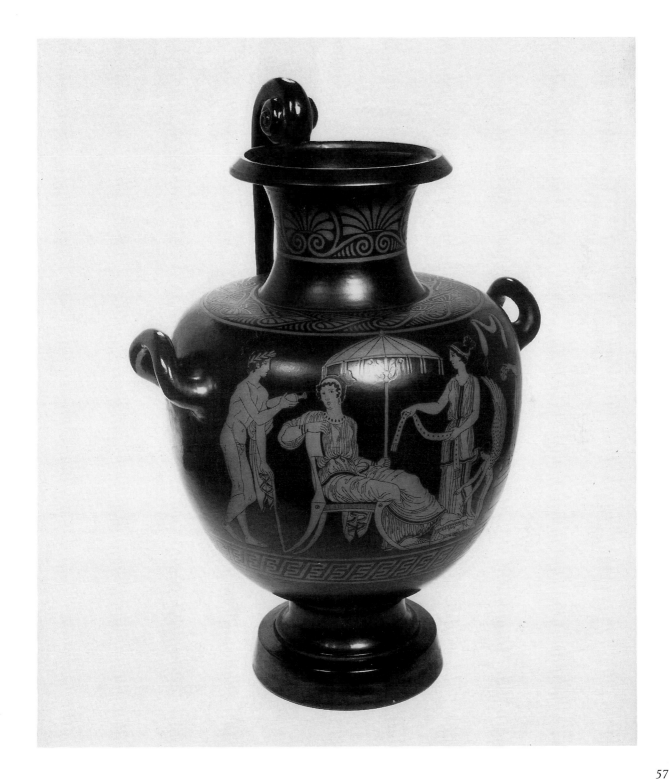

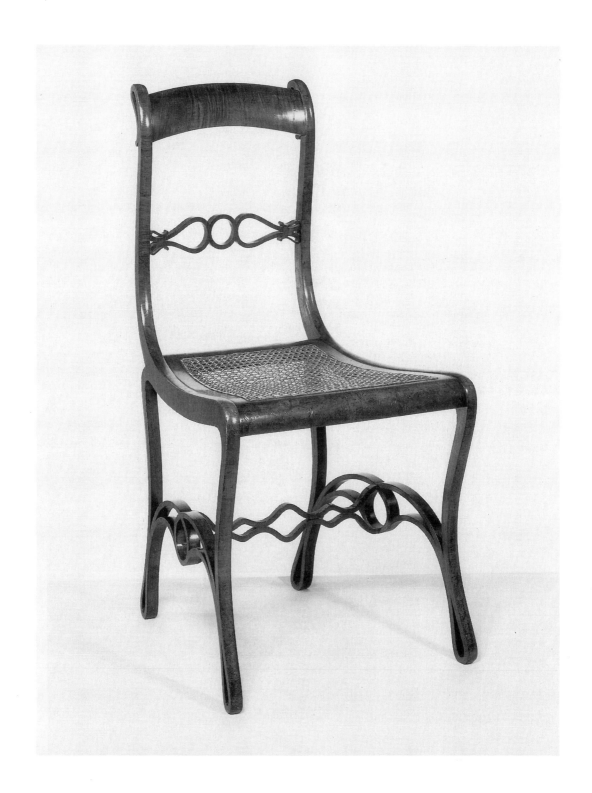

Chair

Made by Michael Thonet
(1796–1871)
German: Boppard am Rhine,
c.1840
Laminated walnut
h 89 cm (35 in.); w 43 cm (17 in.);
d 46 cm (18 in.)
Stencilled inscription: 'Mobel
Magazin von Peter Mundenich:
Tischler'
W.5–1976

Michael Thonet was born in Boppard and apprenticed to a carpenter there. At the age of twenty-three he completed his apprenticeship and set up a small workshop to make simple household furniture. In about 1830 he started to experiment with chairs made from bent and laminated wood, though no documented piece exists from before the late 1830s. Though not marked, this chair is so similar to the small number of surviving works from the earliest phase of Thonet's career that it can confidently be ascribed to him. It was marketed by Peter Mundenich in his shop on behalf of Thonet.

The innovatory nature of the techniques which Thonet had developed for bending and laminating wood was at last recognized in 1841 when Thonet was awarded patents in France, Belgium, and England. Then in 1842 the Chancellery of Vienna granted a patent for the 'Supply of the best quality of wood in selected shapes and curves, by chemico-mechanical means'. In 1842 at the express wish of the State Chancellor, the celebrated Prince Metternich, Thonet moved to Vienna. From 1842–9 he was employed by the leading Viennese cabinet maker Carl Leistler (see pages 74–5), and together they produced even more technically advanced chairs for the Liechtenstein Palace in Vienna.

In 1849 Thonet finally set up his own firm and made his international debut at the London Great Exhibition in 1851. The firm became one of the most successful furniture firms ever. By 1900 it employed 6,000 workers who produced 4,000 pieces of furniture every day. Thonet's patents gave him full protection until they lapsed in 1869, but in Austria alone by 1900 there were twenty-six companies employing 25,000 workers producing 15,000 pieces of bentwood furniture based on Thonet's principles. The firm still manufactures bentwood furniture.

The simplicity of these bentwood pieces has continued to appeal to designers of the twentieth century. Le Corbusier, for instance, frequently used a particular Thonet armchair in his buildings. The firm was also involved with Marcel Breuer in his early experiments with tubular metal furniture and provided the bentwood caned seats and backs for his celebrated 'Cesca' chair. CW

The Clarendon Vase

By Fábrica Platería de Martínez
Spanish: Madrid, 1840–1
Silver, gold
Chased inscription: 'AL/CONDE DE
CLARENDON/LOS PATRIOTAS
ESPAÑOLES/AGRADECIDOS'
Engraved: 'Se hizo en la Fabrica
Plateria de Martinez Madrid
1840'
Marks of the factory, and the
Court and City of Madrid (both
1841)
h 44.5 cm (17$\frac{1}{2}$ in.); w 22 cm
(8$\frac{5}{8}$ in.)
M.28–1985

Literature
A. CAIGER-SMITH, *Tin-Glaze
Pottery*, London, 1973
A.M. JOHNSON, 'The Royal
Factory for Silversmiths,
Madrid', *Notes Hispanic*, 1942
J. FERRANDIS TORRES, *Los Vasos
de la Alhambra*, Madrid, 1925

The Alhambra Vase and the related group of
vases made in the fourteenth century at the
potteries of Málaga in Spain inspired a number
of nineteenth-century versions in metal. The
Clarendon Vase is European in its decoration,
and much more European in its shape than,
for example, an enamelled vase made in Paris
by Charles Wagner in 1839 (Kunstgewerbe
Museum, Berlin), or the later vases by Zuloaga.
It is, however, indebted to a specific vase,
now lost, which was recorded in *Antigüedades
árabes de España*, a fine set of engravings
published in Madrid in 1804 and one of the
earliest signs of the nineteenth-century's
interest in Islamic art. The lost vase influenced
the foliage decoration of the handles, the dome
of foliage decoration on the shoulders, and
the disposition of the vertical panels of the
body.

At the time of the making of the Clarendon
Vase, the Royal Factory for Silversmiths occu-
pied an elegant neo-classical building in Madrid
into which it had moved in 1792. It was run
by Pablo Cabrero (d.1846), who was not himself
a silversmith, but who promoted the factory
and was responsible for the introduction of
the making of plated ware. He was the son-in-
law of the factory's founder, Antonio Martínez
Barrio, an Aragonese silversmith, who had
travelled to London and Paris before setting
up the factory in 1778 under the patronage of
Charles III. The vase is a magnificent tribute
to the factory's capabilities. The gold chasing
is finely executed and its mounting a *tour de
force*. There are, for example, thirty-one bolts
securing the panel chased with the inscription
to Clarendon, and eighteen securing the panel
with his arms.

According to the inscription, the vase was
presented by 'grateful Spanish patriots' to
George William Frederick Villiers (1800–70),
who shortly before the end of his period as
envoy to Madrid (1833–9) succeeded to the
title of Earl of Clarendon. He did much to
further the quadruple alliance of 1834 be-
tween England, Spain, France, and Portugal,
which lent support to the young queens of
Spain and Portugal, and he is credited with
having mitigated the severity of the civil war.
His achievement laid the foundations for his
future career, in which he was three times
secretary of state in Liberal administrations.
His reputation for hard work was second to
none, and he was described by Gladstone as 'a
statesman of many gifts, a most lovable and
genial man'. The ribbon of the Order of the
Bath around the arms on the vase record that
he was made a Knight Grand Cross of the
Order in 1838 on the recommendation of Lord
Melbourne. The form of the arms results from
a royal licence granted in 1782 to Thomas
Villiers (1709–86), Earl of Clarendon, which
allowed him and his issue to bear their arms
on the Royal Eagle of Prussia, in the manner
granted to him by Frederick III, King of Prussia.

RE

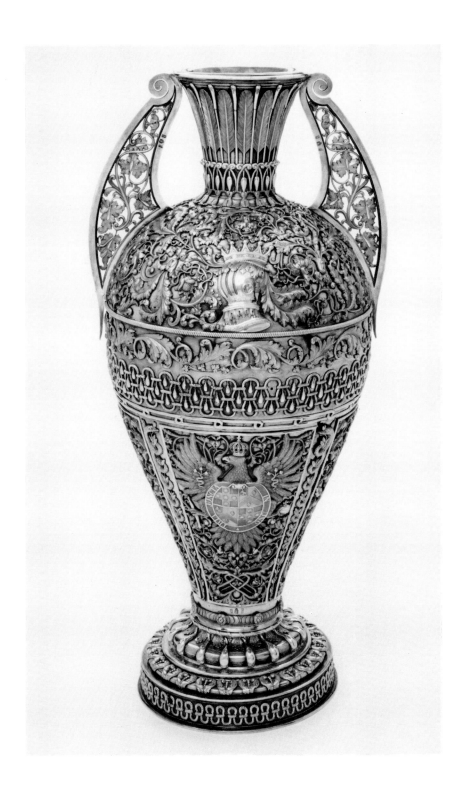

The Chambord Missal

Written and illuminated for
Henry, Comte de Chambord
French: Paris, *c.*1844
h 22cm (8½ in.)
w 14.8 cm (5¾ in.)
MS.L.68–1984

Henry d'Artois (1820–83), known as the Comte de Chambord, fled from France when his grandfather, Charles X, abdicated to make way for Louis Philippe during the Revolution of 1830, and spent the rest of his life in exile. On the death of his uncle, Louis Antoine, in June 1844, Chambord became head of the house of Bourbon and from this date was regarded as the rightful king of France by supporters of the Legitimist cause.

Gifts were made regularly to Chambord and his family as expressions of loyalty by Legitimist sympathizers. This illuminated manuscript appears to have been commissioned to mark Chambord's accession as head of the 'Maison de France' in 1844. Each page bears the name and heraldic arms of a lady of legitimist sympathies, some sixty-nine in all. Among them were Eleanor de l'Orge, Vicomtesse de Guébriant (a title she acquired on her marriage in 1844) and Carliste de Coriolis d'Espinose, Vicomtesse de MacCarthy, who died in 1846.

The missal celebrated Chambord's position in Legitimist eyes as the heir to, and guardian of, a monarchical tradition that reached back to a venerated medieval past. The illumination ranges from virtual facsimiles of manuscripts of various schools dating from the fourteenth to the sixteenth centuries, to floral designs and sugar-sweet angels in neo-gothic architectural niches of a purely nineteenth-century kind. The miniatures of the Gothic cathedrals of northern France similarly evoke a medieval past.

Subjects of the miniatures include Raphael's painting of the Virgin Mary's betrothal and Leonardo da Vinci's *Last Supper* (probably after the eighteenth-century copy by Dutertre), but most either record Chambord's life or highlight his political mission. Thus there is a picture of France bestowing the Château of Chambord on the young Henry in 1821 (it had been bought for him by public subscription after his father's death in 1820) and of his baptism the same year as Duc de Bordeaux in Nôtre Dame de Paris. The scene of Louis IV d'Outremer's return to France bore a direct message, since this king lived in exile in England until invited to return in 936. The miniature of Joan of Arc leading Charles VII to his coronation at Rheims was particularly appropriate. The scenes of Henry IV's entry into Paris and his coronation in 1594 represented a monarch reconciling the French after the Wars of Religion.

The supporters of the Legitimist cause had retreated to their estates in the provinces after 1830. It seems clear, however, that this manuscript was made in Paris. The *Bottin du Commerce de Paris* of 1844 lists numerous miniatures under the rubric '*Enluminage*', one or two of them specifying expertise in the '*genre du moyen age*'.

The red velvet binding of the Chambord Missal, with its gilt accoutrements, was done by Pierre Paul Gruel in imitation of princely bindings of the Renaissance. Gruel, founder of one of the most successful binderies of nineteenth-century Paris, made a speciality of producing bindings of ostentatious luxury for the missals and prayerbooks given as presents by the wealthy Catholic classes at marriages and first communions. Publishers such as Curmer and Hetzel issued printed books of this kind in the 1830s and 1840s. The *Livre d'Heures Complet*, published by Hetzel in 1838 and taken over by Curmer, who inserted a new title-page, and published it later as *Heures Nouvelles*, was a particular success. These books were illustrated and decorated with designs of medieval inspiration; from the 1840s, they often included colour plates of medieval floral designs, produced by chromolithography. It was not until the 1860s, however, that this technique of colour printing made an impact on commercial book production. RW

Seigneur, en reviendra toute la gloire.

Credo.

Je crois en un seul Dieu, etc.

Offertoire.

Père infiniment saint, Dieu tout puissant et éternel, quelque indigne que je sois de paraître devant vous j'ose vous présenter cette hostie par les mains du prêtre, avec l'intention qu'a eu mon Sauveur, lorsqu'il institua ce sacrifice, et qu'il a encore au moment qu'il s'immole ici pour moi.

Je vous l'offre pour reconnaître

Chazeron Desse de Céreste

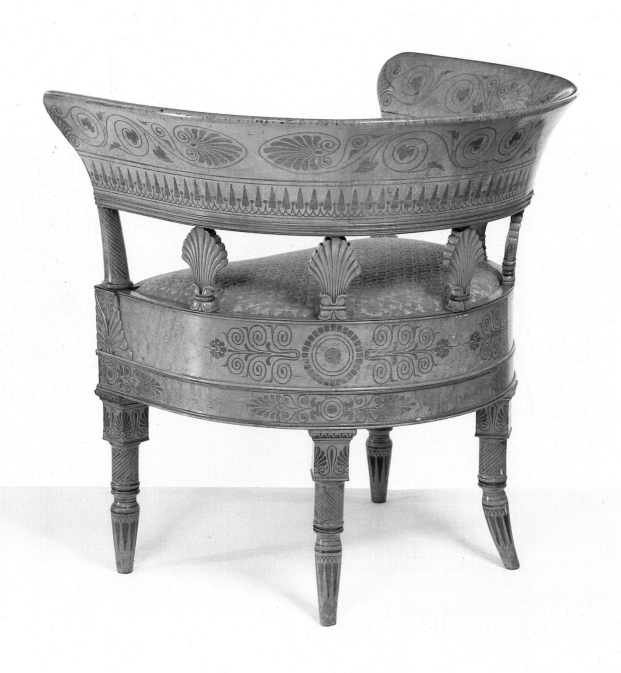

64

Armchair

Designed by Pelagio Palagi
(1775–1860)
Manufactured by Joseph-Pierre-
François Jeanselme
French: Paris, c.1851 (design,
1834)
Burr elm inlaid with amaranthus,
upholstery modern
h 73 cm ($27\frac{1}{2}$ in.); w 72.5 cm
($28\frac{1}{2}$ in.); d 57 cm ($22\frac{1}{2}$ in.)
Marks: faintly stencilled
'Jeanselme' below the front seat
rail
W.28–1969

Literature
DENISE LEDOUX-LEBARD,
*Les Ébénistes du XIXe Siècle
1795–1889*, Paris, 1984
Museo Civico, Bologna, *Pelagio
Palagi artista e collezionista*,
Bologna, 1976

By the mid 1830s the firm of Jeanselme, founded in 1824 by Joseph-Pierre-François Jeanselme and his brother, Jean-Arnoux, was one of the leading chair manufacturers in Paris. In 1847 it took over the great firm of Jacob-Desmalter, and began to execute many official commissions. The firm of Jeanselme only came to an end in 1930.

An armchair similar to this one was shown by Jeanselme at the London Great Exhibition in 1851, where it was described as 'Etruscan style'. The design of this armchair, and that of side chairs *en suite*, is considerably earlier, however, having been executed by Pelagio Palagi for the 'Camera di Toiletta' of Queen Maria Teresia, in the palace of the King of Sardinia, Carlo Alberto (1798–1849), at Racconigi, south of Turin, in about 1834. The chairs were probably made in Paris by a cabinet-maker named Claude Chiavasse, who made a similarly inlaid table. It seems possible that in 1834 Chiavasse was working with the Jeanselme firm who were thus able to secure the design and show it in 1851.

The most famous ensemble of furniture designed in 1834 by Palagi for Racconigi was that in the King's 'Gabinetto Etrusio', which was also later shown in the 1851 exhibition, where it attracted much praise. This suite, however, was made by the royal cabinet-maker, Gabriele Capello called 'Il Moncalvo', in Turin.

Born in Bologna Palagi was trained as a painter, but was also active as decorative designer, architect, sculptor, designer-sculptor, and collector. He worked not only in his native Bologna but also in Rome, where he was closely associated with the Napoleonic regime, Milan and Turin. Although he was highly competent in the Gothic style, has fame rests on his rich but refined neo-classical designs. His reputation extended beyond Italy: Stendhal in his *Chartreuse de Parme* (1838), for example, alludes to silks woven at Lyon to designs by '*le célèbre Palagi, peintre de Bologne*'. SJ

Plaque

Made and engraved by Dominik
Biemann (1800–57)
Bohemian: probably Prague or
Franzensbad, c.1841–5
Engraved glass with a portrait of
Joseph Williams Blakesley
diam. 9.6 cm (3¾ in.)
Signed *D.Biman P*
C.5 to B–1978
Bought with assistance from
Christie's auction house and the
NACF.

Literature

F. BIEMANN, 'Dominik
Biemann's Dealings with the
Dealer Steigerwald in Frankfurt
am Main', *Journal of Glass Studies*
Vol.X, New York, 1968
G. E. PAZAUREK, *Gläser der
Empire- und Biedermeierzeit*,
Leipzig, 1923
G. E. PAZAUREK, 'Der Erste
Glasschneider der
Biedermeierzeit', *Kunst und
Kunsthandwerk*, Leipzig, 1921
Z. PEŠATOVÁ, 'Dominik
Biemann', *Journal of Glass
Studies* Vol.VII, New York, 1965

Dominik Biemann, son of a mould-maker for
the Harrachov glassworks, began work at the
age of seven, learning thoroughly every aspect
of the glass business. Although his natural
talent was encouraged by Count Harrach, and
by his master at the glassworks, the engraver
Franz Pohl, Biemann was socially and finan-
cially ambitious, and in 1825 left to study at
the Academy of Arts in Prague, becoming a
freeman in 1827.

A portrait commission in 1826, intended as
a joke, set Biemann on the path to developing
the engraved portrait-miniature as a serious
rival to the painted kind, which enjoyed a
vogue in the Austro-Hungarian Empire of the
1820s and 1830s. At the Prague Industrial Ex-
hibitions of 1829–31 he exhibited beakers en-
graved with portraits of Kaiser Franz I, Goethe,
and Napoleon, as well as religious and hunting
scenes. By 1830–1 he was well enough admired
to travel to Gotha to engrave portrait-glasses
of the Duke of Coburg-Gotha, followed by a
journey to Berlin in 1834–5 to engrave the
family of the Kaiser. Increasingly he worked
at Franzensbad, where visitors to the fashion-
able spa town would commission portraits
during the season. Between intermittent periods
of working for the glass-manufacturer Franz
Steigerwald, who paid him poorly and spas-
modically, and of managing a mirror-glass fac-
tory, he carried on a successful business and
accumulated wealth, driven by love for his
art and the spectre of his humble origins.

By the 1850s, though still unrivalled as a
portraitist, he had lived to see the maturity of a
new generation of excellent engravers of genre
scenes, as well as the birth of photography,
which heralded the demise of the portrait-
miniature. After unfair eviction from his en-
graving premises, and suffering from mercury-
poisoning contracted at the mirror-glass factory,
he found himself unable to work, and rapidly
declined.

From the records of Steigerwald, and from
Biemann's own unpublished reminiscences, as
well as from the plastercasts he made of his
portrait-discs, it has been possible to identify
much of his work, although the versatility
and conventional form of his animal and genre
engraving leave many problems of attri-
bution. He remains the most important glass
engraver of the Biedermeier period, combining
the meticulous skill of the gem engraver, learned
from Franz Pohl, with great artistic ability
and with a deep interest in capturing in his
portraits the character of the subject.

A label on the original orange moiré paper-
covered box identifies the subject of this
portrait as Joseph Williams Blakesley (1803–
85), an eminent academic of the nineteenth
century. Blakesley is supposed to have visited
Europe while tutor at Trinity College, Cam-
bridge, during the period 1841–5, when it is
likely that he visited Prague or Franzensbad.
He was a member of the celebrated Apostles
Club at Cambridge and an intimate friend of
Monckton Milnes and Alfred Tennyson, later
becoming Dean of Lincoln. RJCH

Cabinet

Made by Angiolo Barbetti
(1805–1873)
Italian: Siena, 1845
Carved walnut
h 383 cm (12 ft 7 in.); *w* 188 cm
(6 ft 2 in); *d* 80 cm (2 ft 7½ in.)
24–1851

Angiolo Barbetti was born in Siena in 1805, the son of one of the city's leading carvers. In 1841 he left Siena for Florence where he set up a workshop. This expanded and he introduced machinery for woodcarving, his production being mainly sculpture in wood and cabinet making.

This cabinet was exhibited as part of a group of pieces by Barbetti at the London Great Exhibition in 1851. For this display and, in particular for a coffer carved 'after the Greek style', Barbetti was awarded a prize medal. The Official Catalogue describes a 'Grand set of ornamental furniture, in walnut, for a drawing room, consisting of a console and frame intended for a glass plate, the latter supported by two columns, and terminating in the richest ornaments; a work of exquisite carving, the architecture in the style of Baldassare Peruzzi.' Peruzzi (1481–1536) worked as an architect and painter in Siena and Rome.

Richard Redgrave, painter and later the Government's Inspector General for Art, wrote in the Report on Design, the supplement to the Jury Report on the exhibition: 'The console table and glass of A. Barbetti of Siena ... are excellent specimens of their kind, well designed constructively and ornamented in exact conformity with the Renaissance style.'

There was an alternative view, however. Ralph Nicholson Wornum contributed to the *Art Journal Illustrated Catalogue* an essay entitled 'The Exhibition as a Lesson in Taste'. In this he described Barbetti's exhibits as '... distinguished more for their abundance of minute detail, especially of the Cinquecento arabesque, than for general taste or effect; the minutiae are overdone, while some of the most conspicuous portions of the designs are worse than ordinary—as the lions in the cabinet or writing-table, which are wholly unworthy of the design and execution of the minor ornamental details. This work, otherwise, would be one of the most

beautiful specimens of wood-carving in the exhibition, and, but for the delicate shield-work introduced, would be also one of the best examples of the Cinquecento; it is pure in style with this exception.' Despite this criticism the cabinet was purchased from the exhibition for the South Kensington Museum for the sum of £400.

Barbetti went on to exhibit at the Paris Exhibition of 1861 and in Vienna in 1873. Together with his four sons, Raffaello, Egisto, Ottavio, and Rinaldo; Manetti, a fellow Sienese, and his sometimes collaborator on church restorations; and Florentine contemporaries such as Spighi and Falcini, Barbetti encouraged a major revival in the art of woodcarving in Italy.

Later commissions include a room in the Palazzo Saracini, Siena; and work on the façades of both Orvieto and Siena Cathedrals. In 1861 he was commissioned by Prince Demidov to work on the orthodox chapel of the Villa San Donato, Florence. All four sons collaborated on this project, Raffaello and Ottavio doing the decoration, Egisto the construction, and Rinaldo the doors. In 1869 Barbetti was commissioned to decorate an office for the Ministry of Maritime Affairs. This he decorated appropriately with carved shells and nautical emblems.

Angiolo Barbetti died in Florence in 1873. His sons continued the business, and Rinaldo (1830–1903) went on to become possibly more famous than his father. At the age of twenty-one he exhibited a carved frame, *La Morte di Filippo re di Macedonia* alongside his father's work in the Crystal Palace, winning much praise. His work includes at least three commissions in England. A room for the Flower family and a library for Baron Leopold de Rothschild were both executed in London between 1879 and 1888. In 1875 he had carved a series of six large reliefs of scenes from the Old Testament for the Collegiate Church in Nottingham.
SA

Literature
Dizionario Biografico degli Italiani Vol.6, Rome, 1964
Enciclopedia Italiana, Milan, 1930
MARIO TINTI, *Il Mobilio Florentino*, Milan, 1929

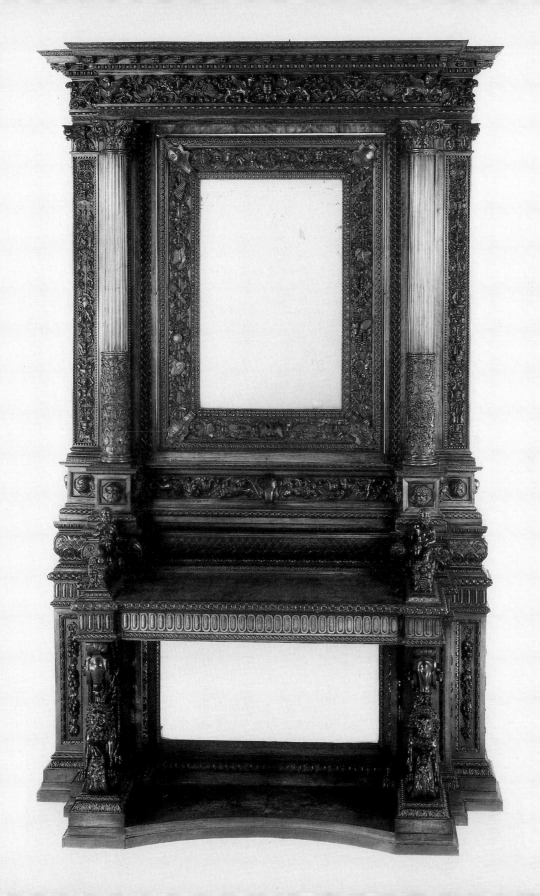

Vegetable dish and cover

Manufactured by Jacob Petit
(1796–1868)
French: Fontainebleau, c.1850
Hard-paste porcelain painted in
enamel colours
l 35.3 cm (14 in.)
Marks: J.P., in underglaze blue
384&A-1902
Given by Col. F.R.
Waldo-Sibthorpe

Literature

C. X. DE CHAVAGNAC and
M. DE GROLLIER, *Histoire des
Manufacturers Françaises de
Porcelaine*, Paris, 1906
A. DEMMIN, *Guide de l'amateur
du Faiences et Porcelaines*, Paris,
1867
STEPHANE FLACHAT, *L'Industrie
Exposition de 1834*, Paris, 1834
HENRY-PIERRE FOUREST, 'Les
Porcelaines de Paris 1800–1850',
*Cahiers de la Ceramique du Verre
et des Arts du Feu*, 46–7, 1970

Working under his wife's maiden name of Petit, Jacob Mardochée was possibly the most influential Paris porcelain manufacturer of the nineteenth century. Unlike most, he received an artistic training, under Gros, and then travelled in Europe. He became interested in the decorative arts after studying various industries in England, publishing his schemes on his return to France in *Recueil de Decorations Intérieurs* (1830).

Petit decided to concentrate on ceramics, and rented a small workshop in Belleville. Some time before 1834 he took over a factory at Fontainebleau. Within four years, its output had become entirely ornamental.

By now, Sèvres' degraded classical style no longer led the way. On the other hand, the Paris factories' exhibits at the 1834 trade exhibition were no better, according to Stéphane Flachat: 'Where are the styles, where are the schools, where are the masters? Are we at the Greek, Roman or Gothic phase? Are we adopting the style of the Renaissance, or of Louis XIV or of Louis XV or of the Empire? ... At present, art is being dissipated and industry is enslaving it to its own needs before even discerning its laws.'

Of Petit, however, Flachat wrote: 'Our praises are unrestricted for this spirited and enterprising artist, who has so rapidly and boldly made his place in an industry which sleeps amongst Greek, Roman and Imperial shapes.' She noted the 'novelty, daring, and originality of his products'. The exhibition's jury disagreed. They were shocked by 'the bizarre and difficult contours' but still awarded him an honourable mention for high technical quality. They also had to admit that Petit had stimulated the porcelain trade — here was the inspiration that the industry was seeking.

Petit's pieces showed the influence of his travels, drawing on eighteenth-century Meissen, Derby, and Capodimonte. From these he introduced a fancy rococo style, as well as using medieval and oriental sources. These were imposed on a range of ornaments, such as mantelpiece sets, *jardinières*, matchholders, perfume burners, ring stands, and food warmers. As a contemporary wrote, 'There is always something new emerging from his kilns.'

This vegetable dish and cover perhaps derives from eastern French faience. Petit also produced covered dishes in the shape of animals, in the Sceaux and Chelsea tradition; he delighted in *tromp l'oeil* effects, also specializing in applied flowers and jewels.

Described as 'one of the premier designers and modellers of our time', Petit enjoyed great success, with two factories (at Fontainebleau and, between 1845 and 1850, at Sèvres) and warehouses in Paris, Hamburg, and London. However, this was a difficult period for the Paris porcelain factories. In the political upheaval following the 1830 Revolution, their number declined rapidly. During the 1848 Revolution trade in porcelain was reduced by two-thirds, and nearly 60 per cent of craftsmen did not survive the crucial four months.

Petit was one of the casualties. He filed a bankruptcy petition in 1848. Fortunately, his creditors allowed him thirteen years to repay his debts, and Petit continued not only to decorate his own wares, but also to sell white items to other concerns for decoration. Confusingly, he also bought white blanks from Limoges to decorate himself.

In 1862 Petit sold his moulds and marks to an employee, Jacquemain. In 1867 Demmin remarked: 'Today at Chantilly, M. Petit has unhappily abandoned his original factory to make imitation Meissen figures.' Many of these he marked with crossed swords or decorated with lace dipped in slip.

Jacob Petit died in 1868 in Paris. HB

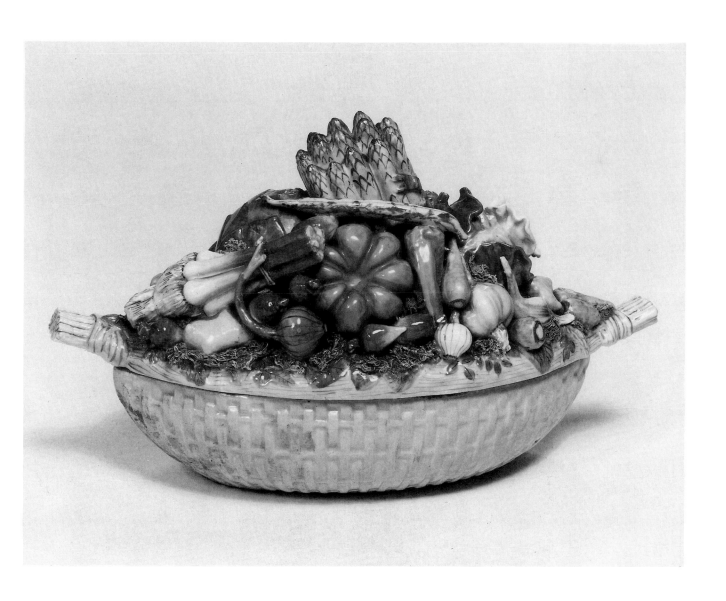

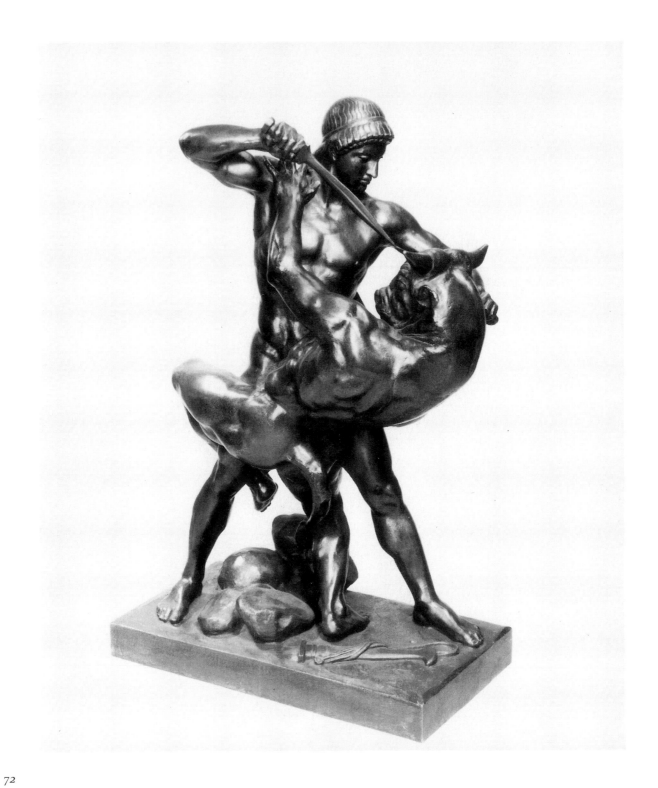

Theseus and the Minotaur

By Antoine-Louis Barye
(1796–1875)
French: Paris, c.1850, from a
model of c.1835
Bronze
h 45 cm (18 in.)
2708–1856

Literature

C. DRURY, E. FORTNUM FSA
(Introduction), *A Descriptive
Catalogue of the Bronzes of
European origin in the South
Kensington Museum,* London,
1876
GLENN F. BENGE, *Antoine Louis
Barye, Sculptor of Romantic
Realism,* University Park and
London, 1984

The Greek myth of Theseus slaying the Minotaur—half bull and half man—was a popular neo-classical subject and had been represented by Canova in his marble group (also in the Victoria & Albert Museum) which is arguably the earliest expression of the neo-classical style in sculpture. Appropriately, Antoine-Louis Barye's composition has a severity reminiscent of Greek archaic sculpture, the interest of which was first recognized by the neo-classical theorist Winckelmann. However, the surface of this bronze has a vibrancy and movement seen also in the contemporary paintings of Delacroix and Géricault. The theme of conflict involving men and animals was already well-established in French sculpture, notably in the groups of Milo of Croton by Puget and Falconet, but it became far more common in painting and sculpture of the 1830s onwards, a particularly celebrated example of the latter being Frémiet's *Gorilla carrying off a Woman*.

The *Theseus* was executed relatively early in the sequence of small bronzes produced by Barye from the early 1830s onwards. Most were of animal subjects, prompting Gautier's description of him as the 'Michelangelo of the menagerie'. This cast, shown at the Paris Exhibition of 1856, was probably produced and marketed through the business he ran between 1845 and 1857 with Emile Martin for the replication of his compositions.

At Barye's death his models were taken over by Barbedienne whose workshop employed 300 workers and, using Collas' mechanical reduction process, produced over 1,000 bronzes each year. The bronzes of Barye and other *animalier* sculptors were thus made available in large-scale editions. This mass replication met the growing demand for relatively inexpensive luxury objects to decorate bourgeois interiors. MB

Bookcase

Designed by Bernardo de Bernardis (1807–68) and Joseph Kranner (1801–71)
Carved by Anton Ritter von Fernkorn (1813–78) and Franz Maler (dates unknown)
Manufactured by Carl Leistler & Son
Austrian: Vienna, 1850
Carved oak
h 463 cm (15 ft 2½ in.); w 579 cm (19 ft); d 167 cm (5 ft 6 in.)
W.12–1967
Given by Edinburgh University

This remarkable Gothic revival bookcase was shown in the Austrian section of the London Great Exhibition in 1851. A suite of rooms, furnished by the celebrated firm of Leistler to the designs of Bernardis, included a dining room with a dining table to seat forty people, a drawing room, a bedroom with a massive four-metre (13 ft) high state bed of carved zebra-wood, and a 'Ladies Library' which contained the bookcase. In the glass sections of the bookcase were shown a number of the finest examples of Austro-Hungarian bookbindings, including several decorated with silver and ivory mounts, designed by Professor Raesher and shown by M. Habenicht of Vienna.

There are many references to this piece in the catalogues and articles published in 1851 concerning the exhibition. Most commentators praised the design and the quality of the carving but the *Illustrated London News* commented: 'It is rather too architectural in its arrangement and the introduction of the statuettes in all directions is not to be approved of on the score of taste or propriety.'

The South Kensington Museum purchased from the 1851 Great Exhibition several pieces of furniture both English and Continental, including the celebrated cabinet by A.W.N. Pugin —which is still on display in the Victoria & Albert Museum. This and the Leistler bookcase were considered at the time to be the two most important pieces of Gothic revival furniture in the exhibition and both are elaborately carved.

After the exhibition the bookcase and the bookbindings were presented by Emperor Franz Josef of Austria to Queen Victoria. A watercolour in the Kunstbibliothek in Berlin shows Queen Victoria standing in front of this bookcase. It was moved from the Crystal Palace by Leistler's men who re-erected it in one of Prince Albert's rooms at Buckingham Palace. Later in the century it was sent to Edinburgh and installed at Holyrood Palace, and in 1923 was presented by King George V to the Department of Forestry of Edinburgh University. CW

Literature
ELISABETH ASLIN, 'A Viennese Gothic Bookcase', *Victoria & Albert Museum Yearbook*, IV, 1974

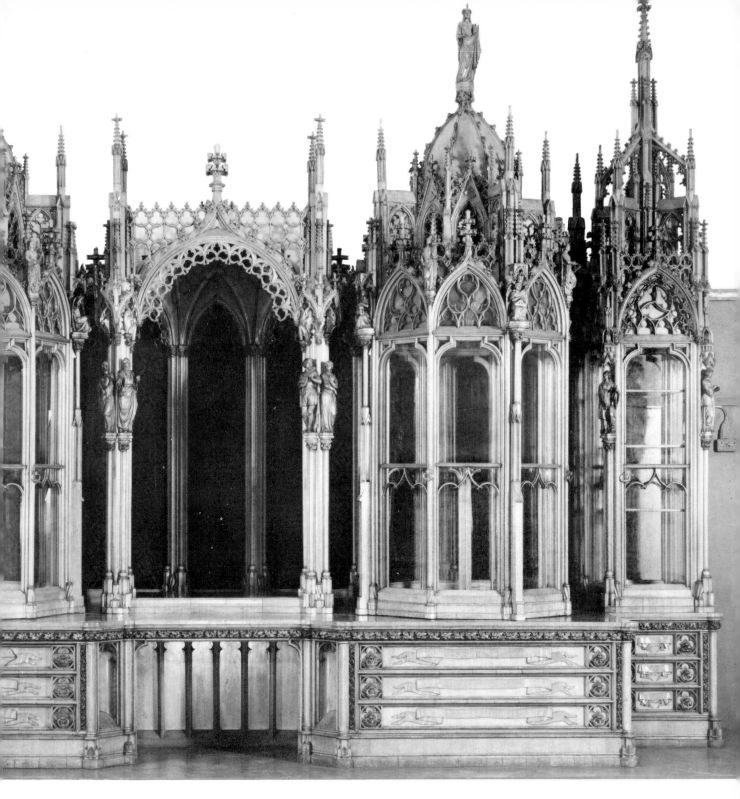

Two Greyhounds

By Louis-Godefroy Jadin
(1805–82)
French: Paris, 1850
Oil on canvas
Signed and dated G. JADIN, 1850
114 × 146 cm
(3 ft 9 in. × 4 ft 9½ in.)
86–1880

The Parisian Louis-Godefroy Jadin was the son of a composer, his brother being a dramatist. In about 1830 he became the pupil of the successful artist Louis Hersent (1777–1860), a painter of history pictures and portraits, and Abel de Pujol (1785–1861), a heavy-handed classicist. In 1836 he travelled to Italy with Alexandre Dumas *père*. Jadin gained steady recognition at the Salon, winning a third class medal in 1834, a second class medal in 1840, and a first class medal in 1848.

Jadin was a keen huntsman and, with the accession of Napoleon III, he found his true *métier* as '*Peintre de la vénerie imperiale*'. As official court painter he recorded the pleasures of the chase, with its stirring horn calls and dignified rituals. Such a role recalls inevitably the career of Jean Baptiste Oudry (1686–1755), animal painter to the court of Louis XV. Unlike Oudry, Jadin did not design tapestries, but he did execute several decorative schemes, notably a series of eight panels showing hunting and falconry for the dining room of the Ministry of State.

Jadin specialized in portraits of dogs, mostly life-size heads. In this portrait of two greyhounds—the personification of chasing, hunting, running beasts—his characterization is seen at his best. He portrays vividly the quick, alert movement of the principal dog's head towards the spectator, its deep chest and its pricked up large ears, so different from the 'rose ear' now favoured by judges of the animal in the show ring. As a breed, however, the greyhound has changed relatively little since Jadin's time, although it was then used far more for hunting, rather than racing and the show ring. LL

The Italian Poets Shield

By Antoine Vechte (1799–1868)
Exhibited by Le Page Moutier
Paris or London, exhibited 1851
Steel, embossed and chased
Punched on boss plates: 'LE PAGE'
Signed on Ruggiero's shield:
'Vechte'
diam 67.4 cm (26½ in.); d 27 cm
(10⅝ in.)
1482–1851

Literature

S. BURY, 'The lengthening
shadow of Rundell's. Part 3:
The Rundell influence on the
Victorian trade', *Connoisseur*,
April 1966
J.B. CARRINGTON and G.R.
HUGHES, *Plate of the Worshipful
Company of Goldsmiths*, Oxford,
1926
B. FERREY (ed. C. & J.
Wainwright), *Recollections of
A.W.N. Pugin, and his father,
Augustus Pugin*, London, 1978
G.M. WILSON, 'Antoine Vechte,
The Nineteenth Century Cellini',
in The First Park Lane Arms Fair,
London, 1984

This shield, which was bought for £220 from the display of Le Page Moutier of Paris at the London Great Exhibition in 1851, is decorated in a romantic Renaissance style. Portraits of four Italian poets are matched with scenes from their work: Ariosto (1474–1533), Ruggiero rescues Angelica from the orc (*Orlando Furioso*, X, 92–115); Tasso (1544–95), Carlo and Ubaldo, in search of Rinaldo, refuse to be waylaid by a nymph (*Gerusalemme Liberata*, XV, 55–66); Dante (1265–1321), the centaur Cacus attacked by snakes (*Inferno*, XXV, 16–24); Petrarch (1304–74), Petrarch laments the captive state of Italy, an appropriate theme for the nineteenth century when Italy was struggling for liberty and unity. The Petrarch scene may derive from his letters to the Emperor Charles IV (1316–78), urging him to intervene in Italy, and from the famous *Rime CXXVIII, Italia mia*. Since at the time of the chasing of the shield *Italia mia* was thought by many to contain a reference to another emperor, Louis the Bavarian (1287–1347), an alternative interpretation is that the emperor depicted may be Louis, not Charles.

Antoine Vechte was acknowledged to be the finest chaser of the mid nineteenth century. After early difficulties, he won the patronage in the later 1830s of the Duc de Luynes, and he contributed to the making of the sword designed by Klagmann for presentation by the city of Paris to the infant Comte de Paris which was completed in 1841. From about 1849 to 1862 he worked in London for Hunt & Roskell, the silversmiths, who exhibited his virtuoso pieces to huge acclaim. In the London Great Exhibition they showed the Titan Vase, first seen in Paris in 1847, and an unfinished shield dedicated to Shakespeare,

Newton, and Milton. They showed the vase and the completed shield in Paris in 1855, and again in London in 1862. The Wardens of the Goldsmiths' Company reported that 'We cannot however refrain from expressing our conviction that the superiority of Antoine Vechte over all existing artists in the precious metals, whether British or foreign, is as unquestionable in 1862 as it proved to be in 1851 and 1855.'

When the list of objects bought from the Great Exhibition for the Museum of Manufactures at Marlborough House was published in 1852, with an introduction by Henry Cole, Owen Jones, and Richard Redgrave dated 17 May, *The Italian Poets Shield* was the only purchased work by Vechte. It appears therefore that it may have been the object of a magnificent attack by the architect A.W.N. Pugin, who wrote in a letter to the Lords of the Committee of Trade on 10 December 1851:

> I hasten to acknowledge with most earnest thanks the communication which I have just received respecting the purchase of the shield of Vechte, No. 25 . . . I repudiated the very idea of purchasing the shield, as, although it was, in the abstract, an exceedingly clever piece of chasing, yet it was diametrically opposite to the style and principles which I considered we ought to put before the students . . . it does not in any way illustrate the English character of the POET to which it pretends to refer, but is a positive revival of Pagan art . . .

Pugin refers in his letter to his recent 'severe attack of nervous fever' and was to die after further disturbed periods on 14 September 1852. His reference to the 'English character of the POET' may therefore result from his confusing the shield with the unfinished Shakespeare, Milton, and Newton shield. RE

Flask

By François-Désiré Froment-Meurice (1802–55) and Jules Wièse (1818–90)
French: Paris, c.1851
Parcel-gilt silver, niello, blue glass, garnets
h 42.3 cm (16⅝ in.); w 16.2 cm (6⅜ in.)
Stopper engraved: 'FROMENT MEURICE'
Mark of Jules Wièse, restricted warranty mark for silver, Paris, in use from 1838
168–1854

Literature
PHILIPPE BURTY, *F.-D. Froment-Meurice*, Paris, 1883

François-Désiré Froment-Meurice was trained in the family firm, studied drawing and sculpture, and later acknowledged a debt to the example and advice of Charles Wagner, the employer of F.-J. Rudolphi. He received the title of '*orfèvre-joaillier de la ville de Paris*', and won gold medals at the exhibitions of 1844 and 1849. In 1841 Victor Hugo praised him in a poem, beginning:

Nous sommes frères: la fleur
Par deux arts peut être faite.
Le poète est ciseleur
Le ciseleur est poète.

Like Hugo, the novelist Eugène Sue saw a parallel with the work of Cellini, and she addressed her letters 'Cher Benvenuto'.

Froment-Meurice was awarded a Council Medal in 1851. The *Art Journal Illustrated Catalogue* gave him the following accolade: 'The visitor to the Great Exhibition may search in vain through the whole length and breadth of the vast edifice for works more truly beautiful of their class, than those contributed by M. FROMENT-MEURICE, the eminent goldsmith and jeweller of Paris.' His triumph was reflected in the number and range of objects acquired for the Museum of Ornamental Art, the ancestor of the Victoria & Albert Museum. This flask in the Renaissance style was bought for £66 16s. An iron seal, which is also in the gallery, was bought for £7: inlaid in gold, it is surmounted by a silver dragon which has the intricate intensity of the monkeys cane head which Froment-Meurice completed for Honoré de Balzac in 1846. Elsewhere in the Museum are a sword and a bracelet which were also bought from the 1851 Exhibition.

Froment-Meurice's success owed much to his selection of some of the finest artists of his time. He not only ran a large workshop which in 1847, before the political upheavals of the following year, numbered 120 craftsmen, but also turned to Klagmann and Feuchère for designs and Vechte and Wièse for execution. Jules Wièse, whose mark this flask bears, entered Froment-Meurice's workshop in 1839 before setting up his own in 1844, which appears to have worked at first only for Froment-Meurice. Wièse had originally been trained by the Berlin court goldsmith J.G. Hossauer. His work for Froment-Meurice brought him a medal as '*coopérateur*' at the Exposition des Produits de l'Industrie Française in 1849. He exhibited on his own account in Paris in 1855, the year in which his mark and Froment-Meurice's name were placed on the elaborate reliquary of the Talisman of Charlemagne executed for Napoleon III (Association Diocésaine de Reims). In London in 1862 he exhibited a sword designed by the sculptor Schoenewerk and chased by Honoré, which had been presented to Marshal MacMahon, victor at the battle of Magenta.RE

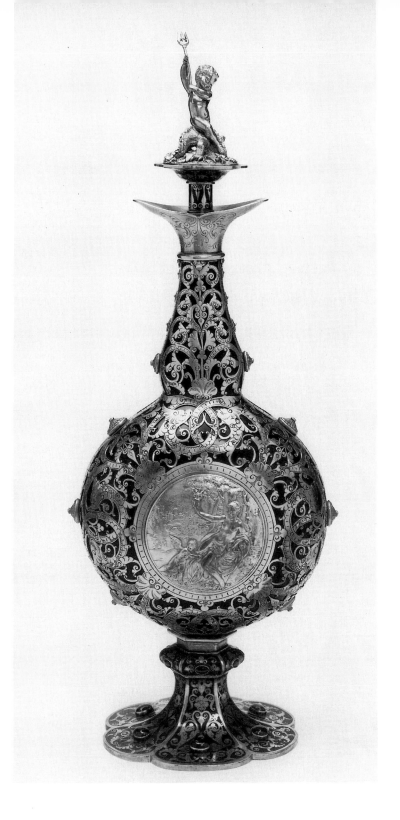

Casket

By Alexandre Gueyton
(1818–62)
French: Paris, c. 1851
'Oxidized' silver; set with rubies
and half-pearls
h 16.2 cm (6⅜ in.); l 17.5 cm
(6⅞ in.); w 10.2 cm (4 in.)
155–1852

Literature
*Reports by the Juries of the 1851
Exhibition*, 1852
H. VEVER, *La Bijouterie Française
au XIXe Siècle*, II, 1908

Alexandre Gueyton was born in Tournon (Ardèche) in 1818, and worked in Geneva before setting up in Paris in 1840. His work in Egyptian, medieval, and Renaissance styles reflected his frequent visits to the museums of Paris. At the London Great Exhibition of 1851 he was awarded a Council Medal. His over-stretched finances were rescued by a friend, an engraver, who persuaded a wealthy foreign patron to buy a number of Gueyton's most important exhibits.

This casket in neo-Gothic style was purchased from the 1851 Exhibition for £36, together with another in Renaissance style for the same price (154–1852). The purchasing committee commented: 'Notwithstanding the general form is too architectural for a work of ornament and many portions are out of scale: it may be studied with advantage, as a good example of surface decoration. The execution, also, is very perfect.'

The Duc de Luynes, chairman of the jury responsible for precious metal and jewelry, described the casket as 'chased in a very artistic manner', and of Gueyton's exhibits in general, he wrote: 'The variety of objects exhibited by M. Gueyton bespeak great felicity of invention and a felicitous application of old as well as novel processes.' The 'novel processes' were the use of electrotyping, of which Gueyton was a pioneer in France. A necklace in the Victoria & Albert Museum's Jewellery Gallery, purchased from Gueyton at the London Exhibition of 1862, has five electrotype medallion pendants. It is appropriate that this casket was selected for electrotype reproduction by Elkington & Co, whose versions cost between five guineas and £7 in 1869.

The use by French silversmiths of the colouring process known as 'oxidization' (although it frequently results from the creation of a sulphide rather than an oxide on the surface of the silver) was particularly attractive to R.D. Wornum, the contemporary critic whose prize-winning essay was printed in the *Art Journal Illustrated Catalogue* of the Great Exhibition. He praises the work of Froment-Meurice and Rudolphi, and 'some equally good specimens by Gueyton, where the effect of oxidation is very well illustrated, as it is so variously applied'. He contrasts the burnished and frosted finishes of English silver with the 'oxidized' surfaces of the Continental silversmiths:

Flashiness may be a natural refuge for vague undefined forms, to the deformities of which it is an effective cloak; and so long as our silversmiths adhere to their Rococo scrolls, and other inanities of the Louis Quinze, its aid will be indispensable. Immediately the details of design, however, are substantially reformed, frosting and burnishing, except as occasional incidental aids, must go together with the preposterous forms to which alone they owe their present popular development. If we turn from the English to the foreign silver-work, the contrast in this respect is surprising; frosting and burnishing seem to be unanimously banished from all high class design, whether French or German, and oxidising substituted in their places, and the consequence is, that in many foreign examples we have specimens of the most elaborate modelling, most effectively displayed as works of Art . . .

RE

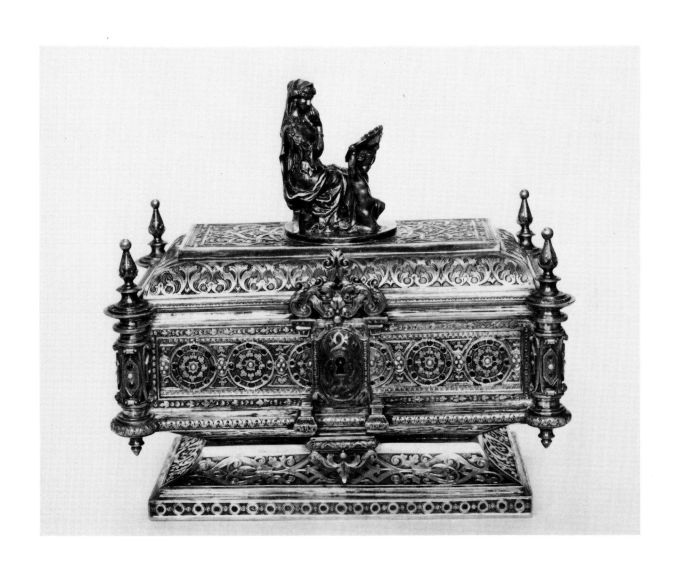

Sofa

Manufactured by John Henry
Belter (1804–63)
New York, c.1856
Laminated rosewood, upholstery
replaced
h 148.6 cm (4 ft 10$\frac{1}{2}$ in.);
w 232.4 cm (7 ft 7$\frac{1}{2}$ in.);
d 114.9 cm (3 ft 9$\frac{1}{4}$ in.)
W.22–1983

Literature

A.J. DOWNING, *The Architecture
of Country Houses*, New York, 1850
MARVIN D. SCHWARTZ,
EDWARD J. STANEK, and
DOUGLAS K. TRUE, *The Furniture
of John Henry Belter and the
Rococo Revival*, New York, 1981

John Henry Belter (born Johann Heinrich Belter in Ulm, Württemberg) is the most famous cabinet-maker of the rococo revival era in America. He is known as the creator of an elegant type of curved, generously proportioned, deeply, though delicately carved parlour suites. When Belter emigrated to America in 1833 he was already a skilled craftsman and by 1844 was New York's best-known cabinet-maker, working almost exclusively in the rococo revival style.

The rococo revival began in England in the 1820s, and was an obvious reaction to the comparative simplicity of the neo-classical style. It drew upon the baroque and rococo elements of eighteenth-century design: the 'S' and 'C' scrolls, naturalistic carving of fruits, flowers and foliage, and the sensuous curving silhouette. In America the rococo revival was most popular from the 1840s to the 1860s as was noted by the American architect A.J. Downing: 'Modern French furniture, and especially that in the style of "Louis Quatorze", stands much higher in general estimation in this country than any other.' This fine quality furniture was one of the many, varied luxuries much sought after by the fashion-conscious nouveau-riche.

Belter translated the quality of eighteenth-century craftsmanship into a more widely available commodity through the use of nineteenth-century technology. His reputation is based on the distinctive design of what was termed his parlour sets. This sofa can be viewed equally well from the front, side, or back because the curving back and rectangular rear legs are set into the frame to maintain a continuous flow. Termed 'pierced-carved', the frame is curved, carved, and perforated. Fluid scrolls form the silhouette of the sofa back and encircle pierced-work ornament; serpentine front seat and carved seat rails are highlighted with carved flowers and foliage. The cresting of each of the three sections is carved in an elaborate design of flowers with grapes. There is a similar sofa, dated c.1855, in the Museum of the City of New York.

Although rosewood lacked sufficient strength for carved work, and was difficult to use for veneering on curved surfaces, it was Belter's favourite material for furniture with its dark colour and heavy grain. Belter applied for four patents (1847, 1856, 1858, and 1860), the last three of which are concerned with the use of laminated construction in furniture. It was this process that enabled Belter to use rosewood for intricate work on a large scale. With this technique Belter replaced traditional rail and stile construction of chairs with moulded one-piece laminated backs, carved and upholstered.

Belter's interest in laminated construction was shared by many other cabinet-makers. These included Samuel Gragg of Boston (active 1808–30), Jean Joseph Chapuis of Brussels (active 1802–30), and another German cabinet-maker, Michael Thonet (1796–1871). While Thonet's early patents were for laminated wood chairs, he later became famous for founding an industry based on the mass production of bentwood chairs.

In the mid nineteenth century Belter was considered 'New York's most fashionable cabinet-maker after Duncan Phyfe'. Elaborately carved, pierced, and moulded rosewood, together with deep upholstery, was produced in some quantity under the general name 'Belter furniture'.

In the 1870s 'Belter-type' furniture declined in popularity; it was considered to be heavy and ostentatious and was generally removed to the attic. The revival of Victorian taste in the 1930s brought it back into fashion. VJV

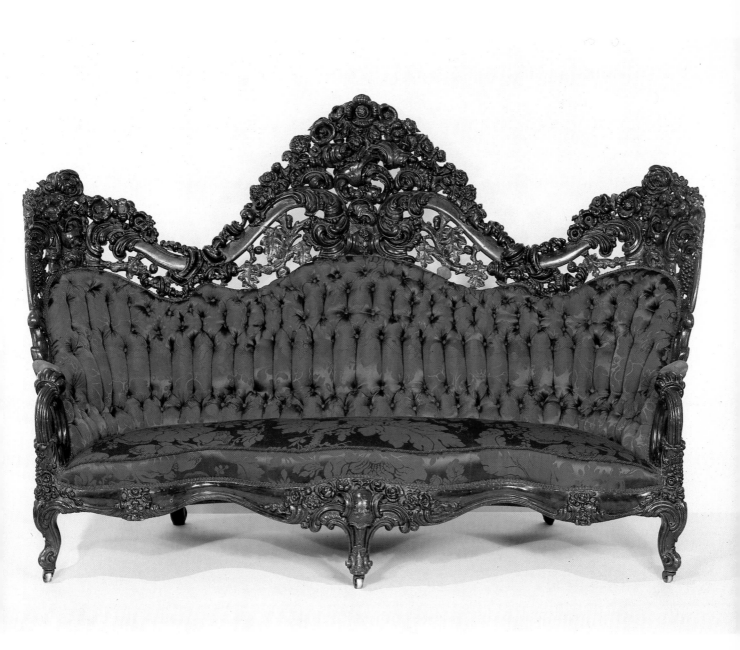

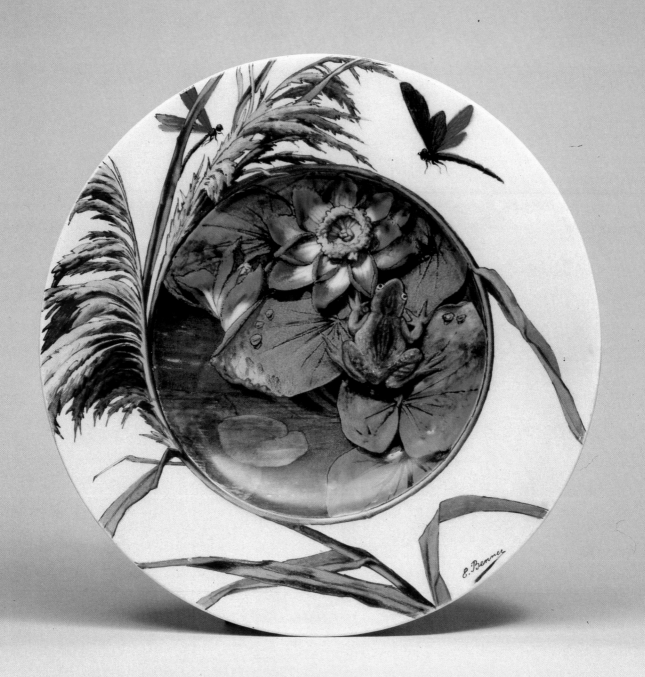

Dish

Decorated by Emmanuel Benner
(1836–96)
Manufactured by
Joseph-Théodore Deck
(1823–91)
French: Paris, c.1860–70
Earthenware with painted
decoration
diam 33.6 (14$\frac{3}{8}$ in.)
Marks: E. BENNER in the painting,
T.H. DECK impressed twice,
151 handwritten on paper label
C.286–1921
Given by C.H. Campbell

Literature
JULES MARTIN, *Nos Peintres et
Sculpteurs*, Paris, 1897
RÉNE MENARD, *L'Art en Alsace-
Lorraine*, Paris, 1876

Joseph-Théodore Deck is one of the major figures of nineteenth-century French ceramics. His wide ranging interests in decorative styles and techniques led to the production of ornamental wares in tastes as varied as medieval, Japanese, Islamic, and European Renaissance.

Around 1856 Deck acquired an Islamic tile and, investigating its construction, discovered the technique of first coating the ceramic body, the earthenware, with a white alkaline slip containing tin oxide and then applying a transparent glaze over painted enamel decoration. The resulting brilliant luminosity and richness of the enamel colours led Deck to adopt this technique not only for his own 'Persian style' but also, as in this case, for free painting in the 'Japanese manner' practised by several of his artist collaborators.

Born in Guebviller, Alsace, Deck spent his early years travelling and gaining experience in various tile and stoveworks in the area near his birthplace. He worked at the Hügelin factory in Strasbourg, spent some time in Vienna, Hungary, Budapest, Prague, Berlin, Hamburg, and Dusseldorf, eventually arriving in Paris in 1847. The Revolution of 1848 precipitated an early departure but he returned and finally settled in Paris in 1851. After some further years in stove-tile production, in 1858 he set up his own workshop with his brother Xavier and began to make the highly original ornamental wares which were to excite admiration and finally to lead to his appointment as Director of the Sèvres factory, the first practising potter to hold the post.

While he was responsible for a number of designs himself, a large part of his production was done in collaboration with a team of visiting artists, many of them friends or compatriots. Emmanuel Benner and his twin brother Jean (1836–1906) were born in Mulhouse, Alsace. Both studied painting, Emmanuel under Jakob Eck (1812–87). Both brothers' careers as painters were highly successful and both collaborated with Deck. They specialized in still lives, portraits, and genre subjects, and Jean, who studied in Italy and for a while settled on the island of Capri, also included dramatic landscapes and religious subjects among his work. Both brothers were awarded medals at various exhibitions, Jean in 1872 for *Aprés un Tempête à Capri*, Emmanuel, whose inclinations tended also towards subjects from classical mythology, demonstrating *'un penchant marqué pour l'Italie'*, for a work shown in the Paris International Exhibition of 1889. Despite these successful if apparently unremarkable academic careers both men shared with many contemporaries, and with Deck in particular, an interest in the 'Orient', especially the Far East. Jean Benner painted his *Chanteurs de Capri* on a dish by Deck. Emmanuel Benner's decoration of this simple plate is a freely painted, richly coloured example of *Japonisme* at its most expressive and successful.

The donor of this dish was C.H. Campbell, a member of the Minton family. Herbert Minton (1793–1858) assembled a considerable reference collection of ceramics during travels on the continent. He made one such journey to Vienna in the company of Henry Cole, first Director of the South Kensington Museums, of whom he was a close friend. This collection was available for reference and inspiration to the Minton artists and technicians and in some cases it is possible to match a French original with its Minton counterpart. Herbert Minton's collection descended, in part at least, to Colin Minton Campbell (d.1885) who represented the china manufacturing company after the original partnership was disbanded in 1859. His collection was sold by Christies in 1902 but again part at least was acquired by or descended to his grandson C.H. Campbell and sixty-two pieces were given by him to the South Kensington Museum in 1921. The paper label 151 refers to an inventory of the complete collection drawn up by Joseph François Léon Arnoux (1816–1902), the Minton factory's designer and Art Director from 1849. JHO

Vase and cover

By Marrel Frères
French: Paris, c.1851
Parcel-gilt silver; *champlevé*
enamel; garnets
Inscribed on base: 'MARREL
FRERES A PARIS'
Maker's mark, restricted
warranty mark for silver, Paris,
in use from 1838; small import
mark for gold and silver (?), in
use from 1838
h 27 cm (10⅝ in.); *diam* 13.5 cm
(5¼ in.)
160 & a–1851

Literature
*Official Catalogue of the
Exhibition*, London, 1851, III

This vase in the Renaissance style is ornamented with cast plaques representing the four seasons inset into the foot. These reliefs and their bold strapwork frames are in that mannerist style which developed at Fontainebleau in the 1530s. Round the edge of the lid are naturalistic bunches of grapes flanked by frogs, representing a synthesis of nineteenth-century naturalism and mannerist revival: frogs, lizards and snakes were conspicuous ingredients in contemporary imitations of Bernard Palissy's sixteenth-century pottery. The vase was bought for £100 from the London Great Exhibition in 1851. For its display at the exhibition, the firm of Marrel Frères won a Council Medal. Included were a large gilt vase with a scene in 'oxidized' silver after Rubens, the neo-gothic hunting sword bought by the government for £200 and also displayed in this gallery, and a silver cup, *The Revival of the Arts*, which included among the illustrious persons depicted, Benvenuto Cellini, the hero of mid-nineteenth-century goldsmiths.

'A beautiful vase ... designed in purest Venetian style, and most artistically executed throughout', stated the *Art Journal*. The only adverse contemporary criticism appears to have concerned the thinness of the ornament. The committee which recommended its acquisition described the vase as 'very elegant and playful in the general form, and well executed; the enamelled decoration, though rather thin in character, and in parts not well distributed, is beautifully drawn.'

John Charles Robinson (1824–1913), Curator of the Museum of Manufactures at Marlborough House Museum from 1853 and the greatest English connoisseur and art scholar of his time, shared the committee's reservation:

Although not an inelegant object, there is a certain thinness and poverty in the ornamentation, contrasting most forcibly, for instance with the massive richness of the previous example [a sixteenth century chalice]. As a specimen of careful and dextrous workmanship, however, this leaves nothing to be desired; it is likewise in all its parts consistently treated in the true direction of the material. On the whole a more characteristic specimen of French taste in goldsmiths' work, as displayed in 1851, could not have been selected.

RE

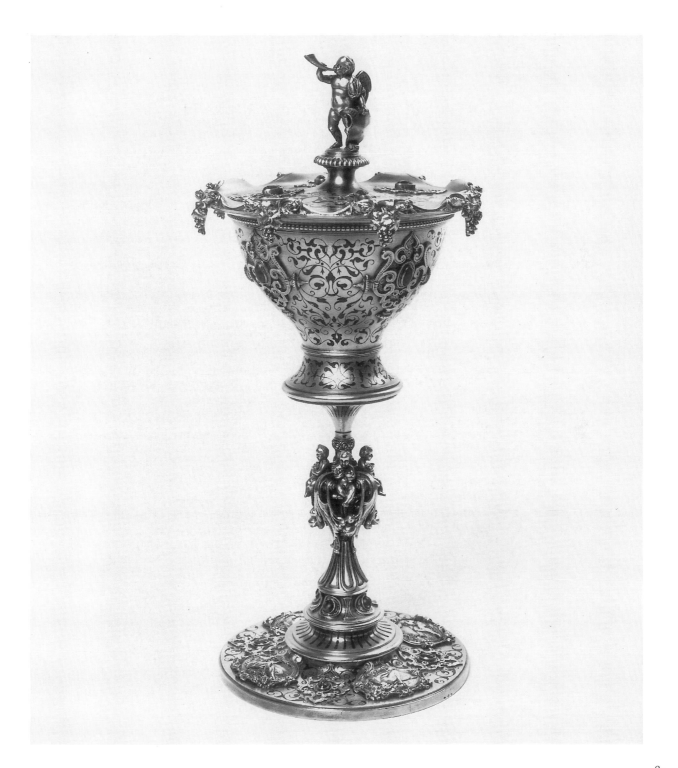

Robinson des Glaces

Text by Ernest Fouinet (d.1845)
Published and bound by Martial
Ardant Frères
French: Limoges and Paris, 1855
h 28.7 cm ($11\frac{1}{4}$ in.)
w 19 cm ($7\frac{1}{2}$ in.)
Circ.188–1948

Literature

SOPHIE MALAVIELLE, *Reliures et cartonnages d'éditeur en France au XIXe siècle, 1815–1865*, Paris, 1985

The mechanization of book production in nineteenth-century Europe had a dramatic impact on book design. Some operations, sewing for example, continued to be done largely by hand until the introduction of perfected American machinery at the end of the century, but binding was radically transformed by industrial methods of production from the 1830s. Books like the Martial Ardant Frères' *Robinson des Glaces* must be seen against the background of a publishing boom that started at this time, a boom that was fuelled by a number of factors: the introduction of a national education system demanding large numbers of teaching and other texts, an increased and more concentrated reading public, a swift method of distribution ensured by the new railway network, and the emergence of the publisher to replace the individual bookseller or printer as the driving force in the business of producing and selling books.

The firm of Martial Ardant Frères, founded in Limoges in 1837, was among the first to exploit new technical possibilities, and evidences a new kind of business structure in contracting out specialized functions to binding and other workshops in the city. Book covers were produced independently from the text-blocks. Under the influence of English practice, boards were covered with cloth which was then blocked (i.e. stamped) with a design. A consistent evolution is seen in the style of these designs: in the early 1840s, they were in gold on dark coloured cloth, with colour being painted in by hand from *c*.1845; from *c*.1850–60, colour was added in the form of paper overlays, as in the *Robinson des Glaces* of 1855; the 1860s saw a preference for gold with the introduction later of designs printed in ink.

The design for the *Robinson des Glaces* binding, a blend of rococo and naturalism, suited popular taste of the mid-1850s; it was used again for the 1858 edition of the work. The design on the spine was one used for a number of books produced by this firm at the time.

Robinson des Glaces had first been published in 1835, ten years before the death of its author. One of the numerous works based on the Defoe Robinson Crusoe story, its moralizing tone demonstrated the value of honest self-sufficiency and steadfast Christian faith. It was no doubt eminently suitable as a prize for achievement in schools, a market which the Martial Ardant Frères binder-publishers succeeded in dominating in the nineteenth century and which, with works of religious devotion, was the basis of their financial success.

RW

Tankard

By Frédéric-Jules Rudolphi
French: Paris, c.1855
Parcel-gilt silver set with rubies;
ivory inlaid with turquoise;
interior gilt
h 23 cm (9 in.); w 17.5 cm (6$\frac{7}{8}$ in.)
Maker's mark; second standard
and restricted warranty marks
for silver instituted in 1838
2653–1856
Purchased from the Paris
Exhibition of 1855 for £150

Literature
P. KJELLBERG, 'L'Orientalisme',
Connaissance des Arts, August
1973
*Reports on the Paris Universal
Exhibition*, Part III, 1856
H. VEVER, *La Bijouterie Française
au XIXe Siècle*, I, 1906

'From Monsieur Rudolphi', declared the *Art Journal*'s review of the Paris Exhibition of 1855, 'English Art may learn much'. Richard Redgrave, who had been one of the committee responsible for purchasing three works by Rudolphi from the London Great Exhibition in 1851, wrote in his report on the Paris Exhibition:

> [Rudolphi] had adopted on this occasion a singular combination of materials giving a great diversity and originality to his works, although in some few cases they were more singular than pleasing. Many of the works by M. Rudolphi consisted of treatments combining lapis lazuli and oxydised silver, turquoise and ivory mounted in silver, and bloodstones and lapis in juxta-position. The effect was very singular, and the peculiar harmony obtained was somewhat analogous to the use of the minor scale in music, being a little sad and uniform, and in so far not well fitted for jewellery. There was, however, high merit in many of the works; the tankard of silver encrusted with ivory and turquoise, purchased by the Department of Art, is a good specimen of the style.

The tankard demonstrates Rudolphi's creative use of his sources. Daniel Alcouffe has suggested that the general shape is reminiscent of the German Renaissance, and that the pierced decoration of the handle may derive from twelfth- and thirteenth-century ironwork. There is Middle-Eastern or Indian influence in the rich materials and the ogival arches, a reflection, like the paintings of Eugène Delacroix, of the attraction of the Islamic East, which found some of its origins in the French campaigns in Egypt in the 1790s, the Greek War of Independence, and the French conquest of Algeria which began in 1830.

Rudolphi was born and trained in Copenhagen. In Paris he worked for Charles Wagner, who was described by F.-D. Froment Meurice as *'le premier dans son art'*, and who had a great success at the national exhibition in Paris in 1839. After Wagner's death in a shooting accident, Rudolphi registered his mark in 1842 and exhibited under Wagner's name in 1844. He won a Council Medal at the Great Exhibition in 1851 and was subsequently awarded the Légion d'Honneur.

In addition to this tankard, the Gallery displays an emerald and turquoise-set vase (2654–1856) by Rudolphi, also bought from the 1855 Exhibition, and a silver bottle (919–1844) bought for the collections of the London School of Design from the national exhibition held in Paris in 1844. RE

Table

Designer unknown
Manufactured by Edouard
Kreisser (fl.1843–63)
French: Paris, 1855
Marquetry of various woods,
porcelain plaques, ormolu
mounts, and silvered mounts
h 120 cm (3 ft 11 in.); w 78 cm
(2 ft 8⅜ in.); d 61 cm (2 ft)
Marks: The top is inscribed in
the marquetry 'E. KREISSER.
a Paris. 52 Rue Basse du Rempart
Exposion. Universelle de Paris
1855'
W.9–1964
Given by George Farrow Esq.

Literature
G. DE BELLAIGUE, 'Victoria Buys
French in 1855', *The Antique
Collector*, April 1975

Queen Victoria and Prince Albert went to see
the Paris Exhibition of 1855 and stayed at the
Palace of St Cloud as guests of Napoleon III.
At the exhibition the Queen purchased three
pieces of furniture: an ebony display cabinet
by Grohé Frères, as well as this table and a
cabinet, both by Kreisser and both in an elab-
orate version of the Louis XVI style. She paid
2,500 francs for the table, which she gave
to Prince Albert as a Christmas present in
1855. The cabinet which is *en suite* cost her
8,000 francs, and she gave it to Albert as a
birthday present in August 1856; it survives
at Kensington Palace. The enamel and silver
plaque of the table bears the cypher V&A and
was presumably designed at the Queen's re-
quest. How and when the table left the Royal
Collection is unknown.

Kreisser was in business from 1843–63 and
on the evidence of these pieces his workshops
were capable of producing cabinet work of a
very high quality. They seem to have shown
at only one other exhibition other than 1855,
the Exposition des Produits de l'Industrie
Française in Paris in 1844.

Kreisser's was not one of the large and
important firms in Paris, such as Fourdinois,
and the design of this table though elaborate
is not as sophisticated as that of the import-
ant Fourdinois cabinet (*see* pages 46–7).

In a letter written on 12 September 1855
Colonel Phipps, Prince Albert's Private
Secretary, said of the Queen, 'What she wants
is not anything very magnificent but two good
specimens of French upholstery as memorials
of the Exhibition.' CW

Goblet and stem

Engraved by Franz Paul Zach
(1819–81)
Probably made by Wilhelm
Steigerwald
German: Zwiesel, Bavaria, c.1855
h 32.4 cm (12¾ in.)
Signed: 'F.P. ZACH'
2672–1856
Bought from Franz Steigerwald,
Munich

Literature

R.J. CHARLESTON, 'The
Glass-engraver F. Zach: 17th or
19th century?' *Apollo*, February,
1964
W.B. HONEY, *Glass, a
Handbook*, London, 1946
S. LEONARD and JULIETTE K.
RAKOW, 'Franz Paul Zach,
19th c. Bohemian Master Glass
Engraver', *Journal of Glass
Studies*, 25, New York, 1983
Paris International Exhibition
1855, *Rapports du Jury*

Franz Paul Zach was born in Prague in 1819. Between 1834 and 1837 he was apprenticed to the Glasmeister Johann Bamberger, for whom he worked a further six years. He moved to Munich in 1843, where he shared a house with Franz Steigerwald. This was the beginning of a long association with the entrepreneur, who owned glass shops in Munich and other cities. From these, Steigerwald sold glass manufactured by his brother Wilhelm (died 1869) and decorated by well-known German glass artists, including Dominik Biemann and, of course, Zach.

Skilled engraving of glass has long been a German and Bohemian speciality. It began as a natural development of the sixteenth-century taste for engraved crystal and gems and was at its height between 1685 and 1775. Although most engravers worked independently and remained anonymous, they were an industry which exported to every part of Europe and to Persia and the East. Gradually, however, the demand for engraved pieces declined, in favour of more common wares.

The nineteenth-century revival of glass-making and engraving in Bohemia arose as a result of middle-class prosperity following the Napoleonic wars. The growing market demanded a new, fashionable Biedermeier style, represented in glass by clumsy classical forms with heavy feet and bold faceting.

As a reaction against crystal glass, new colours were developed and combined particularly effectively with engraving. Typically, a blue layer was flashed over clear glass and then engraved. At first the design was simply cut on the wheel through the thin outer layer so that it appeared clear on a blue background. By the mid century the background was ground away instead, so that the design appeared blue against clear glass. In addition, the blue of the design itself was engraved to varying depths, thus yielding different intensities of colour. The outer layer was thick enough to be engraved because it was produced by casing. In this process the glass blower formed a bowl-shaped case of blue glass which he then placed in a metal mould. A ball of clear glass was blown into it and the combined piece reheated so that the two layers fused together.

In this goblet Franz Paul Zach has carried the engraving of the cased glass even further. The background has been stipple-engraved so that it appears matt. Even more subtle are the *vermicelli* clouds within it, which are only visible from certain angles. Indeed, such was Zach's skill that some pieces signed by him were thought until fairly recently to date from the seventeenth century.

This goblet was probably made at Wilhelm Steigerwald's Schachtenbach glassworks at Zwiesel, Eastern Bavaria, which he founded in 1822. It was so near the Bohemian border (indeed, its closest neighbour was the Meyr's Neffe factory) that its products were virtually indistinguishable from those of Bohemian glassworks. Like them, Steigerwald made a great effort at international exhibitions to show pieces which were exceptionally large and skilfully decorated, and also his everyday production. At the Paris Exhibition of 1855, Steigerwald was awarded a medal of honour: the jury commented that his 'numerous, varied products' were a testimony to the great manual skill of his workers. This is certainly true of this goblet, which was bought by the South Kensington Museum from the exhibition via Franz Steigerwald's shop in Munich.

Wilhelm Steigerwald continued to exhibit at international exhibitions, but changing to a more historical style and tending towards larger, prestigious pieces. He owned two other glass factories, one at Theresienthal (founded 1834, sold 1861) and the other, the Regenhütte, which was also at Zwiesel (founded 1844–5). The latter was looked after by his son until his death in 1880 and still exists under a different name. HB

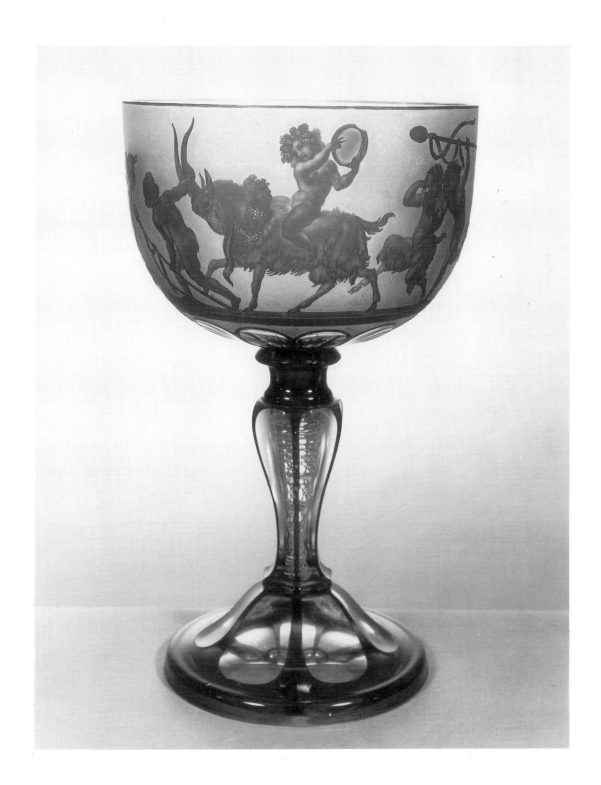

Louvre, Pavillon Mollien

By Gustave LeGray (1820–82)
French: Paris, c.1855
Photograph (albumen print)
Facsimile signature in red ink on photograph
Blind stamped on mount
h 37 cm ($14\frac{1}{2}$ in.)
w 48 cm ($18\frac{3}{4}$ in.)
35.799

Literature

EUGENIA PARRY JANIS, et al., *Gustave Le Gray*, catalogue of the exhibition organized by The Art Institute of Chicago and The Metropolitan Museum of Art, New York, 1987
ANDRÉ JAMMES and EUGENIA PARRY JANIS, *The Art of French Calotype* (with a critical dictionary of photographers, 1845–1870), Princeton University Press 1983

Trained like Britain's Roger Fenton as a painter, Gustave Le Gray wrote in 1852: 'The future of photography does not lie in the cheapness but the quality of a picture. If a photograph is beautiful, complete and durable, it acquires an intrinsic value before which its price disappears entirely. It is my wish that photography, rather than falling into the domain of industry or commerce, might remain in that of art.' The accuracy, grandeur, and tonal richness of this architectural view, purchased by the South Kensington Museum in the late 1850s, typify Le Gray's work.

'Albumen', wrote Le Gray in 1853, 'has been of much service in Photography ... it gives a brilliancy and vigour not to be easily obtained by other means.' It is salutory to remember that Le Gray, trained as a painter in the studio of Paul Delaroche (1797–1859), pioneered early methods of photography. He invented the Dry Waxed Paper process, experimented with collodion in the making of negatives and, among his many writings, published *A Method of Procuring Black and Violet Colours in the Positive Proofs and of more Permanently fixing them by the use of Chloride of Gold and Hydrochloric Acid* (English translation published 1853, reissued by Bloomfield Books & Publications, Doncaster 1974). In the 1850s his treatises, private instruction, and participation in public exhibitions were of particular importance because methods were far from standardized, certainly not industrialized.

This photograph is a superb example of the 'brilliancy and vigour' ascribed by Le Gray to the albumen-coated photograph introduced in 1850. For such works Le Gray was awarded a first class medal at the Paris International Exhibition of 1855. Other branches of his photography include views of the Forest of Fontainebleau—which can be classed with the Barbizon School—the Salon of 1851–2, showing major canvases by Courbet hanging on the line, the celebrated seascapes of 1856–7 (which were so ecstatically received in England), reproductions of works of art and architecture, portraiture, and the military camp at Châlons. His work belongs to the highly ambitious, exploratory era of the late 1840s and 1850s prior to the massive commercialization achieved during the 1860s. His vehicle was the craft-made, large-scale print for exhibition, museum archive, or collector's portfolio. One of the finest collections of his photographs which survives today is that built up in the 1850s and 1860s by the South Kensington Museum.

MH-B

Vase

Made by the Royal Prussian
Porcelain Manufactory
Prussian: Berlin, 1857–67
Hard-paste biscuit porcelain
with enamelled decoration
and gilt
h 86.3 cm (34 in.)
942–1869
Given by the Royal Prussian
Porcelain Manufactory

Literature
Reports of the Jury of the 1867
Paris Exhibition
AARON GREEN, 'Ceramic
Decoration', *Reports of Artisans,
selected to visit the Paris Universal
Exhibition*, London, 1867

Like the other Royal and Imperial Factories,
Berlin relied heavily on commissions from
the court and concentrated on the production
of large display pieces. Juries at the various
international exhibitions recognized the
special advantages that these factories enjoyed:
'Imperial and Royal Manufactories ... have
resources which the private industry cannot
equal ... They alone can undertake works of
art without regard to money, and most of the
objects shown prove that their efforts are often
happy.'

The Berlin factory could not afford to ignore
financial considerations completely, how-
ever. From the 1840s it relied increasingly on
sales of lower-cost porcelain, aimed at a wider
middle-class market. This funded the elaborate
ornamental wares and the technical develop-
ments necessary for such high quality pro-
duction. Under Friedrich Philip Rosenstiel
(manager 1832–48) a particularly workable
porcelain paste was developed which was ideal
for the production of the large display vases
for which Berlin was famous. Variations of
these vases were shown at all the international
exhibitions. An English porcelain decorator,
Aaron Green, who was selected by the Society
of Arts to visit the Paris Exhibition of 1867,
reported that:

> The most noticeable objects are the large vases,
> some of them of elegant and graceful form . . . A
> very large vase, of elegant form and proportions,
> in bisque, is decorated . . . with figures . . .
> painted in a cool natural tint, that is nicely in
> harmony with the bisque body . . . there are two
> reductions of this vase likewise in the bisque . . .
> one has Vulcan, Mars and Venus, in monochrome
> of a mauve tint: this colour is carried into the
> gold ornamentation in a very pleasing manner.

Aaron Green found the general standard of
the factory's works disappointing, however, and
it was under increasing general criticism for its
failure to break away from the classical tradition.
The large display vases were all variants on the
amphora and crater shapes, mostly developed
under the influence of the architect and interior
designer Karl Friedrich Schinkel. These basic
shapes were all designed before 1830, and by
1847 had been commissioned as gifts by the
court well over 220 times. Thus, although the
shape of this particular vase was first introduced
in 1857, it was a variant of an earlier shape of
1833.

After Heinrich Gustav Kolbe (1809–67) was
appointed as manager, Frederick William IV
formed an 'Honorary Council of Noted Artists'
to improve the range of the factory. However,
its influence was minimal, since the artists
themselves were rooted in the neo-classical
tradition. Kolbe did manage to change the
factory's output gradually, including after about
1860 the fashionable neo-renaissance style.

This vase reflects the factory's new in-
fluences. Its shape owes much to Italian maiolica
of the Urbino region, and its handles take the
form of Renaissance griffins. Cleverly, these
suggest also the Prussian Eagle. They were
almost certainly modelled by Julius Wilhelm
Mantel (1820–96), who was responsible for
all vessel and figure moulding between 1841
and 1884. They reflect Kolbe's interest in the
sculptural properties of porcelain, rather than
its use purely as a canvas for decoration.

There seems to have been some confusion
about the subject of the painting, which in fact
depicts Vulcan forging weapons for Aeneas,
who was about to go to war in Latium. The
outcome of Aeneas' victory was the founding
of a Trojan settlement on the Tiber, from which
the Romans were said to have descended. This
was therefore a particularly significant neo-
renaissance motif. HB

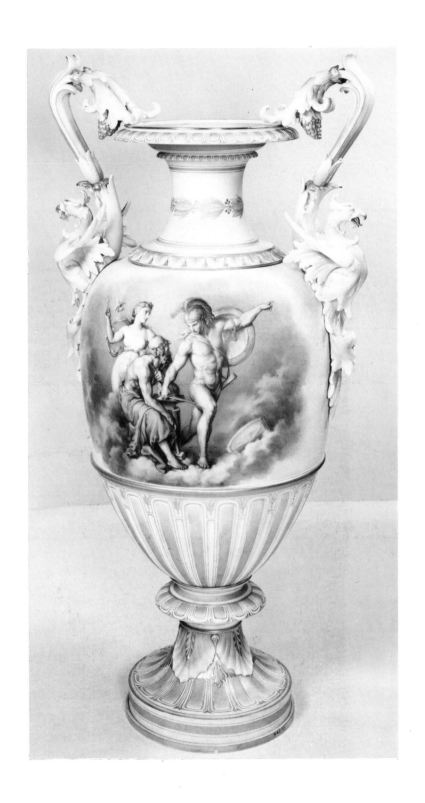

Chair back and seat

Designed by Pierre-Adrien
Chabal-Dussurgey (1819–1902)
French (National Manufactory of
Beauvais) c.1860–62
Tapestry-woven in wool and
silk; 14 warp threads to the cm.
(34 to the in.)
Back
h 62.3 cm (24½ in.); w 66.1 cm
(26 in.)
Seat
h 85.1 × 81.3 cm (33½ × 32 in.)
7927 and 7928–1862
Given by the Emperor
Napoleon III

The Beauvais manufactory was the second
ranking tapestry manufactory in France, giving
precedence to the Gobelins in Paris. During the
nineteenth century comparatively few sets of
tapestries were woven because they were not
particularly in fashion as wall hangings. Such
larger tapestries as were made came from the
Gobelins and the production of Beauvais tended
to be restricted to small decorative panels and
sets of coverings for seat furniture. These were
very much in fashion in the nineteenth century
– perhaps more than they had been in the
eighteenth century – and their production
helped to keep the art of tapestry-weaving
alive, not only in Beauvais, which from 1804

supplied only the French royal and imperial
palaces, but also in the independent tapestry
workshops at Aubusson which reached a wider,
more commercial market.

These back and seat covers for a chair
are restrained in style compared with the more
characteristic nineteenth-century designs,
in which a profusion of flowers and birds
were combined with rampant acanthus scrolls,
strapwork, cartouches, swags of drapery and
jewels, giving much the overcrowded orna-
mental effect of the two allegorical trophy
tapestries representing the continents of Africa
and America displayed in this gallery. By con-
trast, the delicate rococo scrolls and slightly

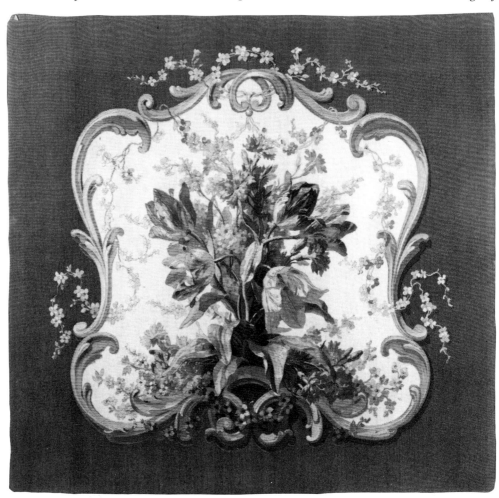

stylized blossoms surrounding a bouquet of exquisitely-woven naturalistic flowers recall the designs of the preceding century, an exercise in the 'Louis XV' style by the designer, Pierre-Adrien Chabal-Dussurgey. He may have used the same designs for some of his work exhibited in 1862, described in the catalogue as 'furniture in the style of Louis XV and XVI . . . intended for Imperial palaces'.

The chair covers were given to the South Kensington Museum, along with the tapestry picture after Raphael also in this gallery, by the Emperor Napoleon III in recognition of assistance given by officials of the museum to the members of the French jury at the London Exhibition of 1862.

Chabal-Dussurgey was employed as a painter of flowers both at Beauvais and at the Gobelins, where he held the post of professor from 1850. He was trained in the Ecole des Beaux-Arts at Lyon (1833–8) and understood designing for textiles. He exhibited as a painter both in Lyon and at the Paris Salon. His work won medals at various international exhibitions, the enraptured French jurors of 1855 becoming lyrical over the many fine qualities of his designs, with the peroration: 'These are no conventional flowers, but a truly magical bouquet sown on these fabrics by a felicitous hand.' WH

Night

By Albert Ernest Carrier-Belleuse
(1824–87)
French: Paris, c.1860–70
Terracotta
h (incl. wood base) 62.9 cm
(26¾ in.)
A.13–1968

Like other mid-nineteenth-century French sculptors, Carrier-Belleuse executed much decorative sculpture for the buildings erected during the redevelopment of Paris according to Haussmann's plans after 1850. Throughout his career, however, he was preoccupied with the application of industrial techniques to sculptural production and the links between sculpture and the decorative arts; these interests are reflected in the publication in 1884 of 200 of his drawings under the title *The Application of the Human Figure to Industrial Decoration and Ornamentation*. Although he executed some important monumental sculpture, his significance is primarily as the most successful and accomplished producer of small-scale bronzes and terracottas which were conceived from the start as compositions to be replicated in considerable numbers. Such serial production of statuettes for a steadily growing market of middle-class consumers was typical of nineteenth-century sculpture as was the proliferation of commemorative statuary for public spaces.

The figure of *Night* is characteristic of Carrier-Belleuse's terracottas; though cast in a mould, the clay was worked over before firing in the kiln, to give the impression of being freshly modelled, a technique employed earlier in the century by Clodion. By representing Night as a semi-nude female figure, Carrier-Belleuse was following a tradition of allegorical sculptures developed in sixteenth-century Italy and revived in nineteenth-century Italy by Bartolini, whose works were well known in France. But his arrangement of the draperies to reveal rather than to conceal the body gives this figure erotic qualities that are somewhat uneasily combined with its maternal associations. The marketing of the female form in such small-scale multiple sculptures for private consumption frequently involved such implicit eroticism. These qualities were apparently acceptable in works produced for private or gallery contexts but provoked controversy when presented in large-scale public sculpture, such as Carpeaux's group of *The Dance* on the façade of the Paris Opéra. MB

Vase

Manufactured by the Imperial
Porcelain Manufactory
Russian: St Petersburg, before
1862
Hard-paste porcelain, enamelled
and gilt
h 128 cm (50 in.)
9093–1862
Given by the Tsar Alexander II

From its foundation in 1744 the Imperial Porcelain Manufactory remained under the strict personal control of the Tsar, with the result that its products were of the highest quality, although anything but commercial. Partial autonomy achieved under Nicholas I (1825–55) did not lead to technical modernization, although to the continuing production of Empire-style porcelain was now added the influence of the revived rococo from western countries, as well as the copying of eighteenth-century Meissen and Sèvres models.

Alexander II in 1855 appointed a new director, and in the same year Karl August Lippold came from Dresden to train the factory painters in the tradition of copying Old Masters. Attempted improvements to the porcelain body were not successful and, because a quarter of the factory's output remained unsold each year, production was cut, necessitating the purchase of undecorated porcelain from other factories in order to fulfil commissions from the court. In 1871 the Tsarina ordered the ending of the traditional but stagnant range of products, suggesting in vain that the factory should alter direction and look to England for inspiration.

This massive vase well demonstrates the capabilities of the factory, which through Imperial patronage was able to concentrate upon developing a limited range of the biggest vases to be made in Europe during the nineteenth century: except for the use of interlaced geometric native Russian ornament, the vase is almost identical to those produced as early as the 1820s. The smooth painting style, showing Lippold's influence, is of the highest standard, and uses the technically perfect but conventional vase almost as an elaborate picture frame. The Tsar was entitled to three-fifths of the factory's output, including presumably this vase, which he presented to the South Kensington Museum after its showing at the Exhibition of 1862, the catalogue for which said of the St Petersburg vases that they were strongly influenced by Sèvres and were 'remarkable alike for their large dimensions and their admirable execution'. The portrait of the philosopher John Locke derives from the Kneller portrait of 1697, widely known from engravings. RJCH

Literature

H. HYVÖNEN, *Russian Porcelain*, Helsinki, 1982
Manufacture Imperiale de Porcelaine 1744–1904, St Petersburg, 1906

Candelabrum for six lights

By Antonio Salviati (1816–90)
Italian: Venice, c.1862
Clear and coloured glass
h 64 cm (25¼ in.)
9042–1863

Literature

PROFESSOR ARCHER in *Reports on the Vienna Universal Exhibition of 1873*, part III, London, 1874
GEORGE BONTEMPS, *Guide du Verrier*, Paris, 1868
Catalogue for the Kingdom of Italy, International Exhibition, London, 1862
Mille Anni di Arte del Vetro a Venezia, Palazzo Ducale/Museo Correr July 24–October 24 1982, Venice, 1982
ADA POLAK, *Glass, its makers and its public*, London, 1975
WALTER SPIEGEL, *Glas des Historismus*, Braunschweig, Germany, 1980

The nineteenth century saw a rejuvenation of glass-making in Venice. From the 1830s a small group of glassmakers, many of them descendants of old Muranese families, began attempts to rediscover the lost skills of their forebears. By the middle of the century Domenico Bussolin, Lorenzo Radi, and Pietro Bigaglia had succeeded in reinventing filigree glass and the Roman techniques of *calcedonio*, *avventurin* and *millefiori*.

However, the most commercial step in this direction came from Antonio Salviati, a lawyer from Vincenza. After working with Lorenzo Radi on the restoration of mosaics in St Mark's, he began in 1858 to make mosaics and vessel glass himself, using some of the best glassmakers and technicians of his time. Salviati explored various styles, drawing inspiration from the newly-founded glass museum in Murano.

At the London International Exhibition of 1862 he was awarded a medal for excellence of production. Among his 'mosaics and miscellaneous articles in glass, of a very important character' were pieces imitating chalcedony and aventurine and 'sculptured lustre glasses, with ornaments in white and coloured crystal'.

The South Kensington Museum acquired three such candelabra, of which this is one. It shows the fruits of Salviati's studies in the Murano museum, perhaps particularly of the works of the eighteenth-century Venetian glassworker Giuseppe Briati (d.1772). Briati too had briefly revived the Venetian glass trade, successfully combining the fashionable Bohemian style with the lighter Venetian tradition. Briati's chandeliers or *lampadario* consist of an architectural assembly of filigree columns, branches, and finials, with added fantastic flowers, feathers, and dangling fruit in coloured glass. Salviati has used all these elements, possibly copied closely from his own Briati pieces in his collection of Murano glass (now in the Royal Museum of Scotland).

We can judge the success of the imitation by comparing his candelabrum with the Briati chandelier at present hanging in gallery 131 of the Victoria & Albert Museum. Georges Bontemps in his historical and practical survey of glassmaking (1868) stated that modern Venetian glassworkers could not hope to equal their forebears. However, when he saw Salviati's display at the 1867 Paris Exhibition — which included similar candelabra — he admitted that Venice could still produce glass *chefs d'oeuvres*: 'All the glassworkers were struck by the incomparable dexterity with which these pieces were made.'

Salviati's glassworks were purchased in 1866 by the Englishmen Sir William Drake and Sir Henry Layard (the archaeologist), becoming a British holding company, Salviati & Co., Ltd. Salviati continued to rework ancient glass techniques and also received important commissions for mosaics in the Palatine Chapel, Aachen, Germany, Westminster Abbey, and this museum, among others. In 1872 the firm became the Venice and Murano Glass and Mosaic Co. Ltd (Salviati & Co.), which Salviati split away from in 1877 to work as 'Dr A. Salviati'. The original factory became known as the Venice and Murano Glass Co. The two factories had similar output, further refining Roman techniques and including iridescent glass and copies of German Roemers. The Salviati glassworks is still in production today. HB

Cabinet

Figures designed by Hilaire and Pasti, ornaments by Neviller
Manufactured by Henri-Auguste Fourdinois (1830–1907)
French: Paris, 1861–7
Ebony with solid inlay of box, lime, holly, pear, walnut, mahogany, and marble
h 249 cm (8 ft 2 in.); w 155 cm (5 ft 1 in.); d 52 cm (1 ft 8½ in.)
721–1869

Literature
D. LEDOUX-LEBARD, *Les Ébénistes Du XIXe Siecle*, Paris 1985

In terms of craftsmanship, this cabinet is the finest piece of nineteenth-century continental furniture in the collection. The *Art Journal Catalogue* of the Paris Exhibition of 1867 at which this piece was shown considered that 'It is impossible, either by pen or pencil, to do justice to the cabinet of M. Fourdinois, the *chef-d'oeuvre* of the exhibition, and certainly the best work of its class that has been manufactured in modern time, by any manufacturer ... The "grand prix" has been allotted to M. Fourdinois, and we believe, by universal consent of his compeers, for this, his latest and best production, is unrivalled.' It was also very widely published and praised in the publications and catalogues relating to the exhibition.

It was purchased from the exhibition by the South Kensington Museum for the immense price of £2,750. It was fully described by John Hungerford Pollen in his *Ancient & Modern Furniture & Woodwork* of 1874 which was the first catalogue of the museum collection. Pollen wrote, 'The work is in the somewhat loaded arabesque style of the Francis I or Henry II period softened with modern luxuriance ... on the right side we have Ceres, on the left Neptune—the earth and the sea. The columns are caryatides with female figures, and these represent the quarters of the globe; Europe and Asia on the right, America and Africa on the left ... The central panel ... represents the Temple of Peace ... The centre is topped by a pedimental niche ... In this stands the image of Minerva.'

The firm of Fourdinois was founded in 1835 by Alexandre-Georges Fourdinois (1799–1871) and continued in business under his son Henri-Auguste until 1887. It was one of the most important, both in Paris and in Europe, and manufactured furniture for the apartments of the Empress Eugénie at St Cloud as well as for the Imperial Palaces at Compiègne and Fontainebleau. The firm also worked for French noble families and many examples of their furniture survive, including a cabinet as elaborate as this one which is now in the museum at the Château of Compiègne. It showed at all the major international exhibitions, and the South Kensington Museum also purchased an elaborate Renaissance revival cabinet (2692–1856) at the Paris Exhibition of 1855 for £320. This cabinet is on display near the 1867 piece.

CW

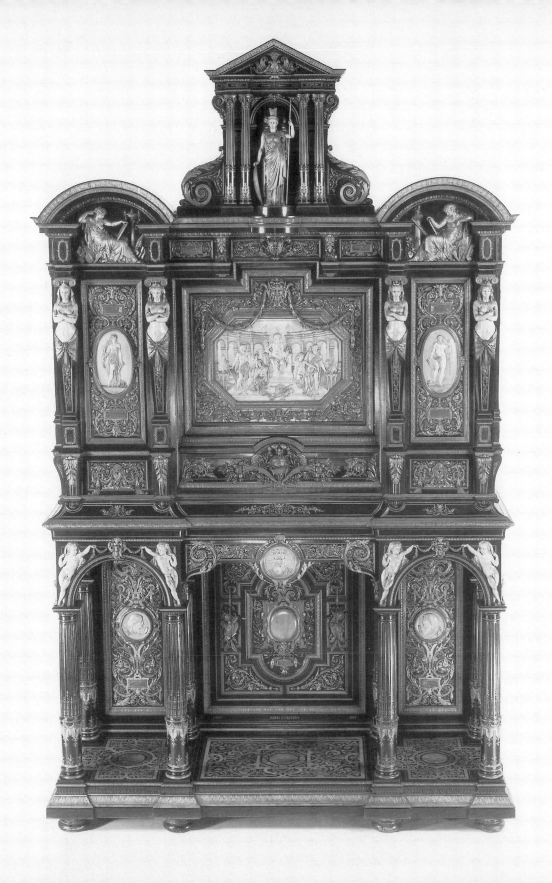

Vase and tripod

Manufactured by Ferdinand
Barbedienne (1810–92)
French: Paris, 1862
Gilt bronze and champlevé
enamel
h 78.8 cm (31 in.); w 26.7 cm
(10½ in.)
8026–1862

Literature

THEODORE CHILD, 'Ferdinand
Barbedienne Artistic Bronze',
Harper's New Monthly Magazine,
Vol.73, September 1886
'Gossip About the International
Exhibition', *The Builder*,
31 May 1862

Ferdinand Barbedienne was apprenticed at the age of twelve to a paper manufacturer and by 1834 had become one of the most successful wallpaper manufacturers in Paris. In 1838 he entered into partnership with Achille Collas (1795–1858) who, two years before, had invented a machine which applied the principles of the diagraph and the pantograph to the reproduction and reduction of sculpture in relief and in the round. Barbedienne started a new career as a bronze founder. His new firm, under the name Collas & Barbedienne, specialized in antique reproductions and developed new processes for patinations and coloured bronzes. Their exhibit at the London Exhibition of 1851, which included, reduced to half the size, a reproduction of Ghiberti's principal door for the Baptistery in Florence, brought them international acclaim, and thereafter, their success was assured. In the latter part of the nineteenth century the firm of Barbedienne became France's leading manufacturer of artistic bronzes.

Barbedienne was always interested in artistic and technical innovation. At the London International Exhibition of 1862 he introduced a range of enamelwork in Byzantine styles; this vase was one of the most spectacular examples. In his catalogue he erroneously described the technique used as 'cloisonné' whereas in fact it was much closer to 'champlevé'. The champlevé technique, which if anything is the reverse of cloisonné, creates a design by hollowing out the surface of the metal to leave thin ridges standing above the resulting troughs and channels. Enamel is then placed in the depressions and often several colours may be included in a single compartment.

This process requires a substantial thickness of metal and, therefore, is most appropriate for base metals such as copper and bronze. Barbedienne developed the traditional champlevé technique a stage further by casting the raised ridges with the body of the vessel, thus avoiding the laborious removal of the metal surface with a chisel or graver.

The design of this vase may have been executed by Constant Sévin (1821–88) who was already closely associated with Barbedienne, but no conclusive evidence exists for this attribution. It evoked considerable admiration when displayed at the 1862 Exhibition. The author of an article in *The Builder* wrote: 'Among the most beautiful objects designed merely for the purpose of ornament, are some vases exhibited by Mr. Barbedienne.' He continued by correctly identifying the source of the design: 'A specimen of this rich enamelwork is a metal vase, the whole surface of which is covered with a Byzantine arabesque, similar in character to the illuminations found in Greek manuscripts of the eleventh or twelfth century.' While fascinated by Barbedienne's enamelwork, the novelty clearly proved a little overwhelming:

> Both these objects are curiously beautiful; and their execution is so perfect in its finish, that they cannot fail to gratify the eye. But then comes the reflection, – Is not this kind of art retrogressive? Is not this accurate and slavish reproduction of old works a trammel calculated to impede the development of original genius in design? I fear it is.

However, the South Kensington Museum authorities were convinced of the vase's desirability and purchased it for the permanent collections for the price of £110. ET

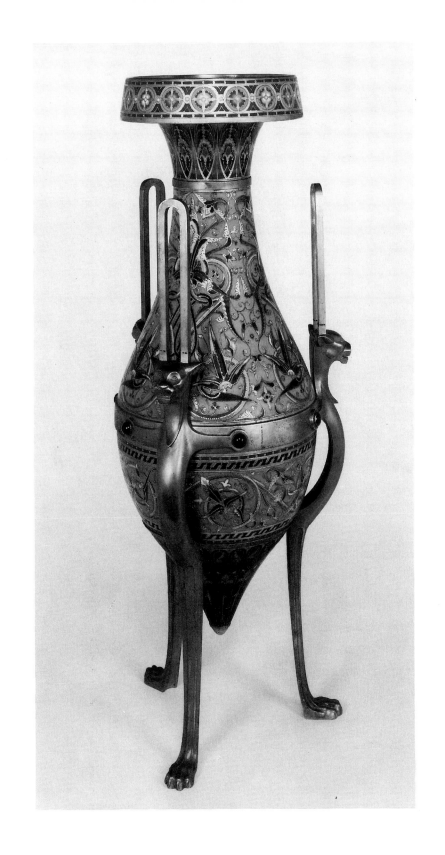

'Alhambra' Vase

Manufactured by
Joseph-Théodore Deck
(1823–91)
French: Paris, 1862
Earthenware with inlaid and,
possibly, painted decoration
h 104 cm (41 in.)
Marks: T.H. DECK 1862 painted
18–1865

Literature

PHILIPPE BURTY, *Chefs d'Oeuvre
of the Industrial Arts* (English
translation), London, 1869
International Exhibition, 1862,
Reports, Class XXXV.5, London,
1863
Real Academia de San Fernando,
Antiqüedades árabes de España,
Madrid, c.1780
J.B. WARING, *Masterpieces of
Industrial Art and Sculpture at the
International Exhibition, 1862*,
Vol.III, London, 1863

The first major display of work by Joseph Théodore Deck was included in the 1862 International Exhibition in London, where he was accorded considerable honours. Deck's pieces were singled out for special mention by John Burley Waring in his lavishly illustrated publication on the exhibition. Under the heading 'Artistic Earthenware', Waring commented that Deck was awarded a medal for a display in which 'the decorative ware designed after Oriental or Arabic models was exceedingly pleasing and effective. Some of these pieces are executed like the Henri Deux ware, that is, by an inlay of various clays but all are characterized by refinement, good taste, finish and brilliancy of tone.'

Deck, until his thirties, spent many years travelling Europe gaining useful technical experience as an assistant at a number of stove-tile factories from Germany through Austria to Hungary. By the time he settled in Paris, in the mid-1850s he was fully conversant with firing techniques and had gained the essential expertise on which to base his rapid artistic development. In 1858, when he established his own workshop with his brother Xavier in Rue St Jacques, he was able to indulge and build upon his passion for the richest and most exotic ceramic techniques of the past — the impressive inlaid wares of the Henri Deux period in France, Hispano-Moresque lustres, 'Persian' enamel colours, Chinese cloisonnés and *flambé* glazes and Venetian mosaics.

His introduction to the Islamic style and techniques was, apparently, due to Adalbert de Beaumont (d.1869), the traveller, Islamicist and collaborator with Deck's rival Eugène Victor Collinot (d.1882). From this introduction it was a short step to the Alhambra. Deck was to use Islamic or near Eastern forms and ornament with a generous artistic freedom, but in this example he was concerned to reproduce, or rather, to re-create the appearance of the original.

The Alhambra, the palace and fortress of the Moorish kings of Granada, Spain, was founded in 1248 and largely completed by 1354. After 300 years of neglect and deliberate destruction, restoration work began in 1828. Its elaborate architecture excited a great deal of interest, disseminated most notably by the *Plans, Details and Sections of the Alhambra*, published by Owen Jones from 1836. Of the original furnishings of the palace, some vases survive, all but one in museums in Spain and around the world. The most famous, the only one still in the Alhambra, was made in the late fourteenth century and is here copied relatively accurately by Deck. It was known from the seventeeth century and engravings were made of it and the other then surviving example and published in Madrid in the late eighteenth century. The second vase was destroyed, possibly by an earthquake, by 1834 when Owen Jones made drawings which he published two years later. Both vases were freely interpreted by Deck's contemporaries, including both individual potters such as Jules Claude Ziegler (1804–56) and Edouard D. Honoré (d.1885) and the factories of Berlin and Sèvres. For the designs they used Jones's published engravings as well as other sources supplied by writers such as Jean Charles, Baron Davillier, and, in England, Joseph Marryat.

In his display in the 1862 exhibition, Deck launched his technical achievement in inlaid ware with this full size copy of the 'Alhambra' vase, earning the comment, 'the vase in the Alhambresque character is deserving of great commendation'. The curiosity of combining the appearance of a medieval French technique with a Hispano-Moresque subject escaped comment. The method appears to be a combination of inlaid brown clay into the cream coloured body with painting in enamels in two different blues. The medieval technique was to entirely inlay the clays. A blue would not have been in use.

Although the Museum's example was bought from Deck some three years later (for £60) it is dated 1862 and it seems reasonably certain that this is the same vase. JHO

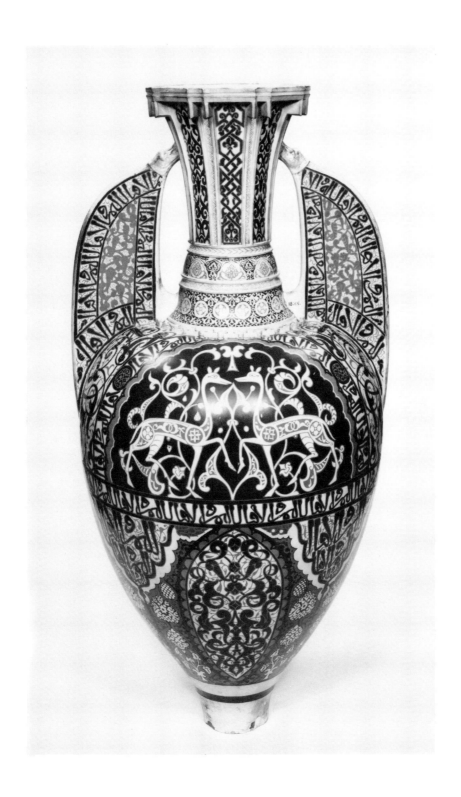

Cabinet

Manufactured by Anthony
Kimbel and Joseph Cabus (both
active 1863–82)
American: New York, c.1876
Cherrywood, with ebonized, gilt,
and painted decoration,
coppered metal fittings, mirrors
and red plush lining
h 207.9 cm (6 ft 8⅞ in.); w 134 cm
(4 ft 4¾ in.); d 49.8 cm (1 ft 7⅝ in.)
W.50–1984

See colour plate on page 120

This drop-front, glazed cabinet with 'what-not' shelves is representative of Kimbel and Cabus's modern Gothic style of furniture. It bears the elaborately shaped and incised coppered brass strap hinges they used on many cabinets. It closely resembles another cabinet, dated 1876, now in the Cooper-Hewitt Museum in New York. Both cabinets are expressly architectural, with turned columns and a flying-buttress crest lined in red plush (which has discoloured over the years). The inset immediately above the vitrine is a scene of two cupids, painted and gilded. (When this cabinet arrived at the Victoria & Albert Museum this panel had been over-painted black, possibly to conform to later tastes.) On either side of the painted inset is a stand intended to hold small pots or candles. Mirrors flank the painted panels and would have provided reflected views of the objects displayed on the shelves in front of them. The lockable vitrine would have been used to display more valuable or vulnerable objects. Below the vitrine, two open shelves are flanked by lockable doors inset with painted panels. On the left a night owl is depicted perched on a branch with a bat hovering overhead in a starry sky. The scene is illuminated by a crescent moon. On the right are two birds, with the rising sun at the bottom. These painted panels may have been supplied by the English designer, J. Moyr Smith (active 1868–94).

Almost every surface of Kimbel and Cabus cabinets was decorated with incised linear and geometric patterns. In place of the painted panels, set-in tiles made by the Minton-Hollins Company of England were often used, as well as inlaid marquetry panels. These ornamental additions, common in English furniture of the period, were rarely found in American work.

The partnership of Kimbel and Cabus is first listed in 1863 where the New York directory places them at 924 Broadway. The furniture made during their partnership, between the years 1863 and 1882, is distinguished by its architectural form, incised linear and geometric surface decoration, and turned columns, expertly rendered, as in this cabinet. This cabinet was made at about the time of the Philadelphia Centennial Exhibition of 1876 in which Kimbel and Cabus displayed an entire drawing room, complete with fittings and furniture of ebonized cherry.

Most of the pieces produced by Kimbel and Cabus in 1876 were inspired by the work of the English designer and writer Charles Lock Eastlake (1836–1906). His name became a household word in America in 1872 with the publication of *Hints on Household Taste in Furniture, Upholstery and other Details* (England, 1868). A philosophic treatise, this book expounded on domestic aesthetics and utility at the lay level. It offered detailed advice on household design and ornamentation. Eastlake's influence is seen in the incised geometric and stylized floral decoration, the squared-off lines, and the use of spindles. The influence of Eastlake brought a new rectilinear simplicity to the pieces produced in the 1870s and 1880s. In contrast to the curved shapes, ostentatious decoration, and heavy naturalistic carving of earlier styles, the new look featured relatively simple and functional lines. Kimbel and Cabus were also influenced by the book of furniture design plates, *Gothic Forms Applied to Furniture, Metalwork and Decoration* (1867), by the Scottish designer Bruce J. Talbert (1838–81). A distinct departure from the Renaissance revival styles, the Eastlake style of furniture was one of the most popular fashions in American interior design during the last quarter of the nineteenth century. VJV

Coffee pot, creamer, and sugar bowl

Designed by Edward Chandler
Moore (1827–91)
Manufactured by Tiffany and
Company (1837–present)
American: New York, c.1877
Silver, with various base metals
applied
Marks (on the underside of each)
and dimensions
Coffee pot
TIFFANY & CO./3401 MAKERS
441/STERLING SILVER/AND/
OTHER METALS/447
h 21.5 cm (8½ in.); l (incl. handle
and spout) 12.7 cm (5 in.)
Creamer
TIFFANY & CO./4759
M.438/STERLING SILVER/
AND OTHER METALS/5143/PATENT
APPLIED FOR
h 7 cm (2¾ in.); l (incl. handle and
lip) 9 cm (3½ in.)
Sugar bowl
TIFFANY AND CO./4759
M.438/STERLING SILVER/
AND OTHER METALS/388
h 5.5 cm (2⅛ in.); diam 11 cm
(4⅜ in.)
M.26–b–1970

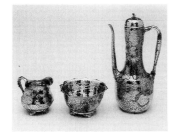

See colour plate on page 121

Literature
CHARLES H. CARPENTER JR. with
Mary Grace Carpenter, *Tiffany
Silver*, London, 1979

Charles Louis Tiffany and his partner John B. Young established their 'fancy articles and curiosities' shop in 1837. Despite starting in the middle of an economic depression, at a then unfashionable address, they managed to prosper by exercising a shrewd business acumen and an imaginative sense of style. They successfully anticipated the public desire for exotic foreign goods and began importing not only from Europe but also from Japan, China, and India. In 1841 they were joined in partnership by J.L. Ellis and in 1848 they brilliantly exploited the political upheavals in Europe by investing heavily in the Parisian diamond market. That year they launched themselves as jewelry manufacturers and, at about the same time, began the manufacture of silver. By the 1870s they were among the leading suppliers of silver and jewelry in the world.

In the beginning it was their custom to commission most of their silverware from independent New York silversmiths. In 1851 they made a contact with the firm of John Chandler Moore to produce hollow-ware exclusively for Tiffanys. In that same year Moore's studio was taken over by his son Edward Chandler Moore who was to exert the dominant influence on Tiffany's production of silverware for the next forty years. In 1852 Edward Moore persuaded Tiffany's to become the first American Company to adopt the English sterling standard. By 1868 Moore's business was so intertwined with the requirements of Tiffany's that they purchased his studio outright, appointing him as general manager of the company's silverware production as well as making him a director of the firm. From 1868 until his death in 1891 the letter M was used on the Tiffany stamp in recognition of Moore's position.

Moore was a brilliant designer, committed to craftsmanship and with widely ranging intellectual interests. He assembled an extensive collection of Oriental, ancient, and medieval art objects, along with a library numbering over 550 volumes which included numerous Indian and Japanese textile sample books. His collections, which he bequeathed to the Metropolitan Museum of Art, provided an invaluable source of prototypes for his own designs. After his visit to the Paris Exhibition of 1867 he became particularly fascinated by Japanese sword furniture and acquired numerous examples himself, probably in part through Christopher Dresser who collected a large number of Japanese objects for Tiffany and Company in 1876, the majority of which were auctioned off in the following year.

Equally significant in the evolution of the design of the service illustrated here was Moore's important collection of fourteenth-century Saracenic metalwork. The shape of the coffee pot is based on an Islamic prototype, while the sugar pot and creamer follow a more conventional European pattern. The decoration on all three vessels, however, is clearly derived from Japanese sources. The hammered surface used here and for several other services designed by Moore in the Anglo-Japanese style was described by one writer in the *International Review* as giving 'an appearance not unlike that possessed in Japanese "crackle pottery".' The mixed metal appliqué ornament combining vines with leaves and gourds and various insects was directly adapted from the decoration of Japanese sword guards. The design has been achieved by small decorative elements of assorted metals affixed to the surface and, in the case of the gourd shape overlaid on the throat of the coffee pot, copper and silver have been blended using a traditional Japanese technique to give a polychromed surface.

Moore's daring innovation of mixing base and precious metals in his silverware designs for Tiffany was a revelation when it was displayed at the Paris International Exhibition of 1878. Siegfried Bing, the Parisian dealer in Japanese art who was later to be influential in the promotion of Art Nouveau, commented that 'the borrowed elements were so ingeniously transposed to serve their new function as to become the equivalent of new discoveries'. Tiffany's virtually had the field to themselves. The British could not compete because their strict hallmarking laws forbade the combination of precious with base metals, but such regulations did not apply in the United States, enabling Tiffany's to create some of the most innovative metalwork of the century. ET

The Visitation, after Ghirlandaio

Made at the Gobelins
Manufactory
French: Paris, 1874–6
Tapestry-woven picture in wool,
silk and gold thread on cotton
warp; approx. 10 warp threads
to the cm (24 to the in.)
h 229 cm (7 ft 6 in.); w 224 cm
(7 ft 4¼ in.)
185–1881
Given by the Government of the
French Republic

Literature
MAURICE FENAILLE; 'Etat
général des tapisseries de la
Manufacture des Gobelins depuis
son origine jusqu'a nos jours,
1600–1900, V (Période du dix-
neuvième siècle 1794–1900 by
Fernand Calmettes) Paris, 1912

A large proportion of the tapestries woven at the Gobelins in the nineteenth century were copies of existing paintings rather than designs made specifically for tapestry. Such copying was prevalent from the beginning of the century, as can be seen from the tapestry of *Arria and Paetus*, after a painting by Vincent dated 1785, hanging at the entrance to this gallery. The appointment of Alfred Darcel from the Louvre as Director of the Gobelins manufactory in 1871 increased this propensity. His decision to copy the fifteenth-century painting of *The Visitation* by Ghirlandaio in the Louvre, among similar copies of Old Masters, prompted Philippe de Chennevières, Director of the Beaux-Arts, to write to Darcel suggesting that *'nous faisons fausse route'* in making such copies and that they might leave a better impression of their administration if they were to reproduce in tapestry contemporary masterpieces rather than works of the past, whatever prodigious skills these elicited from craftsmen at the Gobelins. This led to far more active employment of contemporary artists to design tapestries.

It was widely accepted by those who reported on the international exhibitions of the 1850s to 1870s that *The Visitation* and similar copies, such as *The Holy Family* after Raphael (also in this gallery) were indeed masterpieces of subtle weaving with wools and silks dyed in accordance with 'the perfection of chemical science'. George Wallis, most communicative of the heads of the English Schools of Art, wrote of the Paris Exhibition of 1855: 'If we were asked in what department of industry the precision of science was most perfectly united with the sentiment and beauty of art, our reply would be "In the tapestries of the Gobelins, and of Beauvais".'

The labour involved in making *The Visitation* is reflected in the time the project took. Mademoiselle Houssay provided a painted copy to work from in November 1873. Charles Lameire, much in demand as a decorative painter of churches, had by March 1874 provided the design for the border in an Italian late-fifteenth-century style to harmonize with the painting. Weaving was begun on 19 June 1874 and completed only on 16 July 1876. The mark of the Gobelins, a 'G' and a bobbin for weaving, was proudly displayed in the centre of the top border; and the *chef du pièce* Edouard Flament 'signed' the tapestry in the lower right corner.

An obvious candidate for exhibition, the tapestry was shown twice in Paris, at the Exposition de l'Union centrale des Beaux-Arts appliqué à l'industrie, in 1876, and at the Internation Exhibition of 1878. What should then be done with it? A church or a museum seemed most appropriate; and in 1880 the French government decided to make it part of a most generous gift of Sèvres porcelain and tapestry to the South Kensington Museum. Included in that gift was the tapestry chair seat of 1872 (displayed below *The Visitation*) designed by Jules Diéterle, who in 1877 became Director of the Beauvais National Manufactory. By his influence at Beauvais, Diéterle also helped to diminish the dependence of French tapestry on copying older work and to introduce more original contemporary designs.

WH

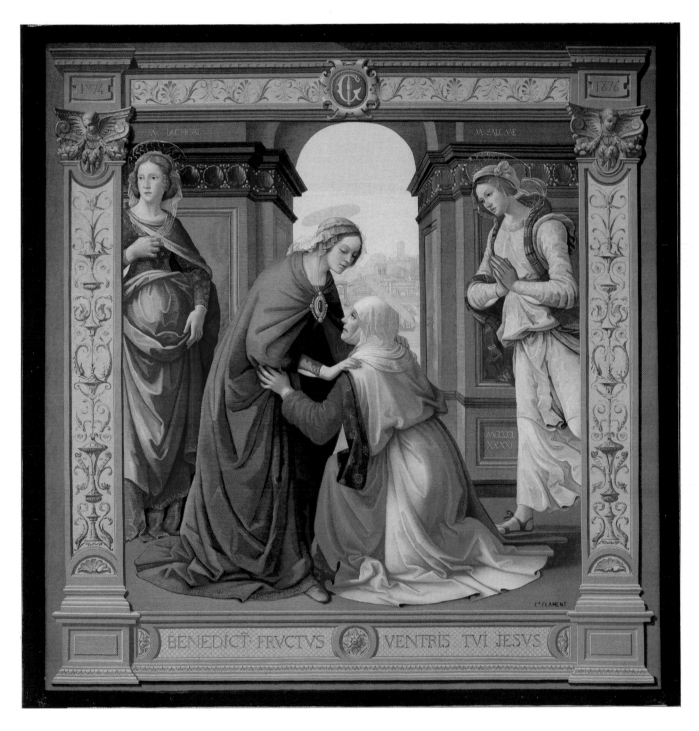

119

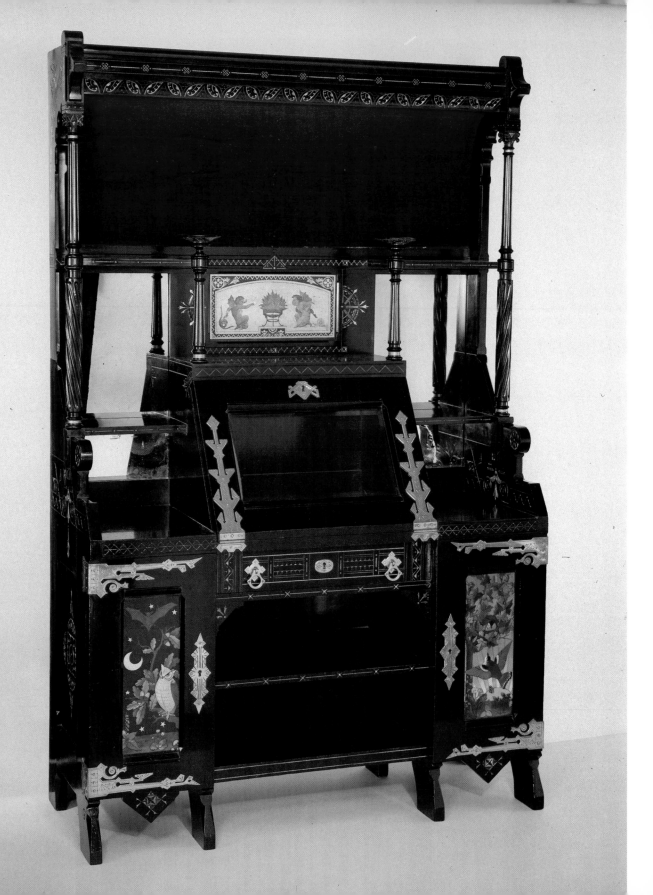

Cabinet manufactured by Anthony
Kimbel and Joseph Cabus (*see* page 116)

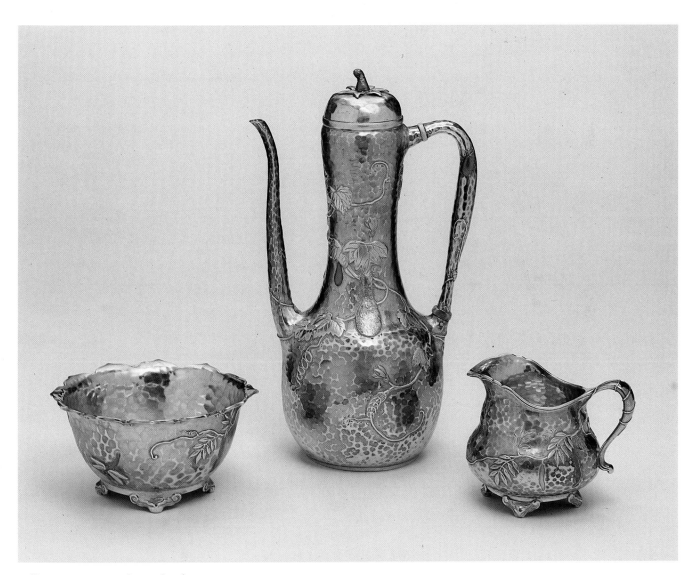

Coffee pot, creamer, and sugar bowl
manufactured by Tiffany & Co. (*see* page 117)

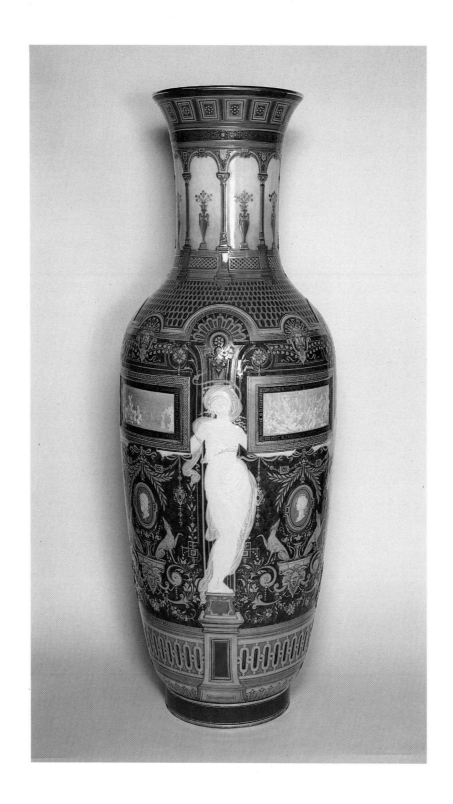

Vase Potiche AB

Designed by Alexandre-Paul Avisse (active 1848–1884)
Figures composed and executed by Taxile Maximin Doat (1851–1939)
Ornaments composed and executed by Charles Céléstin Lucas (active 1865–1910)
Manufactured at Sèvres
French: Paris, 1879–81
Porcelain with *pâte-sur-pâte* decoration
h 97.5 cm (38⅜ in.)
Marks: s83 within a cartouche, printed in green; DECORE A SEVRES 84 and RF in monogram, printed in red within a circle 49–1885
Given by Mons. le Ministre de l'Instruction Publique et des Beaux Arts

Literature

AILEEN DAWSON, 'Pieces for Presentation', *Ceramics*, Feb/Mar, 1986
Keramic Studio, vol. V 1903–4
Sèvres factory records

Pâte-sur-pâte decoration, an extremely expensive and time-consuming method of applying layers of liquid clay, allowing each layer to dry before the next application, had been developed at Sèvres in the late 1840s under Louis-Robert Rémy (active 1832–79), head of the painting and gilding workshop at the factory. The technique was first exhibited at the Exposition des Manufacture Nationales, Paris, in 1850 and then at the International Exhibition in Paris of 1855. The South Kensington Museum bought an example of it: a large *tazza* entitled *Coupe de Pise* and decorated by Hyacinthe-Jean Regnier (1803–70). Several of the Sèvres artists specialized in the technique and spread its use to other factories. Marc Louis Emmanuel Solon (1835–1915) brought it to England when he joined Mintons in 1870.

At Sèvres one of the most skilled and imaginative practitioners of *pâte-sur-pâte* was Taxile Doat who joined the works in 1877 as a sculptor after training at the Ecole des Arts Decoratifs at Limoges and at the Ecole des Beaux Arts in Paris under the sculptor Augustin-Alexandre Dumont (1801–84). Doat was unusual in that he published a number of treatises on the techniques of *grand feu* firing (at high temperatures) and on the development of the ceramic arts particularly in France. He wrote generously about his contemporaries although he clearly did not like Joseph-Théodore Deck (1823–91) as Director of the Manufactory (1887–91). His prolific writings drew the attention of the American potters Adelaide and Samuel Robineau who translated his work on 'Grand Feu Ceramics' and published it in their journal *Keramic Studio*. In 1909 he was invited by them to travel to St Louis, Missouri, to assist with the establishment of the University City pottery and it was during his time there that Adelaide and Samuel Robineau produced their most famous work, the Scarab vase.

According to Sèvres factory records, Alexandre-Paul Avisse's design for this vase was inspired by the style of Jacques Androuet DuCerceau (*c*.1515–after 1584), a prolific designer and publisher of ornaments. DuCerceau's first designs, *Arches* produced in Orleans 1549, was followed the next year by *Temples*, and thereafter by ornament, furniture and furnishings, tableware, and architecture of all types. Within the classic Chinese proportions of the *Potiche* vase form, Avisse assembled an eclectic mixture of renaissance ornamental motifs. The vase form was introduced to Sèvres in 1869, the AB of the title representing Alexandre Brongniart, Director of the factory (1800–47).

Decorated by Doat and his assistant Lucas, work on this vase began in July 1879, continued intermittently, and was finally completed by November 1881. According to factory records it was valued at 10,000 francs and offered for sale in December 1883. In 1884 it was shown at the eighth exhibition of the Union Centrale des Arts Decoratifs, Palais de l'Industrie, Paris. Later that year it was included in the major gift from the national manufactories by the French government to Britain. The factory's notification to the Museum of the gift records the names of the designer and artists and that this vase was the second size. The first size, of which an example is not known to exist, must have been of monumental proportions. The discrepancy between the dates provided by the factory archive and the printed marks on the vase itself make it clear that the vase was stamped on its entry into the saleroom, irrespective of the actual dates of manufacture and decoration. JHO

Teapot

By Antoine Tard (active after
1860)
Manufactured by Christofle and
Company (1831–present)
French: Paris, 1867
Cloisonné enamel on copper
alloy, parcel-gilt
h 11.5 cm (4$\frac{1}{2}$ in.); w 18.7 cm
(7$\frac{3}{8}$ in.)
722–1869

Literature

J. MESUARD, Les Merveilles de
l'Art et de l'Industrie, Paris,
1869–70
Rapports, Exposition Universelle
de 1867, Paris, 1867

Little is known about Antoine Tard's early career. He is credited with re-introducing the technique of cloisonné enamel in nineteenth-century French metalwork. The difference between the various enamelling techniques lies chiefly in the methods used to prepare the metal surface for the enamel. With cloisonné (cell-work) thin strips of metal are bent to form the outline of the design and are soldered edge-on to the surface of the metal object. The resulting cells are then filled with enamel and often restricted to one colour per cell.

Tard's efforts were brought to the attention of Paul Christofle and Henri Bouilhet who commissioned him to execute a series of objects which were displayed on their stand at the Paris Exhibition of 1867. This series includes a teapot (illustrated here), coffee pot, sugar bowl, and a plate which must have been their first production prototype. The centre of the plate is inscribed in cloisonné enamel: 'EMAUX/ à cloisons rapportées/CHRISTOFLE & CIE/PARIS/ 1867/TARD EMAILLEUR'. The decoration is either of Persian or Indian inspiration and is further evidence of the influence of the Near and Far East on the French decorative arts. All these pieces were acquired directly from the manufacturer at the close of the exhibition for the South Kensington Museum.

Tard also executed a series of cloisonné-enamelled pieces for the goldsmith Emile Phillipe which were displayed at the Paris Exhibition of 1867. The novelty of his work was greatly applauded and it drew praise in particular in the Exhibition Reports for its delicacy of design and the quality of the colour separation achieved. Tard continued his association with Christofle after the exhibition, executing an increasingly elaborate series of designs in the Japanese style by Emile Reiber, the head of the Christofle design studio. At the same time he enamelled gold jewelry, using the cloisonné technique, for Lucien Falize. This won him a bronze medal at the Paris Exhibition of 1878. Other jewellers who employed him were Baugrand and Boucheron.

Charles Christofle (1805–1863) began his career in 1814, when his family's silk factory in Lyon was bankrupted and he was forced to relinquish his studies. He moved to Paris and became apprenticed to the jewelry firm founded in 1812 by his brother-in-law Calmette. In 1825 he was made a full partner and by 1831 was in sole charge of the firm. His first success was with the manufacture of jewelry especially for export, which won him a gold medal at the Exposition des Produits de l'Industrie in 1839. In 1842 he obtained exclusive French rights to the patents taken out in 1840 by the Elkington brothers of Birmingham for the commercial application of the electroplating process. These rights lasted for ten years during which he had to fight a succession of acrimonious law suits in order to preserve them, but the lead he obtained in the French market for electroplated goods secured the foundation of his fortune. By 1855 his factory employed over 1,200 workers and he established a second factory in Karlsruhe in 1859. He was made an officer of the Légion d'Honneur in 1862 and died the following year. The business devolved to his son Paul Christofle (1838–1907) and his nephew Henri Bouilhet (1830–1910).

Paul Christofle devoted himself to the administration and commercial promotion of the firm while Henri Bouilhet, who trained as a chemical engineer at the Ecole Centrale des Arts et Manufactures before being employed by his uncle, assumed control of the manufacturing side of the business. It was Bouilhet who was largely responsible for increasing the firm's artistic production and for the technical innovations introduced over the next few years. He played an important role in Union Centrale des Arts Décoratifs and produced a series of important publications on the history of French nineteenth-century silversmiths.

The firm of Christofle and Company still flourishes and remains one of the most important European producers of silver and electroplate.

ET

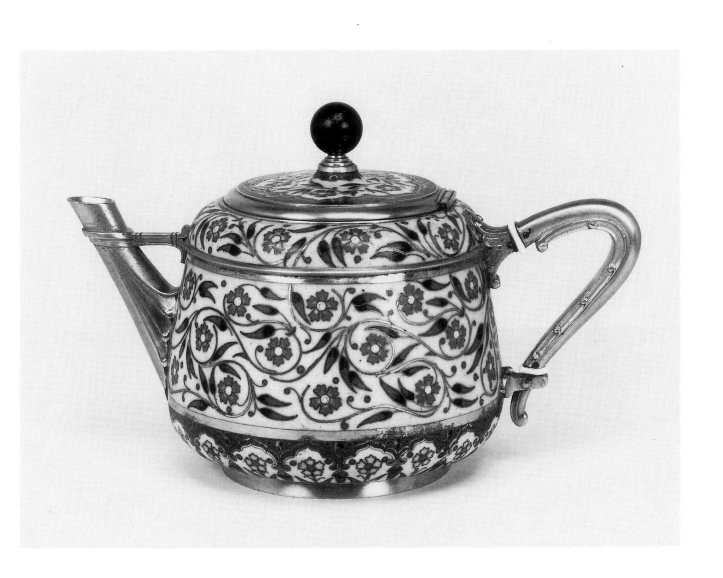

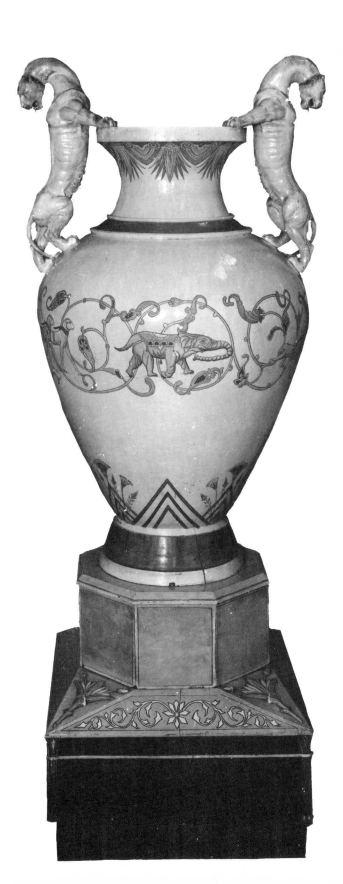

Vase and pedestal

Possibly designed by Adalbert
de Beaumont (d.1869)
Manufactured by Eugène Victor
Collinot (d.1882)
French: Boulogne-sur-Seine,
1867
Earthenware with painted and
enamelled decoration
h 195.5 cm (77 in.)
Unmarked
744–1869

Literature
PHILIPPE BURTY, *Chefs d'oeuvre
of the Industrial Arts* (English
translation), London, 1869
E.V. COLLINOT and A. DE
BEAUMONT, *Recueil de dessins
pour l'art et l'industrie*, Paris,
1859
*The Illustrated Catalogue of the
Universal Exhibition, the Art
Journal*, London, 1868
Paris Universal Exhibition 1867.
Reports, II and III, London and
Paris, 1868

E.V. Collinot's first collection of oriental and
orientalizing designs was produced in 1859.
It was the direct result of his travels with
Adalbert de Beaumont whose interest in Middle
Eastern ornament had already been aroused
by an earlier work on the origin of heraldry.
The publication covered designs from Islam,
the Far East, and Venice and was later, in 1880
and 1883, extended further to illustrate motifs
from as far afield as Russia. Some examples of
Collinot's subsequent ceramic production may
be traced directly to this collection.

Collinot established a faience pottery with
de Beaumont in 1862 at Boulevard d'Auteuil,
Parc-au-Princes, Boulogne-sur-Seine (now
Boulogne-Billancourt). The building was a
model one for the factory and its owner. It
was faced with ornamented tiles in white with
blue relief lettering proclaiming verses from
the Koran and is featured as a frontispiece
to the collection of designs in an etching by
de Beaumont.

Within a year, Collinot was exhibiting at
the Union Centrale, showing Persian-style
faience to de Beaumont's designs. Both men
were awarded medals, Collinot for his pro-
duction, de Beaumont for 'the promotion of
the Industry in France' and for 'publications
which furnished industries with models of
Persian ornament'. De Beaumont was concerned
with textiles as well as ceramics and in 1861
was pressing for a museum of eastern textiles
and various reforms in the industry.

By 1865 Collinot had achieved an impress-
ive award, a decoration by the Shah of Persia
for his contribution to the revival of Persian
ceramic art. Two years later, in 1867, his dis-
play at the international exhibition was an
outstanding triumph. This vase and pedestal
was included, as were a number of other
examples in the Victoria & Albert Museum's
collections. Although described as 'Persian'
by Collinot it is very freely based on gen-
erally Middle Eastern motifs, none of them
from an identifiable source. Nevertheless, he
was awarded a silver medal for his display.

Adalbert de Beaumont encouraged Joseph-
Théodore Deck (1823–91) in his first pro-
duction of Islamic-style pottery in 1858 and
also supplied him with designs. De Beaumont's
collaboration with Collinot began shortly after.
There was, necessarily, at least a working re-
lationship between Deck and Collinot but by
1867 their rivalry had reached a less than
friendly pitch. Both men saw themselves as
technical experts and when Collinot called
'cloisonne' his method of firing raised enamel
decoration within flat outlines of a copper
compound Deck accused him and de Beaumont
of inaccurately claiming a cloison effect and
of using designs which were unauthentic, as
he certainly has in this so-called 'Persian' vase.

Some additional and official criticism was
offered of Collinot's display. Minton's Art
Director, Léon Arnoux, had come from France
in the 1840s and quickly established himself in
the Minton factory and as a writer and auth-
oritative committee member. He reported on
the Paris Exhibition and criticised Collinot's
production: 'Mr Collinot has only applied the
Persian process [enamel colours over a tin glaze
under a clear glaze] in one of the panels which
is the richest in effect … in the other parts as
well as in his vases, whilst keeping to the
Persian style, he has adopted the use of opaque
coloured enamels; this causes his productions
to look less transparent than those of Mr Deck.'

Nevertheless, the French report by A. Girard
was extravagant and *The Art Journal* was
equally enthusiastic: 'Works of high order, not
alone in design … M. Collinot is a true artist';
and it illustrated an 'Arabic mural fountain of
considerable dimension'.

Presumably deciding against the fountain,
the Museum bought this vase for 3000 francs
and three other large items from Collinot's
display; a frame (701–1869) and columns
(746&A–1869) in Persian style and a large panel
of tiles (745–1869) decorated with Japanese
subjects. JHO

Vase and cover

Designed by Emile Auguste
Reiber (1826–93)
Manufactured by Christofle and
Company (founded 1831)
French: Paris, 1867
h 30.5 cm (13¾ in.)
Copper inlaid with silver, the
stand of gilt bronze
700–1869
Given by Messrs C. Christofle
and Company

Reiber was born in Schlettstadt in Alsace. In 1847 he started studying architecture in Paris and in 1850 was awarded the Grand Prix; thereafter he became increasingly involved with industrial design. In association with the ceramist Théodore Deck (1823–91), in 1851 he founded the influential periodical *L'Art Pour Tous*, which specialized in the application of art to industry.

Reiber was distinguished for his ability to assimilate rapidly a whole range of historical styles. He drew with equal facility from ornament of the German Renaissance, the Louis XVI period, and the antique. He supplied a range of Islamic designs for the London Exhibition of 1862 and was fascinated by Japanese art which was beginning to emerge in Paris from the late 1850s.

In the early 1860s he joined the Christofle design studio and by the end of the decade he was placed in charge of it. Reiber's influence made Christofle one of the earliest and most important suppliers of *Japonisme* metalwork.

The oriental shape of this vase, based on a traditional Japanese ceramic pot, the use of inlaid metal, and the deliberate patination of the vessel all register the influence of the Japanese decorative arts. The gilt bronze stand in a Louis XVI style is a reference to the eighteenth-century French custom of mounting imported Chinese ceramics in ormolu.

There was still some confusion between the arts of China and Japan at this time. Ernest Chesneau, in an article 'Le Japon à Paris' for the *Gazette des Beaux Arts* in 1878, recalled the dearth of knowledge of the two cultures prior to 1867: 'curiosities coming from the Far East that one indistinctly con-

fused under the name chinoiserie.' The Paris Exhibition of 1867 included an exhibit sent by the Japanese government that constituted the first major display of Japanese art seen in France. This radically altered the public perception of Japanese art and, at the close of the exhibition, many of the objects were dispersed on the Parisian market, thus further encouraging interest in the field.

But Japanese prints had been available in quantity in Paris since the late 1850s. Two principal sources of supply were Le Porte Chinoise of 36 Rue Vivienne and Desage on the Rue de Rivoli. By the 1870s, and possibly before, they were even being sold through large Parisian department stores such as Le Bon Marché. Equally important was Auguste Delâtres publication of *Receuil de dessins pour l'art et l'industrie'* by Adalbert de Beaumont and Eugène V. Collinot in 1859. This folio album included eighteen engraved plates of Japanese birds, flowers, insects, marine life, *samurai*, and landscapes largely based on Hokusai prints. Reiber's design for the inlaid silver on this vase could have been drawn from either Delâtre's publication or any one of the original albums of prints which were in circulation.

The design of this vase, therefore, amalgamates a variety of sources and is an early metalwork example of *Japonisme*, the influence of Japan on the French decorative arts. In its opening stages, the attitude of the early *Japonistes*—and Reiber was one of the most important among them—was that Japanese art provided yet another source of inspiration for the historic revivalism so prevalent among the decorative arts at the time. ET

Literature
Japonisme, Japanese Influence on French Art 1854–1910,
Cleveland, 1975

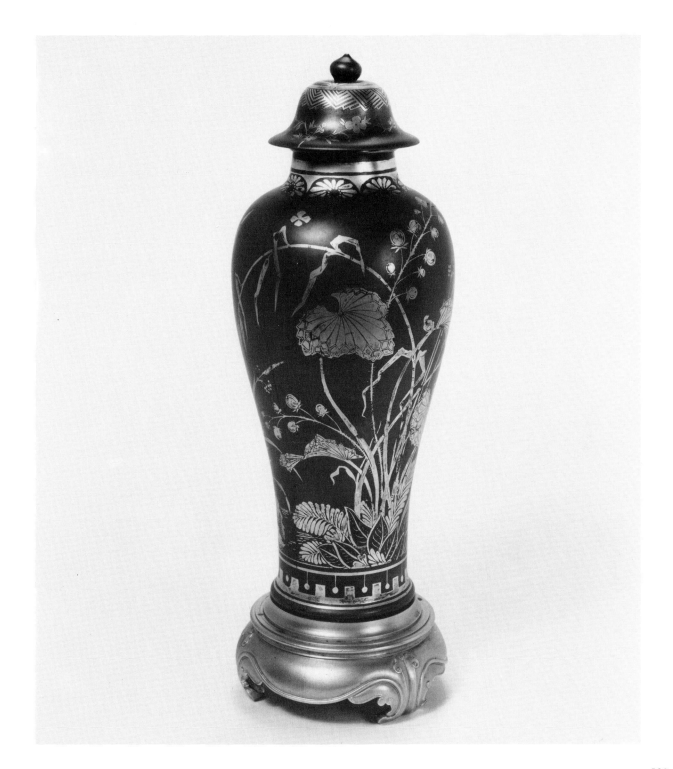

Mrs H.J. Turner

By Jean Baptiste Carpeaux
(1827–75)
London, 1871
Marble
h (incl. marble base) 81.5 cm
(32 in.)
Inscribed 'JBte Carpeaux' on
back of base
A.19–1984
Given by Miss Jessica Turner to
the Tate Gallery and transferred
to the Victoria & Albert Museum

Literature
A.M. WAGNER, *Jean Baptiste
Carpeaux. Sculptor of the Second
Empire*, New Haven and London,
1986
R. ALLEY, *Tate Gallery
Catalogues. The foreign paintings,
drawings and sculpture*, London,
1959

Carpeaux's early career was difficult and, despite his undoubted brilliance as a sculptor, his work did not initially find favour among the academicians who controlled the elaborate system of artistic training and official patronage in nineteenth-century France. By the 1860s, however, he had established himself as the leading sculptor of the French Second Empire and received commissions for many portrait busts and for some of the major projects for public sculpture in Paris, notably a group for the new Opéra. From 1866 he ran a workshop producing reductions in terracotta of his own sculptures as well as small figures and groups intended for serial production. His work may therefore be seen to represent many of the different types of sculptural activity demanded in mid-nineteenth-century France.

The bust of Mrs Turner was commissioned and executed while Carpeaux was in exile in England during the Paris Commune in 1871. The plaster model (in the Carlsberg Glyptothek, Copenhagen) is dated 1871 and the companion marble of Mr Turner is dated 1873, when the sculptor returned to England to model a bust of the exiled and dying Emperor Napoleon III. Mr Turner, the owner of a firm manufacturing paint and varnishes, formed a substantial art collection that included other works by Carpeaux as well as oils by contemporary continental painters.

For his portrait of the vivacious Mrs Turner, Carpeaux adopted a style and type of bust composition that were characteristic of portrait sculptures of the 1750s. The brilliant depiction of the sitter's fashionable dress and the virtuoso carving of the marble surface, which retains the vibrancy of the sculptor's original model, make this not an historicizing exercise in an earlier style but a reworking of an eighteenth-century idiom to perform new functions. Patrons such as Mrs Turner, whose newly created wealth often came from industry and trade, frequently had themselves represented in an eighteenth-century aristocratic manner, a choice that reflected a need in the society of both the French Second Empire and England of the 1870s to identify with the traditions of an earlier age. MB

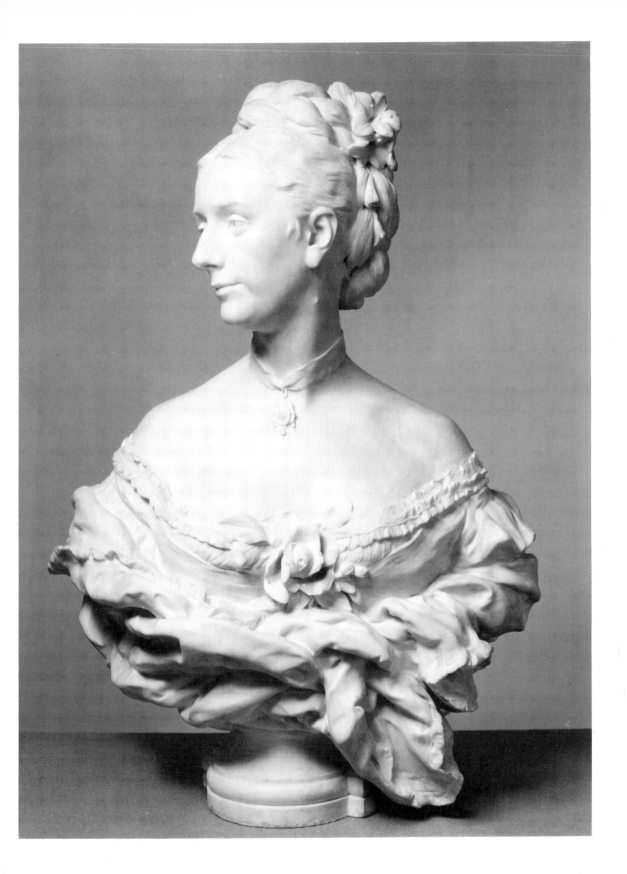

Heron Service (Hejrestellet) icebucket

Designed by Pietro Krohn
(1840–1905)
Modelled by Ludvig Brandstrup
(1861–1935), Carl Oluf Schjeltved
(1829–91), Erdmann
(dates unknown)
Manufactured by Bing &
Grøndahl
Danish: Copenhagen, 1886–8
Porcelain with moulded
decoration, painted in
underglaze blue and gilding
h 26 cm (10$\frac{1}{4}$ in.)
Marks: B painted in underglaze
blue, W.M. painted in gold
C.236–1986

Literature
Exposition Universelle
Internationale 1889, *Rapports*,
Paris, 1891
ERIK LASSEN, *En Københavnsk
porcelænsfabriks historie Bing &
Grøndahl 1853–1978*.
Copenhagen, 1978

By 1880 Jacob Herman Bing's two sons Ludvig and Harald had joined the manufacturing company of Bing & Grøndahl: Ludvig as business manager, Harald responsible for technical developments. Ludvig Bing died at the early age of thirty-nine and in 1885 Harald Bing was left to reorganize the factory. Before his death, Ludvig had singled out Pietro Krohn as an attractive and able addition to the factory's team, and that same year he joined the company as Art Director.

Pietro Krohn's parents were the medallist F.C. Krohn and the sister of Christen Købke, the painter. He trained at the Fine Art Academy and had studied in Italy. His career before joining Bing and Grøndahl included designing costumes for the Royal Theatre. As a painter, illustrator, and writer he was a central figure in Copenhagen's artistic circles and particularly interested in the *Japonisme* movement.

Copenhagen's circle of connoisseurs and collectors of Japanese and Japanese-influenced works included Karl Madsen, William Salomonsen, Emil Hannover, and Bernhard Hirschsprung, all art historians and collectors, as well as Krohn and Arnold Krog (1856–1931), the Art Director at Royal Copenhagen. Madsen had been particularly active in illustrating Japanese arts and crafts through writing, lectures, and exhibitions, taking advantage of his connection with Siegfried Bing the Paris dealer who, later, was to open the influential shop L'Art Nouveau. Significantly, in 1855 Madsen wrote a book on Japanese scrolls decorated with herons and cranes. Between that year and 1888 Krohn had devised the entire Heron service. Also, Krohn was almost certainly aware of the Swan service designed by J.J. Kändler for Meissen in 1737–41. The Heron Service (Hejrestellet) was to be his equivalent.

Krohn's Heron Service was first shown at the Scandinavian exhibition of Industry, Agriculture and Art, held at the Industrial Association in Copenhagen in 1888. The exhibition combined work by Danish artists with Japanese arts and crafts. The reception was impressive; the particular impact made by the Heron Service was due not only to its extra-ordinarily adventurous conception and the skilfully realized modelling, but also to the use of underglaze blue. By the 1880s this traditional form of decoration was regarded as somewhat pedestrian but its application on this most elaborate porcelain service, combined with expensive gilding and modelling, was a revelation. The following year the service was shown in the Paris International Exhibition of 1889, where it was awarded an honourable mention. It was not allowed to compete for medals as Krohn was a member of the jury.

A small number of services were made as part of the first production in 1888 and from then until 1900. A few more were made in about 1915. Although the blue set was the most striking at least one pink version was also made. The Victoria & Albert Museum owns a cup and saucer as well as this ice bucket, both of which were made at the later date of 1915. The modellers were C.O. Schjeltved and an unknown, Erdmann, as well as Ludvig Brandstrup who was responsible for the birds. The painting on the original service was by Fanny Garde (1855–1928) and Effie Hegermann-Lindencrone (1869–1945), both of whom went on to produce some of the most stylish sculptural and ornamental works made at the factory in the early twentieth century, pieces that for sheer technical and artistic daring are unrivalled anywhere and which probably owe a fundamental debt to the early work undertaken by the two artists on the Heron Service. Although some comparisons may be made with Royal Copenhagen production, these are limited. The palette of underglaze colours is comparable but while the Royal Copenhagen factory pursued a form of nationalism, its subjects frequently drawn from Danish motifs of landscape, sea, and birds, the Bing and Grøndahl factory set its sights on rather more internationally flavoured styles such as Art Nouveau produced with a superb technical and sculptural flair.

Pietro Krohn left Bing and Grøndahl in 1895. Before then, by 1893, and until his death in 1905, he was the first Director of the Kunstindustrimuseum in Copenhagen. JHO

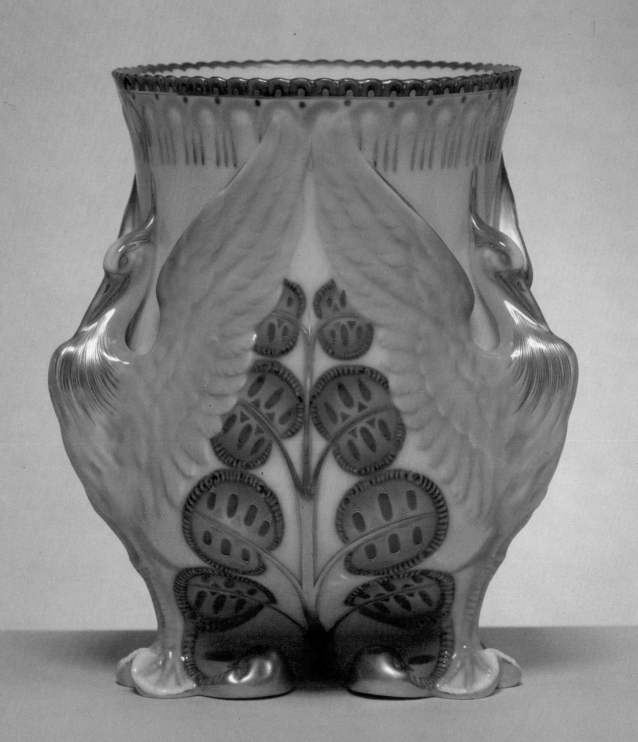

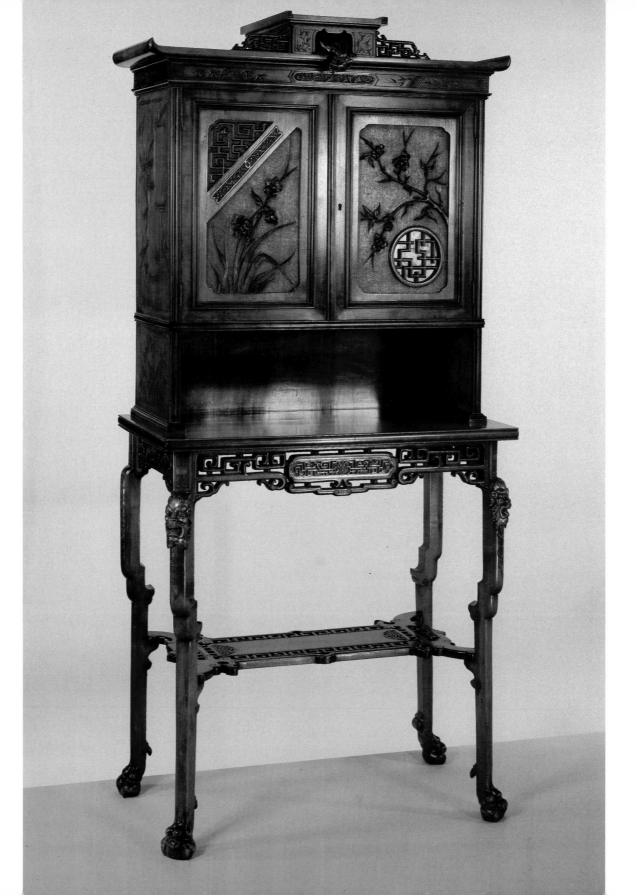

Cabinet

Designed and manufactured by
Gabriel Viardot
French: Paris 1888
Carved walnut with gilt bronze
mounts
h 162.6 cm (5 ft 4 in.); w 79.4 cm
(2 ft 7¼ in.); d 41.0 cm (1 ft 4⅛ in.)
Stamped, inside the left hand
door, 'G. Viardot' and 'Paris
1888'
W.17–1971

Literature
DENIS LEDOUX-LEBARD, *Les
Ébénistes du XIXe Siecle*, Paris,
1985

Gabriel Viardot took over control of the family cabinet-making firm, Viardot Frères et cie, in 1861, from his father Charles Viardot. The firm is recorded as having workshops and a shop at 36 and 38 rue Rambuteau in 1853. Here were sold ornamental boxes, writing papers, and accessories, *jardinières*, wedding presents, and '*objets d'art et de fantaisie*'. At the Paris Exhibition of 1855 the firm had shown a variety of objects including furniture in the Renaissance style, *jardinières*, and various pieces carved from pearwood, including a small casket.

Gabriel Viardot had established his own business in the rue de Grand Chantier in 1860. He maintained the workshops in the rue Rambuteau until 1872, when the firm moved first to 15 rue de Chaume, then to 3 rue des Archives in 1878, and finally to 36 rue Amelot, where they were to remain to the end of the century.

Viardot advertised as a '*createur des meubles dans le genre chinois et japonais*'. The cabinet in the Victoria & Albert Museum has, in fact, few purely Japanese elements. The rectangularity of the upper part and the upswept ends of the top are certainly of Japanese origin, and the decoration on the doors, especially that on the left, owes something to Japanese inspiration. The major influences are, however, those of China and Vietnam. At this date Vietnam was one of France's most important colonies, and considerable quantities of furniture were imported from the Far East, especially from makers in Hanoi and Canton. The form and carving of the front legs, including the gilt bronze dragon mask, are based closely on nineteenth-century furniture imported from China or Vietnam, the only difference being the metal dragon mask. On imported furniture such masks were usually carved as an integral part of the leg. The part of the cabinet which contains the largest element of '*fantaisie*' is the gilt bronze dragon emerging at the top. Fuelled by strong links with the Far East there was a large market in France for this sort of furniture.

Viardot, like all commercial makers, had to maintain strict control over costs. To do this he would produce quantities of elements and use them in many different pieces. For example, copies of the front legs on this cabinet can be found supporting tables and console tables.

Viardot participated in the international exhibitions in Paris in 1867, 1878, and 1889, both as an exhibitor and as a jury member. At the Paris Exhibition of 1867 he was awarded four medals; in 1878 a silver medal; and in 1889 a gold medal. The jury reported: '*Il nous presente ses meubles japonais toujours fort interessants tant par leur tonalité que par leur parfaite execution.*' SA

Vase

Designed by Louis Constant
Sévin (1821–88)
Chased by Désiré Attarge
(c.1820–78)
Manufactured by Ferdinand
Barbedienne (1810–92)
French: Paris, 1871
Bronze inlaid with iron and gold
h 48.3 cm (19 in.); w 18.4 cm
(7¼ in.)
Signed D. Attarge
Circ.370–1960

Louis Constant Sévin, the son of an actor, was apprenticed at the age of thirteen to the Parisian sculptor Marneuf. In 1839 he formed a partnership with Phenix and Joyau with himself as designer to produce ornamental metalwork on commission. They successfully supplied such prestigious firms as Morel and Froment-Meurice until 1848 when the political turmoil in Europe persuaded Sévin to go to London. There he joined Morel, who had also fled Paris, and as his *chef d'atelier* designed a number of pieces that Morel exhibited at the London Exhibition of 1851. Sévin returned to France in 1851 where he was employed by the Limoges porcelain manufacturer Jouhanneaud & Dubois. At the Paris Exhibition of 1855 Jouhanneaud exhibited ceramics designed by Sévin decorated with relief sculptures based on seventeenth-century Italian and German metalwork. That same year Sévin returned to Paris where he became *sculpteur-ornemaniste* for Ferdinand Barbedienne, a post he held for the rest of his life.

Sévin's collaboration with Barbedienne was fruitful. He was awarded a medal at the London Exhibition of 1862 'for the high artistic excellence displayed in the furniture designed by him and exhibited by Barbedienne'. He won a second class medal at the Union Centrale Exhibition of 1863 and was awarded a gold medal at the Paris Exhibition of 1867. As one of the jurors for the Reports of the 1867 Exhibition, Barbedienne praised Sévin's extensive knowledge of historical ornament and his consistent ability to work in a variety of styles in a manner which remained 'sober and pure'. In his use of historical styles Sévin himself was to say: 'If I borrow from the styles of the past . . . I always interpret.' He tended to favour the Renaissance revival style and the Neo-Grec which are evident in the design of the vase illustrated here.

The execution of Sévin's designs for Barbedienne often depended on the accomplished skills of the chaser Désiré Attarge. He too worked for Froment-Meurice, Duponchel and Morel in the 1840s before being appointed *ciseleur-ornemaniste* to Barbedienne in 1855. He was awarded a silver medal as *cooperateur* at the Paris Exhibition of 1867 and in his report Barbedienne praised his skill, 'under which the metal becomes supple and takes on delicate forms'. Darcel in an article for the *Gazette des Beaux Arts* (November 1867) on modern bronzes at the 1867 Exhibition reinforced Barbedienne's high opinion of his craftsman when he wrote, 'It is impossible to handle the tool with more precision and more breadth, or to create a greater richness, despite the preciousness of the details. Thus treated, bronze becomes goldsmith's work.'

This vase was originally acquired by the Commissioners of the 1851 Exhibition, possibly from one of the international exhibitions organized by Henry Cole between 1871–4, and later given to the South Kensington Museum.

ET

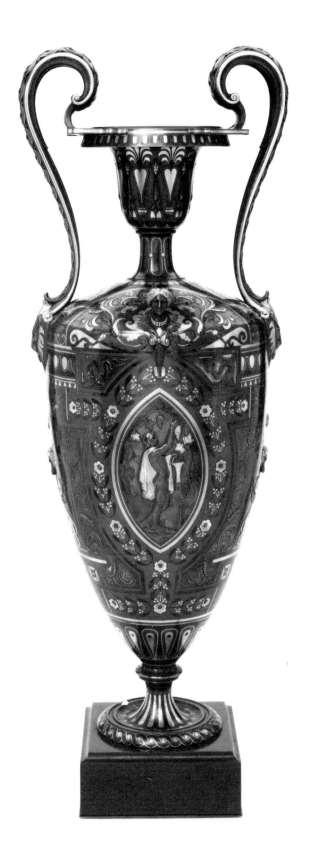

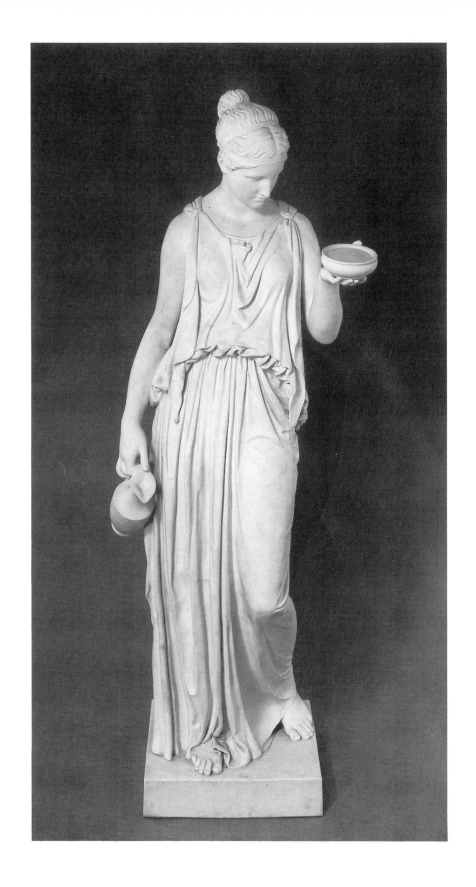

Hebe

A copy of the original by Bertel
Thorvaldsen (1770–1844)
Possibly modelled by Carl Oluf
Angelo Schjeltved (1829–91)
Manufactured by Bing &
Grøndahl
Danish: Copenhagen, 1871
Biscuit porcelain
h 136 cm (53½ in.)
Misc 124–1921
Given by The Royal
Commission for the
Exhibition of 1851

Hebe, the Greek goddess of youth, was a popular figure in ancient symbolism. According to myth she was the daughter of Jupiter and Juno and was wedded to Hercules after his ascent to Olympus. She was the cup bearer and handmaiden of the gods and is, therefore, traditionally depicted offering a wine vessel.

Bertel Thorvaldsen, the great neo-classical Danish sculptor, was born in Copenhagen on 19 November 1770. He was admitted to the Royal Academy of Fine Arts in Copenhagen, where he won the gold medal for sculpture, which entitled him to the Academy's travelling scholarship. In March 1797 he arrived in Rome, then regarded as the centre of the art world. A large population of artists and art lovers congregated there annually, many of them settling permanently.

Thorvaldsen opened a studio in Piazza Barberini where he employed assistants to work on the enormous number of marble statues in the classical manner which he produced over a period of more than forty years. By then his fame was immense and his return to Copenhagen at the age of sixty-seven, in September 1837, was triumphal.

During his residence in Rome he was able to take advantage of the major excavations then underway at Pompeii and Herculanæum. The monthly revelations, as sculpture, coins, metalwork, and other artefacts emerged from the diggings, caused a revolution both in the established view of ancient Rome and in the fashionable taste of the time. Thorvaldsen's own work was a particularly elegant and lively interpretation, accurately based on the simplest classicism, on which rested his reputation as a reviver of Antiquity.

He died six years after his return to Copenhagen, by which time he had amassed copies and originals of nearly all his own work as well as a large collection of books, antique sculpture, coins, medallions, and precious ornaments. These were to be housed in a specially-built museum designed by the Danish architect M.G. Bindesbøll, which, after his death also became his mausoleum. The building is a fantastic creation drawn from antique architectural elements and painted in strong Pompeiian colours and motifs above tessellated floors, all of which serve to set off Thorvaldsen's marble sculptures in the most appropriate and dramatic manner. The original figure of *Hebe* is included in this collection.

The partnership of Bing and Grøndahl was established in 1853 by Frederik Vilhelm Grøndahl, a modeller from the rival company of Royal Copenhagen. He joined with Meyer Herman and Jacob Herman Bing, owners of a large retail shop in Copenhagen, and they began experimental production of figures and reliefs based on Thorvaldsen's work. Grøndahl died before the experimental stage was completed. The sculptor Herman Vilhelm Bissen (1798–1868) was appointed as Artistic Consultant to arrange for and oversee the quality of the Thorvaldsen copies.

The *Hebe* figure was first shown in the London Exhibition of 1862, at which time it was produced in two smaller sizes. The Royal Copenhagen porcelain factory also made reduced copies of *Hebe* from 1846. For the next London Exhibition, held in 1871, Bing & Grøndahl confidently made this, the Museum's figure, believed to be the only example produced at this larger size which corresponds to the larger dimensions of the original sculpture. This impressive biscuit porcelain statue was fired in one piece at a carefully specified angle, supported at the base and shoulders. Although the neo-classical style underwent a gradual decline, with periodic revivals, in the nineteenth century elsewhere, in Denmark it was a continually popular style.

The *Hebe* was on loan to the South Kensington Museum until its formal acquisition in 1921. During that period of some fifty years it spent time on loan to other museums such as that at Manchester. JHO

Literature
BREDO GRANDJEAN, *Biscuit efter Thorvaldsen*, Copenhagen, 1978
ERIK LASSEN, *En Københavnsk porcelænsfabriks historie, Bing & Grøndahl, 1893–1978*, Copenhagen, 1978

Armchair

Designed and manufactured by
George Jakob Hunzinger
(1835–98)
American: New York, c.1876
Turned and painted maple, the
seat of steel strips, covered in
red silk
h 84.5 cm (33¼ in.); w 50.8 cm
(20 in.); d 54.0 cm (21¼ in.)
Stamped, on the back of the rear
right-hand leg 'HUNZINGER PAT
MARCH 30 1869 N.Y. PAT APRIL 18
1876'
W.14–1985

George Jakob Hunzinger, a German immigrant to the United States, designed and manufactured some of the most distinctive chairs made in the nineteenth century. Born in Tuttlingen, Germany, in 1835, his family had been cabinet-makers there since the early seventeenth century, and there are still Hunzingers practising the same trade in Tuttlingen today. After serving an apprenticeship, and a period spent working in Geneva, Hunzinger left Germany in the 1850s to settle in Brooklyn, New York, where he joined the already large German community. In 1859 he married Marie Susanne Grieb, who also came from Tuttlingen, and in 1865 received his American citizenship.

Hunzinger was an astute and hard-working businessman. In 1861 he received the first of his patents: for a folding reclining chair on which the footboard could double as a table. There were to be a further nineteen patents. The first three gave Hunzinger sufficient income to start his own business in 1866, at 192 Lauren Street, New York. Although small, the business prospered: from four or five employees at the start, the workforce grew to fifty in only six years.

Hunzinger's fourth patent was registered on 30 March 1869, and it is one of the two which apply to this chair. The patent was for the system of diagonal braces which gives the chair its distinctive structure. By connecting the seat back to the bottom of the front legs, Hunzinger hoped to provide sufficient strength to resist pressure on the seat back, and to strengthen the frame against the stresses caused when the chair is rocked backwards on the rear legs.

Such was the popularity of his furniture and such was his business acumen that the firm continued its rapid growth. Between 1871 and 1873 its value more than doubled, and expansion necessitated two moves, the first in 1870 to 402 Blecker Street, the second in 1873 to Seventh Avenue.

In 1876 Hunzinger received the other patent which applies to this chair. The seat is composed of a lattice of woven steel strips. Where they meet the frame, the steel bands pass around the frame in a groove, before being turned round two steel pins and returning across the seat through the next groove along. Thus the whole seat is composed of just two long steel strips. These are covered by sleeves of red silk web which have white flecks woven into them.

The firm's progress was interrupted in 1877 when Hunzinger's factory, and those of two adjoining manufacturers with which it shared a common steam engine, was destroyed by fire. Hunzinger's loss was $50,000. He was insured for only $20,000. After operating from a series of makeshift factories, Hunzinger moved in 1879 to new purpose-built premises at 323–7 West 16th Street where, three years later, the firm re-established its sound financial base when Hunzinger patented a spring rocking chair. This proved to be the firm's best-selling item.

After his two sons George and Alfred came into the business in the late 1880s, Hunzinger was able to devote time to the possibilities of exporting furniture. He made visits to London and Paris, shipping back to New York samples of furniture which interested him, some to be copied.

Hunzinger died in 1898, but the firm, under the control of his son George, continued into the 1920s producing furniture of increasingly conservative design. Under the threat of unionization, the family closed the furniture factory and moved into property and stock-holding.

The large number of patents, the astonishing growth of the company, despite setbacks, and the furniture itself remain as a monument to one of the most inventive designers and makers of the last century. SA

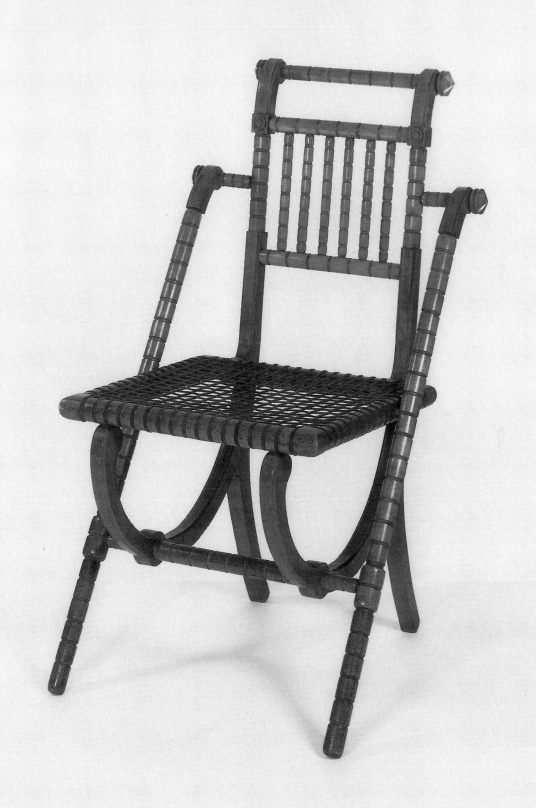

Vase and pedestal

Shape and ornament probably designed by Josef Ritter von Storck (1830–1902)
Made for J & L Lobmeyr, Vienna, probably at the Meyr's Neffe glassworks, Bohemia, 1878
Amber-coloured glass with enamelled decoration
h 115.4 cm (45½ in.)
411–1878

Literature

Illustrated Catalogue of the Paris International Exhibition, Art Journal, London, 1878
L. GONSE, *L'Art Moderne à l'Exposition de 1878*, Paris, 1879
JOSEPH LEICESTER in *Artisan Reports on the Paris Universal Exhibition of 1878*, London, 1879

In 1823 the glazier Joseph Lobmeyr (1792–1855) moved from Upper Austria to Vienna and opened a glass workshop and retail outlet. He was successful enough to receive commissions for the Imperial Court, and in 1848 passed on a thriving concern to his sons Joseph (1828–64) and Ludwig (1829–1917).

When his brother Joseph died in 1864, Ludwig took sole control of the business. He was to be its most important owner. Ludwig's success was due to a combination of business sense, artistic judgement, and sensitivity to contemporary taste. His output reflected the neo-classical, baroque, rococo, antique and exotic styles, developing the glassmaking traditions of Bohemia. Ludwig increased production, taking advantage of a period of economic prosperity which widened the market for his products.

At the Paris International Exhibition of 1878 Lobmeyr showed a bewildering array of clear, coloured, and lustred glass, engraved and enamelled in a variety of styles. He included pieces made in imitation of porcelain or decorated crudely with figures and foliage in a lively medieval German style, and glass with a crackled finish or with gold and silver in the body. The exhibits were greatly praised, especially the large mould-blown vases of which this is an example. Joseph Leicester, an artisan sent by the British to comment on this section of the exhibition, wrote: 'The broad bands of burnished gold, with festoons and droppings of enamel mingled with the iridescent colouring of the vase itself produces a polished graceful influorescence of ornament ... The classical forms are not introduced because they are classical, but in subservience to the expression of great leading principles ... Ornament is kept so subordinate to the ultimate intent that whilst is pleases it never distracts.'

This particular vase and pedestal, which builds up from six stacking parts, was bought from the exhibition for the South Kensington Museum at a cost of £28. It was part of a group of J & L Lobmeyr glass bought to demonstrate that good design could be combined with low price. Costs were reduced because the glass was manufactured relatively cheaply in Bohemia. It was then decorated at other factories according to designs by distinguished Austrian artists or by Ludwig himself. With this arrangement, the same degree of artistic attention could be paid to both exhibition pieces and everyday production.

Except for a short and unsuccessful involvement with two glassworks in Slavonia, the firm did not produce glass itself. Thus this vase was probably made at the Meyr's Neffe factory in Winterberg, Bohemia, the owner of which, Wilhelm Kralik, was married to one of Ludwig Lobmeyr's sisters.

Both the shape and ornament were probably designed by Josef von Storck, a Viennese architect. Between 1868 and 1899 Storck was the director of the design school attached to the Vienna Museum of Applied Arts, which had a close association with a number of manufacturers including J & L Lobmeyr. Storck also produced designs for furniture, bronzes, silver, textiles, and enamels.

From 1894 Ludwig gradually entrusted the management of the company to his nephew, Stephan Rath, in whose family it remains. HB

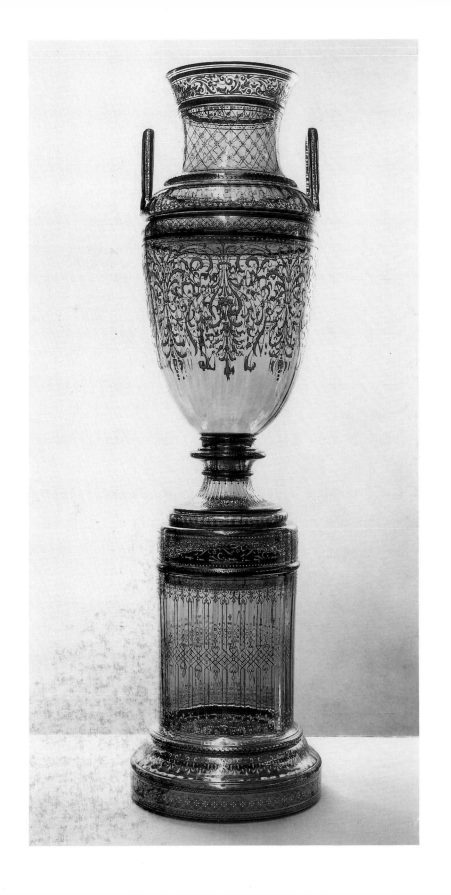

The Age of Bronze

By Auguste Rodin (1840–1917)
First cast in bronze in 1880 after
a model of 1876–7
Bronze
h 182.2 cm (5 ft 11¾ in.)
Inscribed 'Rodin' on the upper
surface of the base and 'Alexis
Rudier/Fondeur Paris' on the
side of the base
A.33–1914
Presented to the Victoria &
Albert Museum by Rodin in
1914; transferred to the Tate
Gallery in 1937 and then to
Bethnal Green Museum in 1970

Literature

ALBERT ELSEN, *Auguste Rodin:
Readings on his Life and Work*,
New Jersey, USA, 1965
ALBERT ELSEN, *Rodin*, London,
1974
ALBERT ELSEN, *Rodin
Rediscovered*, Washington, 1981
JENNIFER HAWKINS, *Rodin
Sculptures*, London, 1975
CATHERINE LAMPERT, *Rodin:
Sculpture and Drawings*, London,
1986

Rodin first became known to the public when he exhibited *The Age of Bronze* at the Paris Salon in 1877. He had made three unsuccessful attempts to enter the prestigious Ecole des Beaux-Arts in Paris and most recently had been working in Brussels with van Rasbourg and Carrier-Belleuse (often anonymously) on public decorative sculpture and small figurines and ornaments for the mass-market. The *Age of Bronze* was Rodin's first full-scale independently-produced statue.

When Rodin started work on the figure in 1876, he had recently returned from a trip to Italy where he was particularly influenced by the work of Michelangelo whose marble *Bound Slave* of 1514–16 is related to Rodin's bronze. During his tour he sketched both classical and Italian Renaissance sculptures extensively, but despite references to revered prototypes, the figure provoked sharp criticism both in Brussels when the plaster model was first shown at the Artistic and Literary Circle in January 1877 and in Paris when it was exhibited at the Salon later the same year.

Most wounding to Rodin were the repeated accusations that life casts had been used to make the figure since, as Rodin stressed, his 'artistic interpretation' is far from being merely a 'servile copy' as a cast would be. To defend himself, Rodin had photographs and casts of his model sent from Belgium to France, where he did not receive official approval of the figure until a cast of the finished bronze was purchased by the state in 1880. Rodin was awarded a gold medal for the statue at the Salon at Ghent that year, and it was favourably received at the Royal Academy in London in 1884. However, in 1887 there was also criticism of the choice of model, Auguste Neyt, who was a soldier in the Belgian army. He was considered totally unsuitable by critics used to more conventional salon figures. Charles

Tardieu (*L'Art*, Jan 1877) described the figure as 'a too servile portrait of a model without character or beauty, an astonishingly exact copy of a low type'.

Finally, there was considerable controversy about the meaning of the figure. Its title when first exhibited in Brussels was *Le Vaincu* (*The Vanquished*). The figure originally held a spear (as shown in a drawing by Rodin of 1876), which was an adaptation of the staff held by Neyt as he posed for long sessions and was wholly appropriate for this title. *The Vanquished* also expressed the disillusionment experienced by the French following their recent defeat in the Franco-Prussian War. When Rodin removed the spear for aesthetic reasons, the resulting ambiguity about the figure led to a number of titles and explanations being given. Some critics suggested that the figure was a sleepwalker, or a man on the point of suicide, or even that it represented the 'Awakening of Humanity'. This latter title, as well as that of *The Age of Bronze* which Rodin chose when presenting the bronze at the Paris Salon of 1877, were perhaps inspired by contemporary thought embodied in the earlier writings of J.J. Rousseau, which Rodin certainly read, about the nobility of primeval man. It also separated the figure from any political associations and raised it to a more abstract level.

It is interesting that Rodin also visualized the figure in marble as he thought that only in this medium could the fine nuances he wanted be achieved. This was expressed in Rodin's letter to Rothenstein of 31 October 1900, when the question of the Victoria & Albert Museum acquiring some of Rodin's work first arose. However, he presented this bronze cast to the Museum in 1914 in appreciation of the English support for France at the start of World War I. AFR

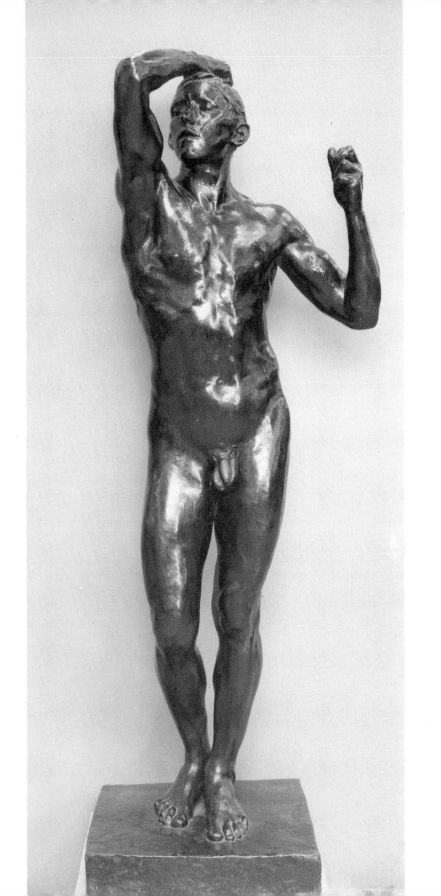

Mosque lamp

Manufactured by
Philippe-Joseph Brocard (d.1896)
French: Paris, 1880
Clear colourless glass with
enamelled and gilt decoration
h 23 cm (9 in.)
Marks: BROCARD PARIS 1880 and
indistinct mark, incised
721–1890
Purchased from E-P. Léveillé

Literature
JANINE BLOCH-DERMANT,
L'Art du Verre en France, Paris,
1974
E. V. COLLINOT and A. DE
BEAUMONT, *Recuiel de Dessins*,
Paris, 1859
KATHERINE MORRISON
MCCLINTON, 'Brocard and the
Islamic Revival',
Connoisseur, December, 1980

Philippe-Joseph Brocard is credited with being the first to re-discover Middle-Eastern enamelling techniques. Nothing is known about his life and career until the 1860s, by which time, as a collector and restorer of glass and other arts, Brocard had begun to investigate and teach himself the art of making, enamelling, and firing glass. The technique was not unknown in France but it was Brocard who revived it, recognized its possibilities, and turned it into a contemporary art.

His first examples were shown in 1867 and were close to originals, some of which have been identified. A footed bowl, also in the Victoria & Albert Museum, is closely related to another Brocard example in the Musée Adrien-Dubouché, Limoges, the original of which is a known thirteenth-century Syrian *coupe*. This *coupe* was in a private collection, exhibited in Paris in 1865 and 1869, and included in Adalbert de Beaumont and Eugene Victor Collinot's *Recueil de Dessins*. Brocard, therefore, took some care to base his first essays into the technique on verified originals.

The exact original of this mosque lamp has not been identified but it was bought by the South Kensington Museum as 'a reproduction of a Damascus lamp'. A number of fourteenth-century lamps are included in the Museum's collections and similar ones may be seen in public collections in France such as the Musée de Cluny which Brocard is known to have studied. Such lamps were luxury items and were made for the Mameluke Sultans of Egypt and their high officials, for use in mosques in Damascus and Cairo. The Brocard lamp is closely based on such originals.

Brocard's methods of production and marketing are largely a matter of conjecture. In launching the newly-revised technique he included Islamic styles and also medieval French, German, and Italian renaissance and within a

short time a school of followers had begun working with the same enamelling methods and historicist styles. His own development using the technique took a rather different stylistic direction. He continued to make glass decorated with Islamic motifs; it had caught the attention of collectors and acquired something of a following in France and also in America through the interest of the New York dealer, Samuel P. Avery. Parallel with this production he met Emile Gallé (1846–1904) in 1878 and the influence of each glassmaker on the other was marked and significant.

On Brocard the influence of Gallé manifested itself in a new freedom. He abandoned the formality and prescribed patterning of his earlier work and entered a period of a freer expressiveness, experimenting with asymmetrical *Japonisme,* even tending, in the last years, towards Art Nouveau. Throughout most of his career, however, he continued to produce mosque lamps, his most successful and typical form.

In 1884 Brocard's son Emile entered the business and the company became known as Brocard et Fils, established at 23 Rue Bertrand, Paris. Finally, Brocard was convinced of the necessity of patenting his technique which he did on 20 August 1891.

Brocard died in 1896 and the company continued in production until 1904, as Verrerie Brocard.

The Museum's lamp was purchased from Ernest-Baptiste Léveillé (dates unknown) for £7 12s 10d. From 1869 Léveillé, with François Eugene Rousseau (1827–91) owned a shop, Rousseau-Léveillé. Both Rousseau and Léveillé were glassmakers and through the shop sold their own work and that of their contemporaries with whom they shared an interest in forms and ornamentation from the Far and Middle East. JHO

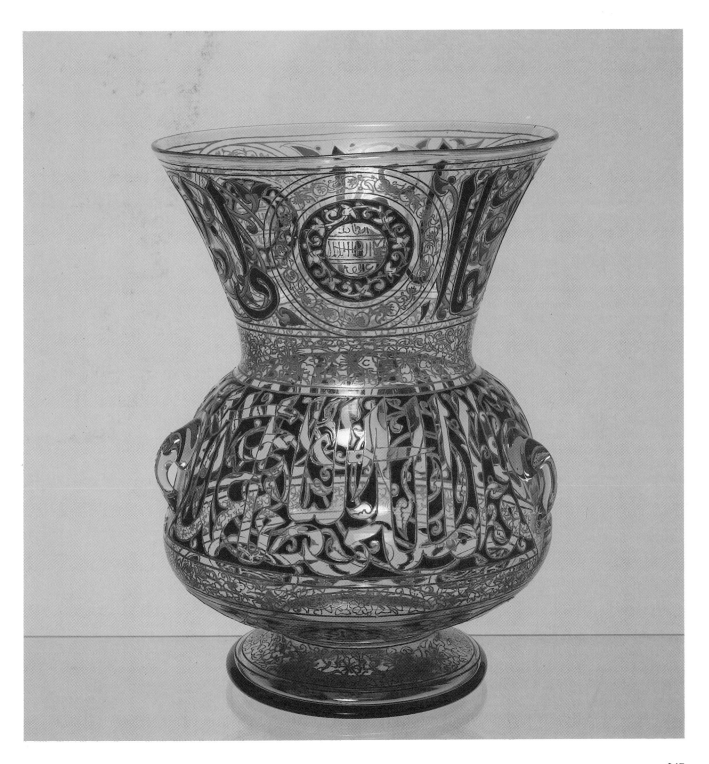

Coffer

By Plácido Zuloaga (1833–1910)
Spanish: Eibar, 1883
Iron, counterfeit-damascened in
gold and silver, with applied
gold and silver mounts; interior
lined with stamped leather
h 31 cm (12¼ in.); w 53 cm
(20⅞ in.)
Inscribed in gold on the flat edge
of the lower rim: 'PLÁCIDO EIBAR.
ĀNO 1883. ZULOAGA'
M.874–1927
Given by Mrs Alfred Morrison

Literature

C. BLAIR, *Arms, Armour and
Base-Metalwork, The James A. de
Rothschild Collection at
Waddesdon Manor,* Fribourg, 1974
JAMES LAVIN, 'The Zuloaga
Armourers', *Journal of the Arms
& Armour Society,* XII, no.2, 1986
'Treasure Houses of Art.–II.',
Magazine of Art, II, September
1879

Plácido Zuloaga was born in Madrid in 1834
into a Basque family of armourers and gun-
makers from Eibar in Guipúzcoa. His father
Eusebio, like his father before him, became
Armero Mayor in the Royal Armouries in
Madrid. Eusebio studied arms manufacture in
Paris and Belgium, imported machinery from
Liège, and later developed interests in ceramics
and the manufacture of synthetic stone. He
sent Plácido to work in Lepage's arms factory
in Paris, from which he had to make his own
way back after the Revolution in 1848. Eusebio's
successes in exhibitions in Spain were followed
by a prize medal in London in 1851. His manu-
factory in Eibar was employing thirty people
by 1850. Plácido's work was praised in the
Paris Exhibition of 1855 and from about 1859
he appears to have managed his father's factory
in Eibar, as well as executing many of his
father's royal commissions. Plácido visited
London in 1862 for the exhibition and his
work may then have attracted the attention
of Alfred Morrison or his future wife. By
1868 the bond was sufficiently established for
Plácido to suggest that the Morrisons should
support the entire expenses of himself and
fourteen workmen in order to avoid the disaster
threatened by the political commotions of that
year. A portrait of Plácido was painted by
his son Ignacio for the Morrisons.

In 1879 the *Magazine of Art* published an
article on Mr and Mrs Alfred Morrison's col-
lection at Carlton House Terrace, London:

Conspicuously in Mr Morrison's collection are a
number of metal works by Zuloaga, of Madrid.
This handicraftsman adopts various styles of
design, but inclines principally to the Moresque.
His smaller works, such as inkstands, boxes,
trays, and so forth, are executed sometimes in a
classical style; the great care bestowed in the

finish of workmanship, especially in the case of
his damascened works – gold and silver forms
let into dark toned steel – gives them a distinc-
tive character. . . . Of another style, but of the
same degree of fine handicraft, are Zuloaga's
caskets and chests. These are chiefly of an Italian
renaissance style of design. Floral arabesques,
with delicate stems inter-twining amongst cupids,
escutcheons, and such-like devices, are wrought
in *repoussé* work upon gold ground.

This casket was made four years after this
description. It was presented to the museum
in 1927 by Mabel Morrison six years before
her death in 1933. At the time of the gift she
wrote that she was disappointed that 'Placido
Zuloaga's fine damascened coffer' would be
displayed in the Bethnal Green Museum rather
than the Victoria & Albert Museum, but that
she appreciated 'how great must be the problem
there of finding available space', and would
give the coffer on condition that 'Zuloaga's
matchbox which I herewith forward is accepted
and exhibited in the Victoria & Albert Museum'
(now in the Jewellery Gallery).

In addition to the objects given by
Mrs Morrison, the museum has works bought
directly from the Zuloagas. In 1866 J.C.
Robinson on a purchasing visit to Spain bought
an unsigned casket for £15 15s 7d from 'Senor
Zuloaga' in Madrid (324–1866; a casket of similar
shape was acquired by the Kunstgewerbe-
museum, Berlin, in 1873, from the Vienna
Exhibition). In 1867 two miniature frames
were bought from the Paris Exhibition, one
for £10 8s 0d (1007–1869), the other for £8
(1008–1869). Although the purchase is recorded
as having been made from 'Euserio Zuloaga',
it seems likely that by this date they would
have been made under the direction of Plácido.

RE

Head of a Satyr

By Alphonse Legros (1837–1911)
Plaster relief
h 81.2 cm (2 ft 8 in.); w 23.7 cm
(2 ft 5 in.)
Signed 'A. Legros'
London, c.1885–95
A.125–1916
Given by Victor Ames

Literature
LÉONCE BÉNÉDITE, *Alphonse Legros, Painter and Sculptor* in *The Studio*, XXIX, No. 123, June 1903
WILLIAM ROTHENSTEIN, *Men and Memories*, London, 1931

Alphonse Legros is remembered chiefly as a painter and etcher, and also as a teacher. His work as a medallist and sculptor is often overlooked. After a short apprenticeship as a house-decorator in Dijon he went to Paris where, having worked with a scene-painter, he studied at the Ecole des Beaux-Arts. He exhibited in the Salons of 1857, 1859, and 1861 as a painter, as well as in the first Salon des Refusés, where works rejected by the official Salon were shown, in 1859. His friends in Paris included Edouard Manet (1832–83) and Auguste Rodin (1840–1917), leading figures in the reaction against the established conventions of the Salons of the time. In 1863 James McNeill Whistler (1834–1903) persuaded Legros to come to England. He taught etching at the National Art Training School (now the Royal College of Art) and in 1876 was appointed Slade Professor at University College, London, a post he held until 1893.

Legros turned to sculpture comparatively late in life. Rothenstein writes that he made 'important decorations for the City celebration of Queen Victoria's Jubilee' and later introduced Legros to Arthur Strong, Librarian to the House of Lords, through whom Legros obtained the commission from the Duke of Portland for two fountains at Welbeck Abbey. The fountains were executed by Edouard Lanteri between 1897 and 1902 under Legros' close supervision, and include satyrs' masks to which this relief relates.

The impressive collection of etchings by Legros in the Victoria & Albert Museum includes several which are related to this relief and to the Welbeck commission. Legros incorporated grotesque masks into a series of designs for fountains, vases, and even a door-knocker. Some are perhaps derived from classical prototypes, while others are more closely allied to Italian mannerist decorative sculpture. Similar in facial type to this relief are etched designs for two satyrs' masks in particular, dated 1881 and 1883 respectively, of which many impressions exist. Also of interest is a sheet of rough sketches of grinning grotesques with wavy hair and beards, one of which appears, like the relief, in an oval surround.

Legros may well have been influenced by his friend Rodin, who stayed with him in London in 1882. He almost certainly saw the designs for *mascarons* (grotesque heads) generally attributed to Rodin for the Trocadéro Fountain, which were published in Paris (1878) and again in London (1881). Both they and Rodin's grotesques on the Loos Monument in Antwerp are stylistically similar to Legros' slightly later work.

During the last decade of the nineteenth century, decorative sculpture in England gained a new status equal to the 'High Art' of independent sculpture, having been regarded as inferior for some time. References to revered prototypes of the past, characterized by the 'Beaux-Arts' style adopted by Legros, accelerated this process. More significantly, the new desire to reaffirm the relevance of art to society by making it more accessible meant that decorative sculpture became a vital part of public façades. This was exemplified in the buildings of the South Kensington School and Museum complex where Legros taught. In France under Napoleon III (1808–73), Haussmann planned the rebuilding of Paris with streets radiating from focal points where a new demand for public monuments and thus decorative sculpture was generated. The decorative sculpture by Legros in England and Rodin in France and Belgium must be seen in the same public context, and the similarities between them exemplify the cross-fertilization of artistic ideas across the Channel which is a notable feature of this period. AFR

Salver

Designed by Ferdinand Levillain
(1837–1905)
Manufactured by Ferdinand
Barbedienne (1810–92)
French: Paris, 1889
Gilt bronze
w 57 cm (22½ in.)
Inscribed, in Greek, 'Dionysus'
Signed under the handle,
'F. Barbedienne'
93–1890

Literature
L. FORRER, *Biographical
Dictionary of Medallists*, London,
1907
ROGER MARX, 'The Renaissance
of the Medal in France', *The
Studio*, XV, 1899

Ferdinand Levillain was born in 1837 at Passy, a suburb of Paris. He studied under Lequien and Jouffroy and first exhibited his work in 1861. He became well-established as both a sculptor and medallist and was officially rewarded with various medals himself throughout his distinguished career. In 1872 he was awarded a medal of the second class, a medal of the first class in 1884, a silver medal at the Universal Exhibition of 1889 and ultimately was made a Chevalier de la Légion d'Honneur in 1892. For many years he was a member of the jury of the Salon.

Levillain's career coincided with a renewed interest in the art of the medal. Towards the end of the nineteenth century the French decorative arts received increasing critical attention and there was an allied tendency to regard the applied arts as on an equal footing with the fine arts. The glyptic arts became very popular and medallists began to enjoy a stature which had escaped them since the eighteenth century. As further inducement, the Ministry of Fine Arts and the Directors of the Mint offered numerous commissions to artists and facilitated collector's opportunities for acquiring specimens.

The revival in glyptic work renewed a well-established French tradition of decorative artists designing medals as part of a larger commission. Within the nineteenth century there are the examples of Morel-Ladeuil and Vechte. Now many medallists were undertaking ornamental work and Levillain was one of the most accomplished in this field.

His bronze salver for Barbedienne in the form of a Greek earthenware calix, considerably enlarged, is characteristic of his ability to express the antique in a modern manner. The central medallion depicting the education of Dionysus is a typical example of his subject matter which was frequently drawn from classical mythology. The composition, as with the ornament, is carefully designed and elaborately executed. ET

153

Vase

Made by August Delaherche
(1857–1940)
French: Paris, Rue Blomet,
Vaugirard, c.1890–2
Stoneware with a high
temperature *flambé* glaze
h 66.5 cm (26¼ in.)
Marks: impressed AUGUSTE
DELAHERCHE within a circle, and
6016
1613–1892
Bought from Auguste Delaherche

Literature
L. DE FOURCAND, 'Les Arts
Décoratifs du Salon de 1892
Champs-Elysées et
Champ-de-mars', *Revue des Arts
Décoratifs*, 1892–3.

Auguste Delaherche was born in Beauvais. His family, and in particular his uncle Eugène Delaherche whom Auguste visited regularly, were collectors. In Eugène's home he saw furniture, copper, and ceramics of all types including the locally produced stonewares.

He went to the Ecole des Beaux Arts in Paris in 1877 at the age of twenty and trained as a designer-decorator. His first job was as a designer for a company of metal-platers working for Christofle, and later as teacher to the new apprentices. However, in 1883, on one of his regular holidays in his native region, he began to study the local potters' work. At a small village just outside Beauvais he was offered the use of a kiln at 'L'Italienne', a pottery owned by Ludovic Pilleux, and began to divide his time between potting and travelling to Paris to teach. Like many of his contemporaries, Delaherche was attracted by the idea of producing cheaply-made fine pottery.

The first pots Delaherche made at 'L'Italienne' were in earthenware and decorated in traditional style with incised patterns and lines. This technique he carried on into his later stoneware in a deceptively unaffected, yet increasingly sophisticated manner. By 1887 he was well enough known in Paris circles to have met Ernest Chaplet (1835–1909) who had been employed for many years by Charles Haviland, the Limoges porcelain manufacturer, as the head of a stoneware studio in Rue Blomet in the Vaugirard quarter of Paris. Here Chaplet perfected a stoneware body and developed special decorating techniques and glazes. The majority of these glazes were based on metals, particularly copper, fired at high temperatures in a kiln in which the atmosphere was dramatically altered at a critical moment by the limitation of oxygen resulting in a violently gaseous condition in the kiln which reacted spectacularly with the glazes.

In 1887 Delaherche took over Chaplet's workshop in a carefully-timed transfer, Delaherche agreeing to absent himself as Chaplet fired his last pots to his own highly-secret formula. In that same year Delaherche displayed a selection of his work at the Union Centrale des Arts Décoratifs, Paris, with con-

siderable success. Two years later, in 1889, he was created a Chevalier de la Légion d'Honneur for his display in the international exhibition where he was awarded a gold medal.

The influence of the local pottery and traditional patterns survived in his work. The strong, even monumental forms of his vases—urn-shaped with handles or plain—*jardinières*, and dishes, were covered with his darkly dramatic glazes and further enriched with bands of incised or slip-inlaid flowers and foliage. In the early 1890s Delaherche experimented with abandoning even this decoration, paring his sculptural forms to a minimum, relieved only by raised or modelled leaf-like forms such as in this vase, one of his most impressive and typical shapes.

As he continued to exhibit his success grew. In 1892 he was included in an exhibition mounted by Les Vingt and, in the same year, at the Société Nationale des Beaux Arts, Champ de Mars, where he was described as '*le maître potier par excellence*'.

Delaherche continued to return to Beauvais for holidays. Between 1891 and 1892 he was working at Hericourt (Haute-Saone) on simple stonewares, where this vase may have been made, although his main studio was still in Rue Blomet. By 1894, finding his Paris successes increasingly hard to accept, he had decided to leave Paris for good and return to the simple principles with which he had started. He retired near Beauvais, settling at Armentières, La Chapelle aux Pots. However, he sent work to Paris for exhibitions, including that in 1900. He was accorded a special retrospective exhibition in 1907 at the Musée des Arts Décoratifs.

The development of Delaherche's work after his departure from Paris took several turns. During the later 1890s and until 1904 he concentrated more and more the forms of his stoneware, rejecting surface decoration. In 1904 he began to experiment with porcelain and, until his death in 1940, these two apparently contradictory techniques occupied him: his stoneware, strong and simple, his porcelain, delicate, carved in a highly ornamental manner recalling his early training as a designer and decorator. JHO

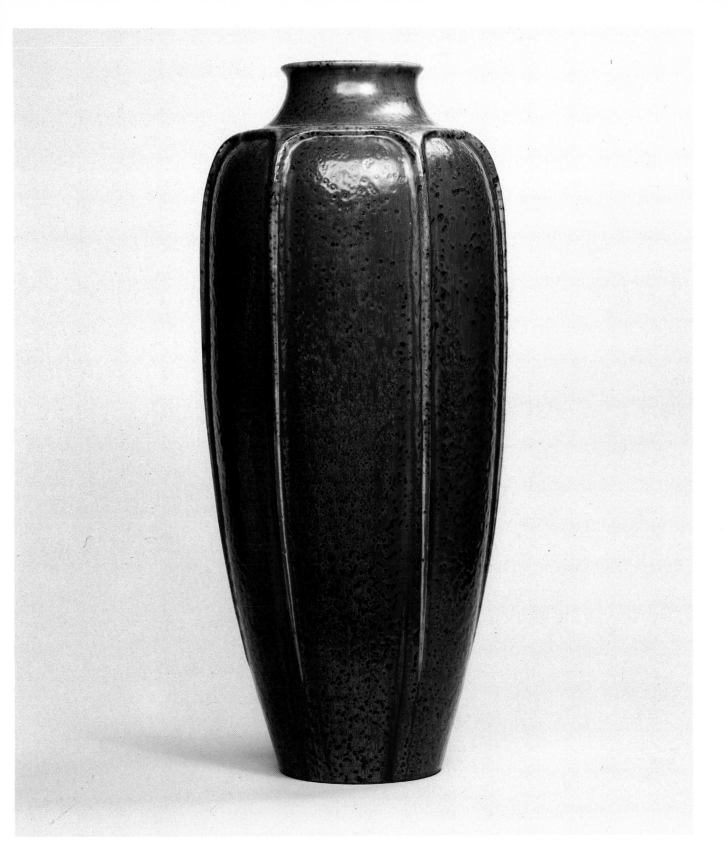

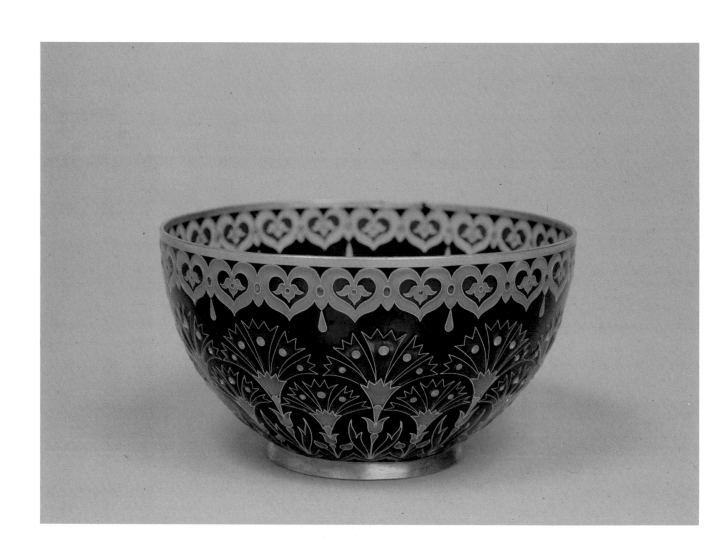

Bowl

By Fernand Thesmar
(1843–1912)
French: Paris, 1893
Gold with *plique-à-jour* enamel
h 4.9 cm (2 in.); *diam* 9.2 cm
(3⅝ in.)
Monogram of Thesmar in black
enamel outlined in gold; '1893'
in gold
357–1894

Literature

H. BOUILHET, *L'Orfèvrerie
française aux XVIIIe et XIXe
siècles*, III, Paris, 1912
V. CHAMPIER, 'Fernand
Thesmar', *Revue des arts
décoratifs*, XVI, 1896
L. FALIZE, 'Les Industries d'Art
au Champ de Mars, II, Les
Bronzes', *Gazette des Beaux-Arts*,
2e période, XVIII, 1878
E. GARNIER, 'Les Coupes de
M. Thesmar', *Revue des arts
décoratifs*, XI, 1890–1
G. MOUREY, 'Fernand Thesmar',
Les Arts, no. 129, 1912
Revue des arts décoratifs, XIII,
1892–3

Fernand Thesmar was born in Chalon-sur-Saône in 1843. Chemistry had an early fascination, but he was trained as a designer of textiles in Mulhouse and learnt to dissect and draw plants. In 1860 he left for Paris where he continued to work in textiles. In 1872 he was invited to devote himself to cloisonné enamels by Ferdinand Barbedienne who had already formed an outstanding collection of Japanese enamels. During the 1870s Thesmar's cloisonné enamels won an international reputation. While Lucien Falize found some grounds for criticizing Thesmar's use of half-tones and of large cloisons in the enamels shown at the Paris Exhibition of 1878, he did not question his virtuosity, and the Japanese government bought his work for the Tokyo Museum.

Despite his success, Thesmar's finances were precarious. In 1888 he found himself excluded from his workshop by his landlord. To his aid came first a firm of art dealers, and then the redoubtable Alfred Morrison, the great collector of manuscripts and the patron of Plácido Zuloaga. In the year of his troubles Thesmar perfected the technique of *plique-à-jour* enamelling, in which translucent enamel is held in its cell without backing. Morrison bought an early example, tracked Thesmar down to his workshop in Neuilly-sur-Seine, and invited him to London. He appears to have remained there until about 1890 when the Musée des Arts Décoratifs in Paris purchased two small *plique-à-jour* bowls. One of these is almost identical in its Ottoman and Mameluke inspired design to the Victoria & Albert Museum bowl, but differs in colour.

This bowl was purchased for £71 10s 10d (1800 francs) in 1894. In recommending the purchase, C.P. Clarke explained how he and his colleague Thomas Armstrong had seen Thesmar's work in Paris in 1892, but 'considered the prices prohibitive'. However, he had since had an opportunity to handle an example in Alfred Morrison's collection and realized the technical complexity of Thesmar's achievement. Armstrong, who was responsible for Thesmar submitting the bowl for purchase, clearly admired Thesmar's technique more than his design:

> All the works of this kind I have seen by Monsieur Thesmar except this one have appeared to me objectionable and unsuitable to our museum on account of bad taste in design generally and especially of the crude contrasts of colour in them but they were interesting by reason of the difficulties overcome in using precious materials which, applied with good taste, lend themselves to combinations of great beauty. In this cup there is a certain restraint in the scheme of colour which makes it the most acceptable specimen of Mons. Thesmar's art I have seen.

In 1912, the year of his death, Thesmar was described by Henri Bouilhet as not only in the front rank of enamellers, but as the best. RE

Mask, self portrait

Made by Jean-Joseph-Marie
Carriès (1855–94)
French: St Amand-en-Puisaye,
Nièvre, c.1890–2
Stoneware
l 25.6 cm (10¼ in.)
Marks: POUR B ... (indistinct) and
J. CARRIES, incised
C.60–1916
Given by Prince Antoine Bibesco
and Paul Morand

Literature

TAXILE DOAT, 'Grand Feu
Ceramics' (transl. by Samuel
Robineau) Keramic Studio, vol.V,
1903–4
EMILE HOVELAQUE, 'The Life
and Work of Jean Carriès',
Architectural Review, vols.III, IV,
1897, 1898
Société National des Beaux Arts,
1892, cat.nos.1457–1473

Jean-Joseph-Marie Carriès was a curious and romantic character even to his contemporaries. He was born in Lyon, one of four children of a cobbler. At fourteen he became apprenticed to a maker of religious statuettes but his ambitions went higher than the multiple production of souvenirs and, visiting the local and Paris museums, he acquired a passion for medieval sculpture. In 1874 he moved to Paris, to the Ecole des Beaux-Arts, but he soon set up independently and continued his own studies in the Louvre. From 1878–88 Carriès concentrated on sculptural work — largely in the form of portraits — living for the most part in penury. Masks, with expressions of various passions, were a much-repeated form and a great proportion depict an intense bearded face that certainly must represent Carriès' own habitual expression of determination and, said his friends, reckless commitment to his art. His first models were beggars from the street, his materials wax or plaster which he patinated (in some cases with wax) in rich browns, russets, and ivories.

In 1881 Carriès achieved his first financially successful exhibition and was thus able to cross the major divide from plaster and wax to bronze by the cire perdue method. He finished each piece meticulously with patinations derived from a potentially lethal mixture of metals, acid, charcoal, and heat. By 1888 he decided to abandon bronze casting in favour of a simple country life as a potter, a vocation which to him had the additional attraction of possibly 'cheap production of sumptuous, varied materials'.

Carriès escaped to St Amand-en-Puisaye where he built his own kiln and also worked at the nearby Château Montriveau. Specializing in stoneware, he experimented with a variety of glazes in emulation of the Bizen and Seto wares he had seen at the Paris Exhibition of 1878, achieving, within a few months, 350 glaze trials and forty sculptural pieces with glazes and enamels which he exhibited. This led to a major commission by the Princesse de Scey-Montbéliard for a doorway in stoneware. The size, weight, the number of individual blocks of minutely finished stoneware, and the degree of perfection which he expected of himself — all contributed to an inevitable failure and, at his death, the door stood unfinished.

At the same time, Carriès continued to produce small-scale pots and sculptural pieces, and in 1892 he exhibited these at the Société Nationale des Beaux Arts, Champ de Mars, with some sections of the doorway as well as fourteen bronze and wax sculptures. The show drew much acclaim and the state placed a large order for its museums. Fellow and younger potters strove to capture Carriès' subtle and natural, yet rich colours, thickly applied to organic forms.

In 1894 he fell ill at Montriveau. His friend and collaborator, Georges Hoentschel (1855–1915), brought him back to Paris where he died of pleurisy on 1 July 1894.

Taxile Doat (1851–1939), one of the senior artists at Sèvres who later moved to America to help set up an art pottery at St Louis, has explained Carriès' impact on his generation of potters: 'Without any help from chemists and without financial resources [he] carried to its apogée the grès cérame ... then ceramists became legion, everyone wanted to model grès. This grand feu stoneware temporarily forged ahead of the porcelain . . . Carriès, taken away in the midst of his youth and talent, had, like Palissy, numerous imitators, not gifted with the flame of the master.'

His work clearly reflects his two major passions, medieval sculpture and Japanese pottery and, in an example like this mask, his interest as a sculptor in the grotesque faces and slightly sinister comedy of cathedral decoration is combined with his skill as a potter and glaze chemist. Many figures and masks took an extreme and sinister form, involving stages of metamorphosis of man, beast or frog, the effect of unease further heightened by Carriès' repertoire of mottled earthy colours. In the same studio he produced pots of an extraordinary delicacy, tinged with pink, greens, and greys. While fascinated by the morbid and the anguished, he also revelled in natural forms and the colours of nature. It was this variety that drew the most fulsome appreciations after his untimely death. JHO

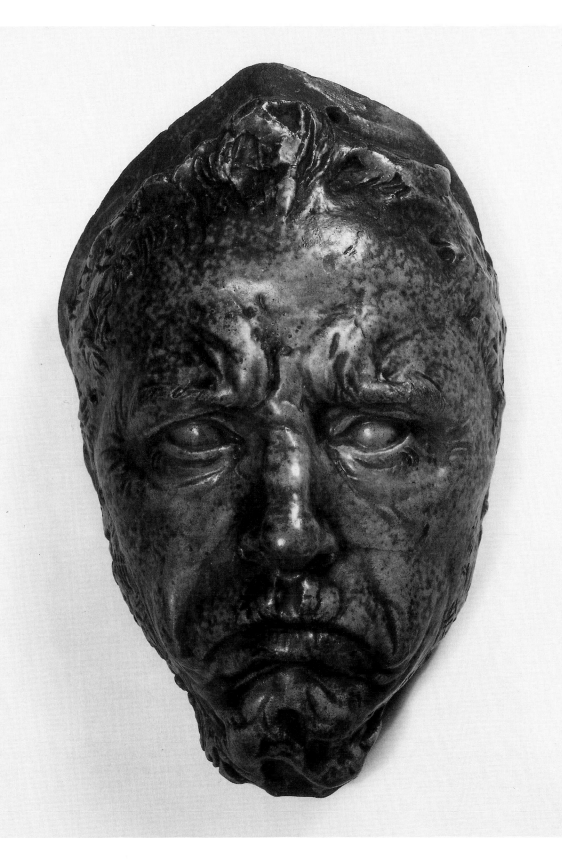

Cours de Danse Fin de Siècle

Text by Erastène Ramiro
Bound by Salvator David
(d.1929)
Illustrated with 11 etchings (of
which there are 2 sets in this
copy), vignettes, and initials by
Louis Legrand (1863–1951)
One of an edition of 49 copies on
Japan vellum paper
French: Paris, E. Dentu, 1892
h 29.5 cm (11½ in.)
w 20.5 cm (8 in.)
L.2211–1953

Literature

E. DE CRAUZAT, *La reliure
française de 1900 à 1925*, Paris,
1932
Göttingen, Stadtisches Museum,
*Louis Legrand. Zeichnungen und
Druckgraphik*, 1983

Octave Uzanne, that arbiter of taste in all things relating to fine books, remarked in his *Nouvelle Bibliopolis* of 1897 that truly modern binding, *reliure d'art*, only emerged with the disappearance of the *'génération de 1875'*. Certainly in the 1880s a new kind of publishing emerged of de-luxe books consciously issued as works of art that could take their place with other specimens of the decorative arts of the day. Books of this kind were often issued in limited editions and reserved for members of the bibliophile societies that were springing up in the last quarter of the nineteenth century. They were illustrated by people termed artists and painters rather than book illustrators, and often included an extra set of illustrations for the delight of the collector and connoisseur. The binder Marius Michel led a vogue for 'artistic' bindings that could match other aspects of such books.

From about 1830 to 1880, bindings done by hand had been decorated with historicist styles that took Renaissance, baroque, and rococo designs as their chief model. As a result of the freedom with which industrially-produced publishers' bindings were decorated, binders commissioned to produce *reliures d'art* on an individual basis towards the end of the nineteenth century adopted a freer approach to the decoration of their work. Bindings of this kind were made to suit the eye of bibliophiles who wanted books that could hold their own with other art forms and who expected the decoration of the binding to provide an individual interpretation of the book's contents.

The binding by Salvator David is in green goatskin with coloured leather overlays and gold tooling. The design reflects the influence of *Japonisme*, then fashionable for the decorative arts. Son of a binder who had worked for Léon Gruel before setting up his own business, Salvator David had at first engaged in the commercial binding of whole publisher's editions before devoting himself to *reliure d'art*.

The text of *Cours de Danse* gave instruction on the different steps, positions, and movements for Cancan dancing. It was written by the lawyer, bibliophile, and art-collector Erastène Ramiro, and aimed to do no more than provide a foil to the accompanying etchings by Louis Legrand. This publication marked the beginning of Legrand's successful career as a *peintre-graveur* until the demise of the de-luxe illustrated book after World War I.

The publisher Édouard Dentu had converted his father's printing business into a publishing house and made a fortune producing political works and modern popular novels before his death in 1884, though he had also published a de-luxe edition of the Goncourt brothers' *L'Art au dix-huitième siècle*. His son-in-law M. Hippeau was responsible for the *Cours de Danse* of 1892. RW

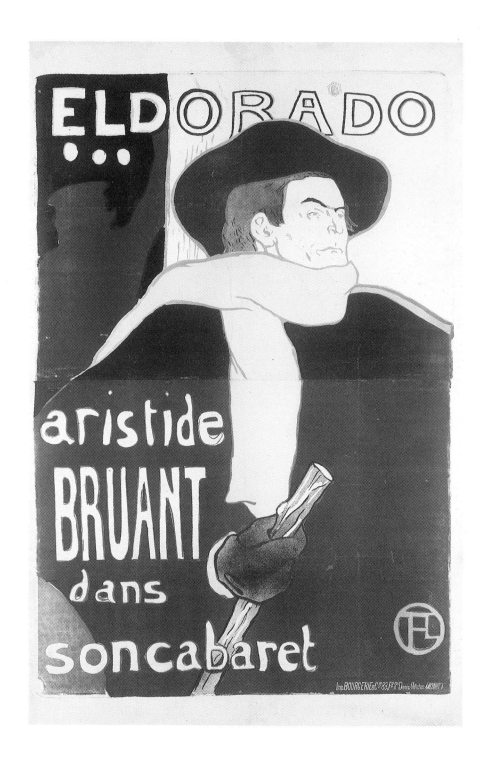

Eldorado . . . Aristide Bruant dans son cabaret

By Henri Marie Raymond de Toulouse-Lautrec (1864–1901) French poster advertising the appearance of the singer Aristide Bruant in his cabaret at the Eldorado café-concert, Paris, 1892
Colour lithograph
Size of sheet 136 × 95.5 cm ($53\frac{1}{2}$ × $37\frac{1}{2}$ in.)
Signed with monogram *HTL*
Lettered *Imp. Bourgerie & C.ᵉ 83, F.S.ᵗ Denis (Affiches Ancourt)*
Circ 669–1967

Literature
Götz Adriani, *Toulouse-Lautrec, das gesamte graphische Werk*, Cologne, 1976
Philippe Huisman and M.G. Dortu, *Lautrec par Lautrec*, Paris, 1964
Philippe Huisman and M.G. Dortu, *Toulouse-Lautrec et son oeuvre*, New York, 1971
Mauric Joyant, *Henri de Toulouse-Lautrec 1864–1901*, Paris, 1927
Edouard Julien, *Les Affiches de Toulouse-Lautrec*, Paris, 1956

Henri de Toulouse-Lautrec, the French painter and graphic artist, was born in Albi, the son of Count Alphonse de Toulouse-Lautrec Monfa. Physically deformed as the result of crippling falls in childhood, he nevertheless developed an early talent for drawing which was fostered by his uncle Count Charles de Toulouse-Lautrec, an amateur artist, and other artist friends of the family. He received a conventional academic training in Paris, from 1882 under the portrait painter Léon Bonnat, and from 1883 at the school of Fernand Cormon, a painter of religious and mythological scenes. Once Lautrec was established in his own studio in Montmartre in 1885 he began to make illustrations for contemporary journals, and to come into contact with painters from the Impressionist and Post-Impressionist schools, being particularly influenced by the work of Degas. From the late 1880s and through the 1890s Lautrec frequented the bars and cabarets of Paris, particularly Montmartre, and produced his brilliant series of posters, drawings, and paintings which depict the protagonists of that nocturnal world: singers, dancers, and entrepreneurs, such as Jane Avril, Yvette Guilbert, 'La Goulue', May Belfort, and Aristide Bruant.

Toulouse-Lautrec designed three posters for Aristide Bruant (1851–1925) in 1892, and all show the singer and cabaret owner (who specialized in a biting delivery of topical songs) as a powerful, almost menacing figure in his black cloak, large hat, and red scarf wound around his neck. In this two-sheet poster, advertising Bruant's appearance at the Eldorado, Lautrec portrays the singer in a pose which is a mirror image of the one depicted in the slightly earlier poster for his appearance at the Ambassadeurs. The poster makes its impact through the apparent simplicity of composition, the bold outlines and solid blocks of colour recalling the manner of Japanese prints which Lautrec so much admired. The lettering and even the artist's monogram form part of the overall design. Wherever his posters were printed—in this case at the studios of Ancourt—Lautrec paid meticulous attention to the processes involved, working on the lithographic stone himself, applying splatter with the aid of a toothbrush to achieve a tonal effect, and mixing the inks with a spatula to ensure the colours were exactly those required. His keen interest in colour lithography, and his consummate skill in executing the technique, was a considerable factor in elevating the poster as a major art form.

The Musée Toulouse-Lautrec was founded in Albi in 1921. MWT

La Loïe Fuller

By Jules Chéret (1836–1932)
French poster advertising the
first guest appearance of the
American dancer Loïe Fuller at
the Folies-Bergère variety
theatre, Paris, 1893
Colour lithograph
Size of sheet 120 × 82.3 cm
($47\frac{1}{4} \times 32\frac{1}{2}$ in.)
Signed *J. Chéret*
Lettered *(Encres Ch. Lorilleux &
Cie) –93–23248 Imp Chaix
(Ateliers Chéret) 20, Rue Bergère
Paris*
E.113–1921
Given by Mrs J. T. Clarke

Literature
GUSTAVE KAHN, *L'Esthétique de
la Rue*, Paris, 1901
CAMILLE MAUCLAIR, *Jules
Chéret*, Paris, 1930 (includes a
catalogue of exhibits in the
Musée Jules Chéret at Nice)

Jules Chéret was a pioneer in exploring the possibilities of colour lithography as applied to poster design, and consequently in popularizing the colour pictorial poster and bringing this new art form to the streets of Paris. Born the son of a typographer, Chéret served a youthful apprenticeship to a lithographer, supplementing his education with evening classes at the Ecole Nationale de Dessin and regular visits to the Louvre (where he particularly admired the paintings of the French eighteenth-century artists). His early work as a lithographer included designs for book jackets and music titles, but his first notable commission was a poster in black and white for Offenbach's *Orpheus in the Underworld*, executed in 1858.

From 1859 to 1866 Chéret visited England for the second time (on his first visit in 1854 he had designed a furniture catalogue for Maples), and studied the techniques of printing in colour lithography which were being widely developed there. He also executed book designs for the publisher Cramer, as well as various posters for the circus, theatre, and music-halls. Accompanying the perfume manufacturer Rimmel, Chéret also travelled to Italy, where he became fascinated by the frescoes of Tiepolo; the style and composition of these murals had an undoubted influence on his future poster design.

On his return to Paris in 1886, with the financial backing of Rimmel (for whom he had designed labels and packaging), Chéret founded his own lithographic printing presses in which up-to-date English machinery was installed. Here he produced the first French posters printed in colour, and achieved, both as designer and lithographer, a prodigious personal output. His own designs he drew straight on to the lithographic stone, establishing the potential of the process as a direct graphic medium. Although he sold his press to the Imprimerie Chaix in 1881, Chéret retained artistic control, publishing not only his own posters, but also those of other designers, including Paul Berthon.

Chéret's best-known poster work captures the *joie-de-vivre* of the cabarets, music- and dance-halls, operas and theatres of Paris, and it was he whom the American star Loïe Fuller selected to design the poster for her Paris début at the Folies-Bergère in 1893. Loïe Fuller had begun her career as an actress in stock companies, burlesque, and vaudeville, but later changed to become a dancer. Her success lay in the inventiveness of her dancing, a style which combined graceful movement with the skilful manipulation of soft, billowing fabrics, the act illuminated by various lighting effects projected on to the darkened stage. While performing in America she had commented on the poor quality of the posters, which were all based on photographs; in contrast, Chéret's design for her French début succeeded in capturing the image of Loïe Fuller suspended in one of her light-and-movement dances. Chéret printed the poster in different colour combinations, possibly to give an impression of the four dances she performed on this occasion: the Serpent Dance, Violet Dance, Butterfly Dance, and White Dance. Other artists who also depicted Loïe Fuller were Toulouse-Lautrec, Jean de Paléologue, Georges de Feure and Manuel Orazi. She was also admired by Rodin, who dedicated a copy of *Le Baiser* to her. MWT

Two elevator grilles

Designed by Louis Henry
Sullivan (1856–1924)
American: Chicago, 1893–4
Iron with a painted finish
h 186 cm ($73\frac{1}{4}$ in.); w (left-hand
grille) 99.5 cm ($39\frac{1}{4}$ in.); w (right-
hand grille) 74 cm (29 in.)
M.9 and a–1983

Literature

ARTHUR J. PULOS, *American
Design Ethic, A History of
Industrial Design*, Cambridge,
USA, 1986
JOHN VINCI, *The Stock Exchange
Trading Room*, Chicago, 1977
WIM DE WITT (ed.) *Louis
Sullivan, The Function of Ornament*,
New York and London, 1986

Louis Sullivan was born in Boston, the son of an Irish dancing master. He began his architectural training at the age of sixteen when he entered the Massachusetts Institute of Technology. He studied there for a year under William Robert Ware. In 1873 he moved to Philadelphia where he served for several months as a junior draughtsman in the office of Frank Furness and George Hewett, after which he moved to Chicago to complete his apprenticeship in the office of William Le Baron Jenney, an engineer/architect who helped to develop the skeleton structure for skyscrapers.

In 1874 Sullivan left Chicago for Paris to study at the Ecole des Beaux Arts in the atelier of Joseph-Auguste Emile Vaudremer, a leading proponent of the French Neo-Grec style. Sullivan was never in favour of historical revival simply for its own sake and his stay in Paris was brief. By July 1875 he was back in Chicago where he held a number of different jobs until 1879, when he was hired by Dankmar Adler to take charge of his drawing office prior to being made a full partner in 1881. The partnership of Adler and Sullivan was to last until 1895 during which time they designed, for the mid west, some of the most influential buildings in the history of American architecture. These were to include the Auditorium Building in Chicago (1887–9) which established their fame nationally, the Getty Tomb in Chicago (1890), the Wainwright Building in St Louis (1890–91), the Transportation Building at the Chicago World's Columbian Exposition in 1893, the Guaranty Building in Buffalo, New York (1894–96), and the Chicago Stock Exchange Building (1893–4) on the corner of La Salle and Washington Streets for which these lift grilles were supplied.

Sullivan always considered the ornamental element in his architectural work to be extremely important. His mature decorative style was an intensely personal expression of organic motifs. The richly ornate cast-iron panels of the first two floors of the Chicago department store for Schlesinger-Meyer (1899–1904), later renamed Carson Pirie and Scott and Sullivan's last major commercial commission, is perhaps the most convincing illustration of this. But his early designs owe something to English Reformed Gothic prototypes. Christopher Dresser's influence by his advocacy of conventionalizing motifs from nature can be traced in Sullivan's more geometrical ornament along with the principles outlined by Owen Jones in his *Grammar of Ornament* (published in 1856) where it was stated that 'all ornament should be based upon a geometrical construction'. The stylized repetition of linear motifs, evident in the polychromatic friezes for the trading room ceilings and in the design of these lift grilles which screened the shafts from floors three to thirteen of the Stock Exchange Building, shows evidence of all these influences. These grilles, a combination of strap iron and small iron spheres, were originally framed by bronze-plated cast-iron casings and ornamented with cast bronze T plates. A complete assembly is in the architectural collection of the Art Institute of Chicago, acquired after the demolition of the Stock Exchange Building in 1972.

Sullivan's work at times has been compared to the aspirations of the English Arts & Crafts movement and to Continental Art Nouveau. Although he shared some principles common to both, he was never a part of either. Sullivan never allowed his ornamental detailing to disguise or interfere with the structure of the building. He despised the work of the fashionable Beaux Art architects employed by the East Coast establishment who used a range of historical styles to shroud all evidence of the building's internal structure. Sullivan through his experience in Jenney's office was committed to structural innovation. His use of the cast-iron skeleton, always given external expression in the office blocks he designed, allowed him to build taller buildings than had hitherto been possible and paved the way for the development of the American skyscraper of the twentieth century. Frank Lloyd Wright was so impressed by the work being carried out by Adler and Sullivan that, after a year studying engineering at the University of Wisconsin, he refused the opportunity to study at the Ecole des Beaux Arts in Paris in order to apprentice himself to Sullivan's office in Chicago. His experience there had a lasting influence on his career which Wright always gratefully acknowledged. ET

Vase

Made by Georges Hoentschel
(1855–1915)
French: St Amand-en-Puisaye,
Nièvre, c.1895
Stoneware, carved and modelled,
glazed and with gilt splashes
h 44.6 cm (17½ in.)
Marks: GH in monogram
impressed, 19X and other
indistinct marks incised
c.60–1972
Formerly in the Handley-Read
Collection

Literature

EMILE GALLÉ, 'Le Pavillon de
l'Union Centrale des Arts
Décoratifs à l'Exposition
Universelle', *Revue des Arts
Décoratifs*, vol.XX, 1900
GEORGES HOENTSCHEL,
*Décoration et mobiliers des édifices
publics et des habitations,
Rapports des groupe 37*, Paris,
1907
Paris, *Musée Centennal de la Class
72 Céramique à l'Exposition
Universelle Internationale de
1900*, Rapport du Comité
d'Installation
ANDRÉ PÉRATÉ, Conservateur
adjoint des Musées Nationaux,
*Collections Georges Hoentschel,
acquisés par M.J. Pierpont Morgan
et prêtées au Metropolitan Museum
de New York*, Paris 1908

Georges Hoentschel was an architect, sculptor, and collector, as well as a ceramist. His particular interest in ceramics, like that of many of his contemporaries, was inspired by the Paris Exhibition of 1878. While Japanese art had made its first international impact in London in 1862 and Paris in 1868, it was the 1878 exhibition that triggered a revolutionary impulse through the French pottery movement. For the stoneware potters the most interesting displays were those of *Bizen* and *Seto* wares. Hoentschel drew on both the materials used, the combination of stoneware and dark, mottled glazes, and also the Japanese skill and delight in playing visual tricks: ceramic made to imitate bronze lacquer or natural forms such as plants or fruits. This humour and virtuosity plays a part across a wide spectrum of Japanese art. From metalwork to ivory, any material may be fashioned to mimic another. With this vase, Hoentschel produced an extravagant and entirely personal interpretation of the Japanese manner. The influences are discernible but the resulting fantasy is entirely Hoentschel's own.

Hoentschel was born in the same year as his close friend Jean Carriès (1855–94). Carriès enjoyed widespread influence following his exhibition of stoneware (*grès cerame*) in the Société National des Beaux Arts in 1892. He was not the first to exhibit stoneware with coloured glazes as its sole or chief decoration— Auguste Delaherche had shown such pieces in 1889—but his repertoire was more varied than that of most other potters. His expert superimposition of glazes, in deliberately uneven or run layers, on natural, organic forms caught the imagination of contemporaries and critics. As well as Hoentschel, his direct followers included the potter and collector Paul Jeanneney (1861–1920) and Emile Grittel (1870–1953).

Hoentschel's friendship with Carriès and his enthusiastic adoption of the potter's life apparently date from about 1888 to 1890 when Carriès was established at St Amand-en-Puisaye in the Nièvre district of mid France. Working with local potters Armand and Eugène Lion, Hoentschel joined Carriès at St Amand in the early 1890s and became a close friend, collab-

orator, and admirer. On Carriès' death in 1894 it was Hoentschel who cared for him in his last days, who bought up the contents of his workshops, and, subsequently, acquired the nearby Château Montriveau where he worked with Grittel until about 1902.

Grittel, also a former student of Carriès, established his own studio in Paris where he fired stoneware made by Hoentschel and he may have been partly responsible for this piece. His own work was in similar vein, in stoneware with mottled glazes, gilt 'splashes', and based on natural, organic forms. By 1900 Hoentschel had also enlisted the services of a modeller, Deschamps. This was probably the Frédéric Deschamps who modelled the large *jardinière* also shown in this gallery, and which Hoentschel produced in numbers.

Hoentschel amassed a large collection of French art from the middle ages to his own time and by 1908 had sold the major proportion of the earlier pieces to J. Pierpont Morgan, who subsequently presented them to the Metropolitan Museum in New York. He lent his collection of Carriès ceramics to the Paris Exhibition of 1900, and afterwards donated it to the state. It was as a collector, decorator, and connoisseur that he fulfilled a number of official, or semi-official roles in the international exhibitions. Apart from his loans, he also arranged the Pavillon de l'Union Centrale des Arts Décoratifs, the show place for the most progressive and experimental of the decorative and applied arts. In Emile Gallé's effusive appreciation of the design and arrangement, Hoentschel is praised both for his exquisite taste and beautiful artistry as well as for his emulation of and friendship for '*le grand Carriès*'. Eugène Grasset, the Paris designer who was included in Hoentschel's arrangement at the Paris Exhibition of 1900, drew up the basic design for the portal on which Carriès worked in his last years.

In 1904 Hoentschel was exhibiting in the international exhibition in St Louis and also contributing to the reports on decorations and furnishings. Towards the end of his life he returned to Paris where he worked at Grittel's studio until his death in 1915. JHO

The Pardon

By Constantin Meunier
(1831–1905)
Bronze
Belgian: Louvain, cast 1896 after
a model of 1895
h 44.8 cm (17⅝ in); w 21.9 cm
(8⅝ in.); d 42.5 cm (16¾ in.)
Signed 'C Meunier' on the back,
and inscribed 'B. VERBEYCT.
FONDEUR. BRUXELLES' on side
764–1899

Literature
MARGARET DEVIGNE, *La
Sculpture Belge 1830–1930*,
Bruxelles, 1930
ANDRÉ FONTAINE, *L'Art Belge
depuis 1830*, Paris, 1925
ANDRÉ FONTAINE, *Constantin
Meunier*, Paris, 1923
MICHELINE HANOTELLE, *Rodin et
Meunier: Sculptures Français et
Belges à la fin du XIXe. Siècle*,
Paris, 1982
CAMILLE LEMONNIER,
Constantin Meunier, Paris, 1904

Constantin Meunier studied sculpture for a short time before taking up painting in about 1854. Many of the subjects he chose were religious and reveal an early inclination towards themes of death and suffering. He was profoundly influenced by a tour he made of the Black Country and coal mines with his friend and biographer Lemonnier in 1881, and thereafter industrial themes dominate his work. After a break of nearly thirty years, Meunier returned to sculpture in about 1884, and his figures of *The Hammerer* (Paris Salon, 1886) and *The Puddler* (Salon, 1887) won universal acclaim. His work was also admired in Belgium by the avant-garde Les Vingt where Rodin, Gauguin, and Seurat also exhibited. In 1887 he was appointed Professor of the Academy at Louvain where much of his sculpture, including work for his planned monumental *Glorification of Labour* was produced.

When *The Hammerer* was first exhibited, the precedent for workers and peasants as protagonists was already well-established in both art and literature. The peasants in Millet's work were almost certainly known to Meunier. Courbet's *Stonecutters* and *Burial at Ornans* had provoked controversy in 1851. Awareness of the working class as an integral part of society was increased in 1885 by the publication of Zola's *Germinal* and specifically in Belgium by the establishment of the official Workers' Party that year. However, critics were still struck by Meunier's heroic treatment of such lowly subject matter.

There are comparatively few religious sculptures in Meunier's work but all are characterized by an emotional intensity seen particularly in this work, and in the utter dejection of Christ in *Ecce Homo* of a similar date. *The Pardon* was first exhibited as *The Prodigal Son* both at the Salon des Beaux-Arts and des Vingtistes in 1892. After the tragic deaths of his two sons in separate incidents in 1894, Meunier returned to this subject which appeared in the Salon at Ghent in 1895 as a plaster model, and in bronze the following year at the Salons de la Libre Esthétique and de L'Art Nouveau as *The Pardon*. The personal significance of the work is emphasized by Lemonnier who comments on the facial similarities between Meunier's own son Karl and the figure. Seen in this personal context, the change of title to *The Pardon* is interesting, as it shifts the emphasis from the fact of the son's return to the emotion, so acutely portrayed, of his father's forgiveness.

In 1900 Gustave Geffroy described Meunier's work as 'a sombre poem of labour and suffering'. These two themes, often overlapping, characterize most of Meunier's sculpture. It is for the figures, reliefs, and drawings of workers, whether industrial or agricultural, that Meunier is best known. The depiction of suffering seems to be Meunier's chief objective in the more personal bronzes exemplified by *The Pardon*.

AFR

Lorenzaccio

By Alphonse (Alfons Maria)
Mucha (1860–1939)
French poster advertising
Lorenzaccio, adapted by Armand
d'Artois from the play by Alfred
de Musset, first performed at the
Théâtre de la Renaissance, Paris,
3 December 1896, with Sarah
Bernhardt in the leading role of
Lorenzo de Médicis (Lorenzaccio)
Colour lithograph
Size of sheet 205.7 × 75 cm
(81 × 29½ in.)
Signed *Mucha*
Lettered *Imp. F. Champenois.
Paris*
E.1283–1963

Literature
JIŘI MUCHA, *Alphonse Mucha:
his life and art*, London, 1966
JIŘI MUCHA, *The Master of Art
Nouveau: Alphonse Mucha.*
Prague, 1966
JIŘI MUCHA, *Alphonse Mucha:
Posters and Photographs*, by J.M.,
M. Henderson, A. Scharf,
London, 1971
JIŘI MUCHA (ed.) *The Graphic
Work of Alphonse Mucha*,
London, 1973
BRIAN READE, *Art Nouveau and
Alphonse Mucha*, London, 1963

Alphonse Mucha was born in 1860 in Ivančice in Moravia. He began his career (which later encompassed book illustration, painting, design for the decorative arts, and posters) in a scene-painting workshop in Vienna. In 1881 Mucha left Vienna and, while working as a restorer in the castle of Mikulov, met Count Karl Khuen-Belasi who commissioned him to paint a series of murals for the library and dining room of his country house at Emmahof. The count later recommended Mucha to work for his brother at Schloss Gandegg at Bolzano in 1883, and subsequently financed Mucha's studies at the Munich Academy until 1887. Here Mucha was taught by Ludwig von Löfftz and Johann Caspar Herterich, and also came under the influence of the decorative and historical painter Hans Makart. From 1887, Mucha attended the Académie Julien in Paris, under Jules Joseph Lefebvre, Gustave Boulanger, and Jean Paul Laurens, and in 1889 was briefly at the Académie Colarossi. The suicide in that year of his patron, Count Khuen-Belasi, was a financial blow, and from then until 1894 Mucha sought to make a living by supplying illustrations to various French and Bohemian books and journals; the style and subject matter of these drawings were largely influenced by his academic studies.

Mucha's sudden rise to fame, and his consequent popularity during the whole period of Art Nouveau, was sparked off by a commission in 1894 from the printers Lemercier to design a poster for Sarah Bernhardt (1844–1923) in her leading role in Sardou's play *Gismonda* at the Théâtre de la Renaissance in Paris. Various artists had received earlier commissions to make posters for Bernhardt (notably Eugène Grasset who portrayed her in *Jeanne d'Arc* in 1890), but Mucha's *Gismonda* so delighted the actress that she gave him a six-year contract for the design of her future posters. She also commissioned him to create various stage designs and costumes, as well as menus, calendars, and other printed ephemera. Mucha now developed freely as one of the most original artists of Art Nouveau, combining in his work elements from contemporary French styles (the decorative, formalized compositions

of Grasset were a particular influence) with those from the traditional decorative sources of his own Austro-Bohemian background. In all he designed at least eighty-three posters, including those for Sarah Bernhardt, and advertisements for the *Salon des Cent*, 1896 and 1897, *Job* cigarette papers, and *Bières de la Meuse*, 1898, as well as decorative panels such as *Les Saisons*, 1896, and *Les Fleurs*, 1897.

Lorenzaccio was printed by Champenois of Paris and, like his others for Bernhardt (for example *Gismonda*, 1894, *La Dame aux Camélias*, 1896, and *Medée*, 1898), has tall vertical proportions consisting of two sheets lithographed separately and fitted together. The figure of Bernhardt as the young Lorenzo de Medici is shown full length, elongated and curved within a semicircular frame. This frame is lettered 'Sarah Bernhardt Anno Domini MDCCCXCVI' and decorated with stars—the six-point stars which appear here were among Mucha's favourite symbols. A dragon surmounts the niche, while within it the coat of arms of the Medici family is placed among the stylized plant motifs; a male figure pierced by a sword lies beneath the plinth. As with all Mucha's posters the colouring is muted and subtle, in this case with brown, green, and gold predominating.

Various exhibitions of Mucha's work were held during his lifetime, the first in Paris in 1897—the year when *La Plume* devoted a special number to the artist. In 1963 the Victoria & Albert Museum held a large retrospective exhibition of his work. MWT

Bowl

Designed and made by Hanna
Gabrielle Hoffmann (1858–1917)
Danish: Copenhagen, c.1896
Silver, parcel gilt
h 8.1 cm (3⅜ in.); w 15.5 cm
(6¼ in)
Marks: French first standard
mark in use from 10 May 1838; a
small illegible French mark
(perhaps an import mark) on one
of the feet; English import mark
for 1896–7; J.G. crowned for
Garrard's
470–1897
Purchased for £11 4s from
Miss Hanna Hoffmann,
23 St Knudsvei, Copenhagen per
Garrard & Co.

Literature

MARTIN EIDELBERG and
WILLIAM R. JOHNSTON,
'Japonisme and French
Decorative Arts' in *Japonisme,
Japanese Influence on French Art
1854–1910*, Cleveland, 1975

Hanna Hoffmann was born in 1858 at Molde in Norway. She began her artistic career by studying painting with Vilhelm Kyhn and O.A. Hermansen. Between 1885 and 1888 she attended the Tegne-og Industrikolen for Kvinder (School of Drawing and Industry for Women) in Copenhagen and then, on the recommendation of August Saabye, she was admitted to the Academy where she studied under the sculptor T.H.Stein. In 1894 she was awarded a travelling scholarship and until 1905 spent most of her time in Paris where she worked principally as a silversmith and chaser for several firms producing objects decorated with *japonoiserie* ornament.

The design of this bowl can be attributed to Japanese sources. A combined motif of Japanese fretwork, interspersed with scrolling clouds, is used in three-dimensional form for the four cast feet and repeated with variations, forming a sequence of arches in a continuously engraved border round the rim of the raised bowl. Beneath each arch is embossed a floral spray set against a punched and matted ground. A simple contrast of colours has been achieved by gilding the interior while leaving the outside plain. Although this particular bowl was produced during one of Hanna Hoffmann's return visits

to Copenhagen, the lack of a complete series of Danish hallmarks and the existence of a French import mark suggests that it was originally intended for the Parisian market.

This design is evidence that the cult of Japan still flourished at a time when it had lost its exotic novelty and when Art Nouveau was rapidly becoming fashionable. Although the curving whiplash line was one of the chief characteristics of Art Nouveau and was often compared to Japanese designs, its rhythmic stylized formality clearly distinguishes it from pure *Japonisme*. It was considered by some that naturalism was the essential basis of a modern style and *Japonisme* survived because it offered a more suitable means of translating natural forms into a decorative system.

Hanna Hoffmann's later career was involved with textiles. After studying the technique of dyeing woollen yarn at Mora in Sweden in 1912, she established her own wool dyeing factory at Birkerød. She died there on 26 February 1917. ET

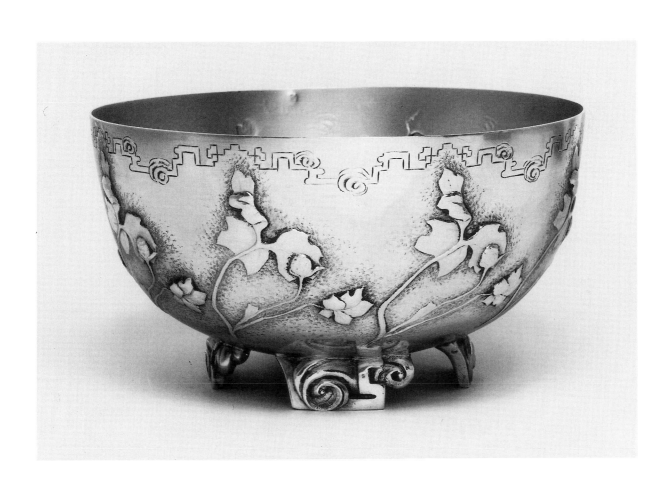

Affiches Charles Verneau 'La Rue'

By Théophile Alexandre Steinlen
(1859–1923)
French poster advertising the
printers Charles Verneau, 1896
Colour lithograph.
Size of sheet 231.8 × 292.1 cm
(91 × 115 in.)
Signed and dated *Steinlen 96*
Lettered *Charles Vernau, Imp.
114 Rue Oberkampf Paris*
E.521–1927
Given by C.G. Holme

Literature

Berlin, Staatliche Kunsthalle,
*Théophile-Alexandre Steinlen,
1859–1923*, Berlin, 1978
Paris, Société de Propagation des
Livres d'Art, Ernest de Crauzat,
*L'oeuvre gravé et lithographié de
Steinlen*, Paris, 1913

The Swiss-born Steinlen came to Paris in 1881. He settled in Montmartre and, during a long, prolific career, produced a number of fine posters (the first in 1885), as well as lithographs, paintings, and bronzes, and many illustrations for books and periodicals. Following his early training in a textile company in Mulhouse, Steinlen originally hoped to earn his living in Paris as a textile designer. However, his career changed direction when he met Rodolphe Salis, the cabaret owner and patron of the arts, who commissioned Steinlen to execute mural paintings of cats to decorate the wall of his cabaret Le Chat Noir. The cabaret had been founded in 1881, and was frequented by writers and artists including Paul Verlaine, Emile Zola, Félix Vallotton, Toulouse-Lautrec, and Jean-Louis Forain. This led to other commissions to provide illustrations for periodicals such as *Gil Blas Illustré, Le Courrier Français, L'Echo de Paris,* and *L'Assiette au Beurre.* Steinlen also contributed to the eponymous weekly magazine of Le Chat Noir from 1883 to 1895, and in 1896 produced one of his most famous images for the club, the wild-eyed black cat depicted in the poster *Tournée du Chat Noir avec Rodolphe Salis* (Steinlen had a lifelong devotion to cats and they frequently formed the subject of his work). When Le Chat Noir moved to new premises in 1885 Aristide Bruant took over the vacated rooms and founded a new cabaret Le Mirliton; as a close friend of Bruant, Steinlen made illustrations for the house journal *Le Mirliton* under the pseudonym 'Jean Caillou', and also illustrated both issues of Bruant's song collections *Dans La Rue* in 1888 and 1895.

From the middle of the 1880s Steinlen had adopted the medium of colour lithography, through which he found fresh and vigorous expression for his art. His linear style, developed during his years as a draughtsman, and his strong feeling for the decorative use of colour, were particularly suited to the medium. Although Steinlen was an ardent socialist, his concern for the ills of poverty and social injustice, so forcefully expressed in many of his illustrations, is not emphasized in his poster designs. *La Rue* which advertises Charles Verneau (the printer of most of Steinlen's posters) is an affectionate though keenly observed portrait of street life in Montmartre. This enormous six-sheet poster is a *tour de force* demonstrating Steinlen's ability to work on a grand scale in colour lithography. The artist creates an animated tableau in which a disparate cast of characters is woven into a total composition: on the left, a laundress bustles past a nursemaid and two workmen; on the right, proceed two young women— possibly a lady and her maid—who studiously avoid the gaze of an ogling businessman; and at the centre of the stage stands the little girl with a hoop. Steinlen's own daughter Colette was the model for this figure; she also appears as the subject of several of his other posters, including the famous *Lait Pur Stérilisé* of 1894. An intended companion poster to *La Rue*, entitled *La Boulevard*, was never executed.

MWT

Le Quatrième Salon Annuel de la Libre Esthétique

By Théodore (Théo) van Rysselberghe (1862–1926)
Belgian poster advertising the fourth exhibition of work by La Libre Esthétique, held at the Musée Moderne, Brussels, February to April 1897
Colour lithograph
Size of sheet 95.7 × 70.9 cm (35½ × 28 in.)
Signed with monogram *TVR*
Lettered *Imp. Monnom. Bruxelles*
Impressed twice over two poster tax stamps with the printer's stamp *Imp. Vᵉ Monnom 18 Février 1897*
E.280–1982

Literature

FRANÇOIS MARET, *Théo van Rysselberghe*, Antwerp, 1948
Ghent Musée des Beaux-Arts, *Rétrospective Théo van Rysselberghe*, Ghent, 1962
YOLANDE OOSTENS-WITTAMER, *La Belle Epoque: Belgian posters, watercolours and drawings*, Washington, 1970

Théodore (or Théo) van Rysselberghe was a painter and graphic artist who was born in Ghent in 1862, the brother of the architect Octave Joseph van Rysselberghe. He studied at the Ghent Academy under Théodore-Joseph Canneel, and later in Brussels under Jean-François Portaels and Léo Herbo. Although his early painting was in the classical manner, his first sight of *Dimanche à la Grande Jatte* and his subsequent meeting with Seurat in Paris in 1886 was a revelation, and he quickly responded to the theories and style of Neo-Impressionism, executing numerous portraits and various landscapes and seapieces in the pointillist manner.

Van Rysselberghe travelled widely during his lifetime, including visits to Morocco, Spain, Italy, France, England, and the East, and frequented various artistic circles. He was a founder member in 1884 of the art group Les Vingt, formed in Brussels by twenty artists who wished to exhibit their work outside the official salons. When the group's founder, the Belgian art critic Octave Maus (1856–1919), transformed the group in 1894 into a more flexible organization called La Libre Esthétique, van Rysselberghe (a friend of Maus) became once again a founder member and frequent exhibitor. In common with Henri van der Velde, he was also greatly influenced by William Morris, and the Arts & Crafts movement, and their place in the development of Art Nouveau.

The few posters that van Rysselberghe produced are outstanding for their high artistic quality, and those he designed for exhibitions held by La Libre Esthétique are undoubtedly his finest. The one advertising the fourth annual Salon is highly decorative in its composition and lettering, but also conveys a feeling for the monumentality of the two women who are admiring the piece of sculpture, within an atmosphere of almost domestic intimacy. An anonymous note on brown paper which is glued to the back of a poster in the collection of L. Wittamer-De Camps bears the inscription 'on the left, in red, Madame Van Rysselberghe, on the right, in an orange dress, Madame Octave Maus'. A second poster announcing the fourth salon of La Libre Esthétique, designed by van Rysselberghe's fellow member Gisbert Combaz, was also produced. MWT

II. KRAFT- UND ARBEITS-
MASCHINEN-AUSSTELLUNG
MÜNCHEN 1898.
PERMANENTE UND PERIODISCHE
GARTENBAU-AUSSTELLUNGEN.
11. JUNI —— 10. OKTOBER

KARL STÜCKER'S KUNSTANSTALT (G. FALTERMEIER) MÜNCHEN

II. Kraft- und Arbeits-Maschinen-Ausstellung, München 1898.

By Adolf Münzer (1870–1953)
German poster advertising the second exhibition of engines and machinery held in Munich,
11 June to 10 October 1898
Colour lithograph
Size of sheet 107 × 83.5 cm
(42 × 33 in.)
Signed with monogram and dated *AM 97*
Lettered *Karl Stucker's Kunstanstalt G. Faltemeier) München*
E.3314–1932
Given by Norman B. Stone

Literature

Munich, Galleria del Levante, *Leo Putz und 'Die Scholle'*, Milan, Rome, Munich, 1968
WALTER VON ZUR WESTEN, *Reklamekunst*, Bielefeld and Leipzig, 1903

Adolf Münzer was a German painter, graphic artist and illustrator who studied at the Munich Academy with Karl Raupp, Otto Seitz, and Paul Höcker. He began his career in Munich, then moved to Paris from 1900 to 1902, before returning to live in Munich from 1903–9. In 1909 he took up a teaching post at the Düsseldorf Academy.

Münzer was a member of Die Scholle, a Munich group of artists formed before the turn of the century as part of the German Secession movement which sought to break with the restraints of historicism and academicism, and to gain new freedom of expression. In 1912 he joined the Deutscher Werkbund, the organization of German manufacturers, artists, and designers formed in 1907 for the improvement of design in man-made products. As one of the chief contributors to the popular satirical magazine *Jugend*, published in Munich between 1896 and 1914, Münzer was closely involved in the development of Jugendstil, the German version of Art Nouveau, which took its name from, and found expression in, the magazine.

Münzer's poster for the Munich exhibition in 1898 emphasizes form and function. The composition is tightly and powerfully constructed, and the image of the two men harnessing their strength to set the great wheel of machinery in motion perfectly reflects the subject of the exhibition.　　　　MWT

The House Beautiful

Text by William Channing
Gannet[t] (1840–1923)
Designed by Frank Lloyd Wright
(1869–1959)
One of an edition of 90 copies
printed by the Auvergne Press
American: River Forest (Illinois),
1897
h 35.2 cm (13¾ in.)
w 29.5 cm (11½ in.)
L.229–1985

Frank Lloyd Wright printed *The House Beautiful* with William Herman Winslow, the owner of the Winslow Ornamental Iron Works, in the winter of 1896–7. The Auvergne Press that published the work had been set up in 1895 by Winslow with another Chicago bibliophile, Chauncey L. Williams. Wright and Winslow took as their text a work by William Channing Gannett, the son of Ezra Stiles Gannett and, like his father, a Unitarian Minister in Boston. Written in the same vein as his religious works,

it praised the benefits of frugality and taste. The author declared that he had learned much from the principle of 'simplicity and repose' which he had first met as a young man in Grimm's biography of Michelangelo.

The commercial edition of *The House Beautiful* had sold 10,000 copies by 1896. Books were said to be an essential element of the ideal home (Darwin, Emerson, Dickens, and George Eliot were among authors recommended), while photography enabled everyone to have pictures

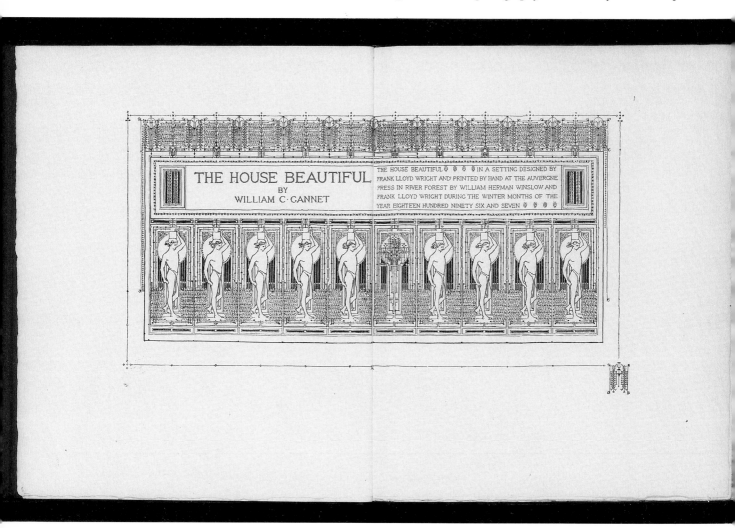

of cathedral façades and works by Raphael, Millet, and Holman Hunt on their walls. It was no doubt in honour of Gannett's work that a Chicago-based journal devoted to decorative art and design founded in 1896 adopted the title of the book for their publication.

The Auvergne Press book was designed by Wright. The decoration that frames each piece of text and covers blank pages was intended as a geometric rendering of organic forms. The source of the design was indicated in a booklet, sewn to the front fly-leaf, containing photographic reproductions of grasses and weeds with seed pods; these, said Wright, provided 'a decorative pattern to harmonize with the type of the text'. The effect contrasts with the ornamental motifs of Arts & Crafts inspiration that graced books from other private presses in the Chicago area. Books printed by American private presses for the publishing house set up by Chauncey Williams and Irving Way reflect variously the designs and ornament found in Kelmscott Press volumes, especially after Irving Way's visit to William Morris at Hammersmith in 1895, in Lucien Pissarro's Eragny Press works, and in books generally designated as evidencing an 'Aesthetic' format.

The House Beautiful marks Wright's development from his 'Sullivanesque' style in matters of ornament. He had begun to work for the Chicago architect Louis Sullivan (1856–1924) in 1887, at a time when, by his own account, he had tired of the pleasant picturesqueness of 'Queen Anne' architecture in the offices of his employer Joseph Slingsby. Making up a portfolio for an interview with Sullivan, Wright recounts that he copied drawings by Slingsby for mantels and ornament where strokes were 'like standing corn in the field waving in the breeze', imitated the ornament he had seen on buildings of Sullivan and his partner Dankmar Adler, and translated gothic ornament from Owen Jones's *Grammar of Ornament* into a 'Sullivanesque' idiom. He was promptly offered work as a draughtsman by the most radical Chicago architect of the day.

Wright left Sullivan's offices in 1893 to

set up his own architectural practice, having previously taken on a number of private commissions to supplement his income. Shortly before his death, Sullivan gave Wright a treasured portfolio of drawings, executed between 1885 and 1896, of luxuriant curvilinear vegetal forms with meticulous patterning of botanical motifs. Wright's first client as an independent architect was William Herman Winslow, for whom he built the house named River Forest. It was in this house that both men printed *The House Beautiful*. RW

Literature
JOSEPH BLUMENTHAL, *The Printed Book in America*, 1977
The Houghton Library, Harvard University, *The Turn of the Century, 1885–1910. Art Nouveau—Jugendstil Books*, 1970
SUSAN OTIS THOMPSON, *American Book Design and William Morris*, New York and London, 1977

Armchair

Designed by Otto Wagner
(1841–1918)
Austrian: Vienna, c.1898–9
Walnut with mother-of-pearl
inlay, and brass feet, the leather
upholstery a recent copy of the
original
h 84 cm (33 in.); w 69 cm (27¼ in.);
d 60 cm (23 in.)
Marks: 'IV' (chisel strokes) inside
the front seat rail
W.13–1982

In 1898 Wagner designed a large apartment house at 3 Köstlergasse, Vienna, just round the corner from and almost contemporary with his celebrated 'Majolika-haus' (40 Linke Wien-zeile). He incorporated a small apartment for himself, for occasional use, comprising bed-room, bathroom, and dining room. The bedroom and bathroom, with its famous glass bath, were shown at the Vienna Jubiläums-austellung of 1898, an exhibition for the golden jubilee of the Emperor Franz Joseph (1830–1916), who had succeeded his uncle in 1848. There they were much admired by the architect and writer Adolf Loos (1870–1933).

This armchair, which was shown later at the Vienna Secession Exhibition of 1900, was one of four. The dining room also contained a cabinet (now also in the Victoria & Albert Museum), a vitrine, and a sideboard en suite. These were the first pieces of cabinet furniture in which Wagner abandoned any suggestion of a classical cornice. On the wall was a large and elaborate mirror in the late-seventeenth-century baroque acanthus style.

In 1900 Wagner used a similar chair as decoration to an initial for an article in the avant-garde magazine Ver Sacrum (1898–1903) on Die Kunst im Gewerbe (Art in Industry), in which he hailed the emergence in the preceding year of an art which mirrored his own time. Wagner was a generation or more older that those who had, in 1897, withdrawn from the Künstlerhaus, an established artists' association under the leadership of the painter, Gustav Klimt (1862–1918), to form the Secession. But he was the inspiration and, in many cases, the teacher of the Secession architects and designers, including Joseph Maria Olbrich (1867–1908), Koloman Moser (1868–1918) and Josef Hoffmann (1870–1956), and in 1899 identified himself with them by joining the Secession himself. His style progressed in the direction of an ever-increasing simplicity, rationality, and rectilinearity, and he was an enthusiast for modern materials and techniques. However, his use of mother-of-pearl on this armchair reflects another aspect of Secession taste: an appetite for luxurious materials, particularly those with elements of sensuality and ambiguity. SJ

Furnishing velvet

Woven by Messrs Kopp & Co of
Berlin at one of their Italian
factories, probably in 1899
Cut and uncut silk pile on a satin
ground
h 335.6 cm (11 ft); *w* 59.1 cm
(1 ft 11¼ in.)
1906–1899

Textiles, like the other arts from the early
nineteenth century onwards, reflected the re-
awakening of an interest in the past. Indeed,
in the 1851 Exhibition the Zollverein showed
brocatelles, their patterns loosely based on
seventeenth-century models. The use of historic
models became increasingly rigorous with the
growing desire for authenticity. The demand
for evidence from original sources led to the
first serious historical research to be carried
out in European universities. The newly
founded public museums were attempting
to acquire the best examples from the past,
and rich men were assembling magnificent
private collections of paintings, furniture, and
other works of art. They required furnishing
textiles to provide an authentic setting for
their collections.

A number of textile manufacturers supplied
this market, drawing upon the first published
portfolios of photographs from the major col-
lections for their designs. F. Fischbach was
the pioneer in this field with his *Ornamente
der Gewebe* published between 1870 and 1880
with an English edition in 1880. E. Kumsch of
the Dresden Museum published four magnifi-
cent volumes of *Stoffmuster des XVI–XVIII
Jahrhunderts* in 1888. These were followed by
a spate of similar publications, among the most
distinguished being those of Lessing from the
Berlin Museums and R. Cox of the Musée des
Tissus in Lyon. The earlier the model, the
greater the respect Kopp and other manufac-
turers showed for it.

Kopp chose to produce fabrics in Italy where
skill in the production of furnishings dated
back to the seventeenth century (it is also
possible that wages in Italy were lower than
in Germany for comparable work). But the
manufactory was based in Berlin which had
both a new collection of decorative arts (guide
published in 1890) and a school of weaving in
which the senior lecturer and 'Schriftführer'
was J. Lessing who was to publish much
on historic textiles. An important part of the
training in the schools of weaving was the
analysis, thread by thread, of the construction
of ancient fabrics, and the late-nineteenth-
century reproductions were so successful that
today it is necessary sometimes to have a dye
analysis made of a silk to establish whether it
is an original or a reproduction.

The Victoria & Albert Museum possesses
more than thirty silks from Kopp, made at its
factories of Curago near Milan, Caserta near
Naples, and in Turin. Some of the fabrics are
close to the plates in both Kumsch and Fisch-
bach, some are taken from other collections,
and some are from pieces which had recently
come to light in European church treasuries.
One, at least, came from an original belonging
to 'Mr Chatel' of Lyon – presumably Tassinari
and Chatel, the firm which was supplying
Ferdinand de Rothschild. Many such repro-
ductions were also made in Krefeld; the Victoria
& Albert Museum has one from a Krefeld
manufacturer taken from an original silk in
the Church of St Gervais in Maastricht. These
reproduction textiles were bought by the public
museums, not acquired as gifts, and there are
often notes attached about the provenance of
the originals. They were clearly regarded as
excellent examples of fine weaving.

What is, perhaps, especially pertinent about
this velvet is that it may not be a faithful
reproduction but an adaptation of several late-
seventeenth-century furnishing velvets. They
had been widely used for both bed and wall
hangings. It can be compared with a silk pub-
lished by Kumsch which also has daffodils
and a design constructed on a heavy strap-
work; but the Kopp silk is much simpler. It is
possible that there was an original model in
the new Berlin collection but, equally, that its
design was subtly adapted to conform to nine-
teenth-century taste and to permit a slightly
more economical fabric. The original would
have dated from the late seventeenth century,
too recent to be sacrosanct, but a room hung
with the Kopp velvet—not one but forty or
more panels—would have been magnificent,
nevertheless. Superb textiles were woven in
this period with a technical expertise in using
the jacquard comparable to that shown in the
eighteenth century on the draw-loom. In nine-
teenth-century interiors the overwhelming
impression would have been of colour and
contrasting textures, not wood. NR

Vase

Decorated by Harriet Elizabeth
Wilcox (worked at Rookwood
1886–1907, ?–after 1930)
Manufactured by the Rookwood
Pottery Co.
American: Cincinnati, 1900
Earthenware with underglaze
slip-painted decoration
h 26.2 cm (10¼ in.)
Marks: RP in monogram
surrounded by fourteen flames
and 892B, impressed; H.E.W. and
an unidentified symbol, incised;
price and South Kensington
Museum paper labels
1686–1900

Literature
HERBERT PECK, *The Book of
Rookwood Pottery*,
New York, 1968

Rookwood Pottery was established by Maria Longworth Nichols (1849–1932) in 1880. She was the daughter of Joseph Longworth, a wealthy supporter of the arts and patron of the Cincinnati Art Museum. At the age of nineteen she married Colonel George Ward Nichols but continued to maintain an interest in the arts which she was able to support with Longworth family money. As Mrs Longworth Nichols, she was a significant figure socially and was among a number of women china painters whose serious attention was caught by, and supported, the growing American art pottery movement.

In 1873 Mrs Nichols was introduced to ceramics by Karl Langenbeck (later, in 1909, chemist to the Grueby Pottery). She joined classes at the Cincinnati School of Design where she met Mary Louise McLaughlin (1847–1939), subsequently her most serious social and professional rival, and by 1876 her work and that of fellow students was included in the Centennial Exposition in Philadelphia. At this international exhibition American potters and decorators were introduced to the French *barbotine* productions developed by Ernest Chaplet (1835–1909) for the Haviland studios at Auteuil. This technique of slip painting (thickly applied liquid clay) was an enormous success and influenced Nichols' first work at Frederick Dallas Pottery, although it was Mary Louise McLaughlin who pioneered and developed the technique in America through the establishment of the Cincinnati Pottery Club.

In 1880, with financial backing from the Longworth family and in collaboration with Joseph Bailey Jnr, Mrs Nichols established the new pottery in an old schoolhouse at 207 Eastern Avenue, Cincinnati, naming it 'Rookwood' after her father's estates in Walnut Hills. Almost immediately her ceramics were bought by Tiffany & Co., New York, and in 1882 the pottery achieved further brief but equally glamorous notoriety as the result of a visit by Oscar Wilde.

In 1883 William Watts Taylor was appointed as business manager. Joseph Bailey Snr had joined as superintendent in 1881 and, apart from a short gap between 1885–7, he stayed at Rookwood for the rest of his life, perfecting and maintaining the highest practical standards. With Watts' appointment, Mrs Nichols gradually withdrew from close involvement. After the death of Colonel Nichols, in 1886 she married Bellamy Storer, the American Ambassador to Spain and Austria. Under Watts the pottery was reorganized on a business-like basis while artistic direction and production methods were systematically reassessed. In his first year a major technical innovation was introduced by Laura Anne Fry (1857–1943) who adapted a throat atomizer to apply the slips on to unfired clay. This discovery gave Rookwood an unmistakable style on which a large proportion of their subsequent artistic and commercial success was built.

In 1884 Karl Langenbeck joined the pottery for about a year, as glaze chemist. A brief but formative period in the pottery's technical development ensued which, after Langenbeck's departure, was sustained by Bailey until his death in 1898. Five years later Rookwood was awarded a gold medal at the International Exhibition in Paris, 1889, a major achievement in the face of continental competition.

Growing commercial success and increased production resulted, in 1891, in a move to Mount Adam, above the main town. By this time Rookwood's complement of artist-decorators included many of those who were to be responsible for its increasingly enviable reputation. Kataro Shirayamadani (1865–1948) joined in 1887 and brought to the pottery the genuine Japanese tradition upon which much of its 'orientalized' decorations were to be based. Albert Robert Valentien (1862–1925) was in charge of the decorating department from 1881 to 1905 and Harriet Elizabeth Wilcox, decorator of this vase, had joined in 1886. The company's display in Paris in 1900 was awarded a gold medal and, later, on appeal, the Grand Prix.

Rookwood's 'Iris', 'Sea Green' and 'Aeriel Blue' ranges were all introduced in the 1890s and exhibited in Paris. The South Kensington Museum purchased eight Rookwood vases from Siegfried Bing (1838–1905).

After 1900 the Storers settled in Paris where Maria Longworth Nichols Storer died in 1932 at the age of eighty-three. JHO

Cabinet

Designed and manufactured by
Louis Majorelle (1859–1926)
French: Nancy, c.1900
Marquetry of various woods,
with wrought-iron fittings
h 184.2 cm (5 ft 11½ in.);
w 62.2 cm (2 ft 4½ in.); d 48.2 cm
(1 ft 7 in.)
Signed 'L. Majorelle, Nancy',
carved into the wood and
highlighted with paint or ink
1999–1900
Given by Sir George Donaldson

The work of Louis Marjorelle and Emile Gallé (1846–1904) represents the supreme achievement of the Art Nouveau movement which revolutionized the fine and decorative arts at the turn of the century. A cabinet-maker by profession, Majorelle was an important member of the L'Ecole de Nancy where he came under the influence of Gallé. In 1890 Majorelle adopted the Art Nouveau style, producing slender furniture ornamented with carving and marquetry utilizing naturalistic floral motifs. By 1900 he had become the main producer of Art Nouveau furniture in France, and perhaps Europe.

The term 'Art Nouveau' was first used in 1895 when Siegfried Bing opened his shop 'L'Art Nouveau' in Paris, marketing the works of leading craftsmen and painters, such as Bonnard, Toulouse-Lautrec, and Vuillard. 'L'Art Nouveau' also sold large quantities of high quality Oriental art.

Majorelle considered structure and proportions to be more important than the decorative ornament. His designs bear affinities with rococo furniture produced in the reign of Louis XV, but he sought new and original forms. This cabinet displays an undulating, dynamic flow of line, but is built with strong, solid, and traditional construction. It consists of two cupboards separated by an open shelf; around three sides of the top is a high, plain gallery. On the door of the upper cupboard is a representation in marquetry of a man sailing a boat on a river; overhead, birds are flying and in the distance are trees. This cupboard is surrounded by a waterlily springing from a long stem passing between the doors of the lower cupboard, its roots in the carved base. Amid this ornament are two frogs and a dragonfly. On the doors of the lower cupboard are wrought-iron hinge bands with curved and interlacing scrolls. There are also two dragonflies in wrought iron.

Majorelle displayed a room based on a waterlily theme at the Paris Exhibition of 1900, for which he was awarded the Légion d'Honneur.

The Maison Majorelle in Nancy produced a wide range of furniture, including chairs, cabinets, fire screens, tables, and trays. Much of this was considerably simpler in design and ornament than exhibition pieces such as this cabinet. VJV

Beaker

Designed by Thorvald
Bindesbøll (1846–1908)
Manufactured by A. Michelsen
(founded 1841)
Danish: Copenhagen, 1900
Silver, parcel-gilt
h 9.5 cm ($3\frac{3}{4}$ in.); w 7.5 cm (3 in.)
Marks (on the base): town mark;
Copenhagen for 1900; maker's
mark; a crown above MICHELSEN
for A. Michelsen; warden's mark,
Sim. Chr. Sch. Groth, warden
1863–1904; date stamp for 1900
Other marks: the initials P.M. and
E.L.; the English import mark
1612–1900
Purchased for £5 19s 10d from
A. Michelsen, Bredgade,
Copenhagen

Literature
*A. Michelsen: Royal Court and
Insignia – Jewellers of Denmark*,
Copenhagen, 1927
GRAHAM HUGHES, *Modern
Silver*, London and New York,
1967

Thorvald Bindesbøll (1846–1908), the son of the most original Danish architect of the neo-classical movement, was himself trained as an architect and began practising from 1876. In 1883 he started designing earthenware for the Copenhagen Valby factory among others and thenceforward began increasingly to devote his attention to designing for the crafts. His work in ceramics and silver in the later 1890s and early 1900s was characterized by bold abstract shapes creating a rich and dynamic pattern across the surface of the object. This beaker combines embossed and chased tongue-like forms, offset on an undulating profile which is surmounted by a wavy lip, embossed with cartouche-like forms connected by a border of narrow swags. The result not only has visual coherence but also tremendous vigour, with a sturdiness characteristic of Danish Art Nouveau. Bindesbøll's brilliant mastery of the style distinguished him both locally and internationally as one of its most proficient practitioners.

The firm of A. Michelsen manufactured the beaker and exhibited it on their stand at the Paris Exhibition of 1900. It is a significant indication of Bindesbøll's considerable international reputation that the South Kensington Museum contemplated purchasing several examples of Michelsen's work at a time when there was widespread antipathy to the acquisition of contemporary objects. Art Nouveau was considered an unwholesome disease, of Continental origin, and the ungracious treatment of the generous gift by Sir George Donaldson of his collection of Art Nouveau furniture only confirms this.

The firm of Michelsen was founded by Anton Michelsen (1809–77) in 1841. He quickly gained royal patronage. By 1848 he was supplying the Danish Court and the firm has continued to do so ever since. He was an early exhibitor at international exhibitions, a tradition which was followed by his son Carl who assumed control of the business on his father's death in 1877. At first Carl Michelsen's productions were either in a traditional Danish style or, in the case of his work for the Danish Court, copied from eighteenth-century German pieces from the Rosenborg collections. He was persuaded to change this practice of copying by the international exhibitions, at which he showed pieces, and through the influence of the architect painter and designer Arnold Emil Krog (1856–1931). Krog's work for the Royal Copenhagen porcelain factory showed the influence of Japanese art and enjoyed great success when exhibited in Paris in 1889. In particular it strongly influenced Danish goldsmiths, and Michelsen's work in contemporary styles really dates from this period.

Michelsen was appointed a member of the international jury of the Paris Exhibition of 1900. The critical and popular acclaim accorded to the firm amply vindicated Michelsen's policy of encouraging and supporting contemporary designers. He exhibited several pieces designed by Krog and the sculptor Frederik Hammeleff (1847–1916) which were extremely well received by the French public. Another sculptor, Niels Georg Henriksen (1855–1922), who worked for Michelsen received a gold medal for his silver designs. Bindesbøll's work was described by a contemporary Danish critic as receiving 'unanimous acclaim at the exhibition for their union of artistic appeal with sensitiveness to the demands of the medium'.

ET

One of a set of fittings for a suite of bedroom furniture

Designed by Georges de Feure
(1868–1928)
French: Paris, c.1900
Electroplated silver on cast copper
l 20 cm (7⅞ in.); h 7.7 cm (3 in.)
2–n–1901 (set of fifteen)
Bought from Siegfried Bing, L'Art Nouveau, 22 Rue de Provence, Paris, for £29 16s 8d

Literature

La Decoration et l'Ameublement a l'Exposition de 1900, Paris, 1900
GABRIEL MOUREY, 'The House of the "Art Nouveau Bing",' *The Studio*, 1900
OCTAVE UZANNE, 'On the Drawings of M. Georges De Feure', *The Studio*, Vol. XII, 1898

Georges de Feure was born in Paris as George van Sluitjers in 1868. His father was a prosperous Dutch architect who shortly after his son's birth moved his family back to the Netherlands.

In 1884 de Feure's father was made bankrupt after a series of disastrous speculations and, at the age of sixteen, Georges de Feure was forced to relinquish his studies. He did a series of casual jobs which included some time spent with a book-binding firm in the Hague and a job as a scene-painter in an Amsterdam theatre. The experience in both places was to have some influence on his later career.

In 1891 he moved to Paris whereupon he changed his name, first to Van Feuren, then to Von Feure, and finally to de Feure. His first job was as a designer for illustrations in the newspapers *Le Courrier Français* and *Le Boulevard*. He was to design many posters throughout his career which initially showed the marked influence of Jules Chéret with whom he had studied. At this stage he started to design extremely elegant and graceful Art Nouveau interiors, along with furniture, metalwork, porcelain, and glass with which to fill them. Until 1900 his dominant stylistic characteristic was a delicate curvilinear quality, closely associated with natural forms such as the stems of plants and flowers. This is perfectly illustrated here by this handle, part of a set of furniture fittings, which has a delicate grace typical of his best work.

De Feure was extensively patronized by Siegfried Bing from whom this set was bought. De Feure exhibited in Bing's Art Nouveau pavilion at the Paris Exhibition of 1900 along with Colonna and Gaillard. The pavilion consisted of six rooms, each individually designed by one of the three exhibitors. De Feure was responsible for the dressing room and the boudoir. Gabriel Mourey in his report on the exhibition in *The Studio* was lyrical in his praise for de Feure, describing the pastel colours, gilt details, and airiness of his interiors with their feminine delicacy as supreme examples of the new style which revived 'the tradition of graceful French furniture of the eighteenth century'.

In 1903 Bing mounted an exhibition exclusively devoted to de Feure's work. De Feure later founded the Atelier de Feure to produce furniture in partnership with the Aachen architect Theodor Cossmann. He also designed for the London theatre, practised as a book illustrator, designed interiors for the modiste Madeleine Vionnet, and towards the end of his life two pavilions for the Paris Exhibition of 1925.

ET

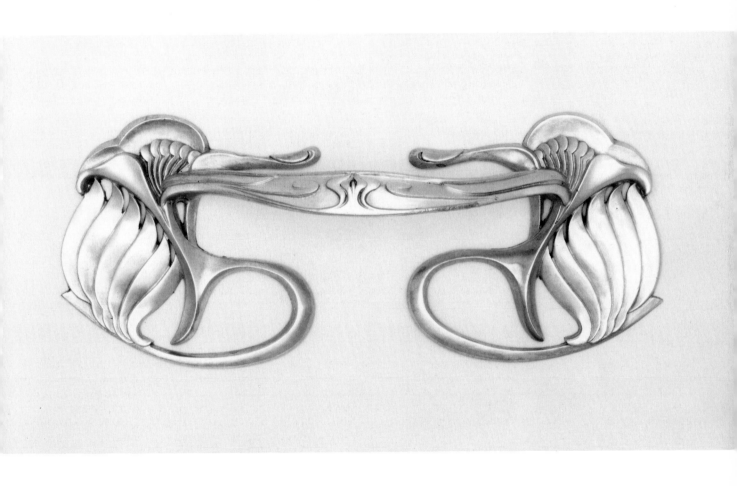

Bowl and mug

Designed by Alfred William
Finch (1854–1930)
Manufactured by the Iris
Workshops
Finnish: Porvoo, near Borgå,
c.1900
Bowl
diam. 34.7 cm (13$\frac{3}{4}$ in.)
Marks: A.W.F. IRIS FINLAND
incised; LMM in
monogram impressed
Mug
h 10 cm (4 in.)
Marks: A.W.F. IRIS FINLAND and
other indistinct marks incised;
LMM in monogram impressed
Circ.758, 759–1966.

Literature

Arabia, *Ceramics & Glass*,
Helsinki, 1973
THERÈSE FAIDER-THOMAS,
'Anna Boch, peintre-
impressioniste sur faience',
*Cahiers de la Céramique du Verre
et des Arts de Feu*, no.41, 1968
DAVID REVERE McFADDEN,
(ed.), *Scandinavian Modern
Design 1880–1980*,
Cooper-Hewitt Museum,
New York, 1983

In the last years of the nineteenth century Finland was riven with political unrest. There was a combination of increasing Russian oppression with centuries of powerful Swedish influence. Swedish was spoken by the educated classes who also acquired Swedish names. The Finnish language and traditions were maintained mainly by the common and country people. The conflict resulted in an awareness of national identity which the Finns expressed in a rediscovery of their own traditional cultures and landscape.

The Iris workshops were part of the new movement of national awareness but, paradoxically, were established by a Swede, Louis Sparre (1863–1964), with the Finnish painter Akseli Gallen-Kallela (1865–1931). Sparre, himself, studied painting in Paris between 1886–90, moving to Finland in 1891 where he stayed until 1911. He was chiefly a designer of furniture but also of ceramics and books. Gallen-Kallela, who converted his Swedish name (Axel Gallén) to the Finnish version in 1905 as part of his identification with the new nationalism, was a painter and designer of furniture, interiors, graphics, and textiles. He was a major figure in the Finnish national romantic movement. These two artist-designers founded the workshops with the stated aim of refining public taste and establishing an essentially Finnish design school of quality domestic objects. The chief production was of furniture, but textiles, metalwork, and ceramics were also made. In 1897 Sparre was introduced to the work of Alfred William Finch in Brussels.

Finch was English by extraction, born and brought up in Brussels where he studied at the Academy of Art. As a landscape painter he was among the founder members of Les Vingt in 1884. He visited England in 1886 where he encountered the ideas current within the Arts & Crafts Movement. At this stage he was concentrating entirely on painting, and around 1888 he was experimenting with pointillism in the style of Georges Seurat (1859–91). A fellow member of Les Vingt, Anna Boch (1848–1936), invited him to visit the family manufactory of Boch Frères at Saint-Vaast in Belgium where he worked between April 1890 and January 1893.

Throughout this period Finch, continuing as painter and ceramist, kept in touch with contemporary developments in design and built up a close network of contacts and friends. He had probably met Henri Van de Velde (1863–1957) as a fellow painter. In 1886 Van de Velde was elected a member of Les Vingt, and their joint involvement with this progressive group which arranged exhibitions of paintings and applied arts, throws the similarities and differences in their work into focus. Van de Velde gave up painting to become a designer in 1892, while Finch opened his own studio at Forges-Chimay in 1896.

Sparre invited Finch to head the ceramics department on the opening of the Iris workshops in 1897. They were an artistic success but an economic failure despite some notable exports to St Petersburg and Paris. The enterprise closed down in 1902 but, nevertheless, was extremely influential in Finland. The major industrial pottery was Arabia, which had been established in 1874 by the Swedish firm Rörstrand. For the first thirty years of its existence it produced wares in a generally acceptable unadventurous style. But in 1902 they introduced their 'Fennia' series, an extremely striking range based on traditional Karelian folk motifs in strong colours, contained within geometric, highly organized patterns on a white ground. Finch's influence is credited by the pottery for this stylish break with established tradition.

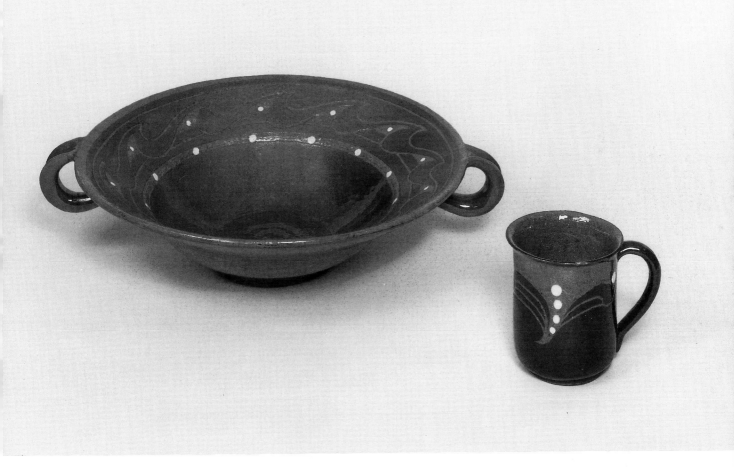

Finch's own designs were a well-balanced combination of traditional forms such as bowls, mugs, and jugs richly decorated in a mannered Art Nouveau style and employing powerfully coloured glazes, sweeping wavy-edged patterns punctuated with incised lines and elegantly placed spots of slip. The result is a lively interaction between the highly sophisticated ornamentation and the domestic utensil of earthenware with naturally textured glazes.

After the closure in 1902 Finch became head of ceramics at the Central School of Industrial Design (Taideteollinen Korkeakoulu) in Helsinki. He taught there until his death in 1930, directing experiments with complex high temperature glazes. JHO

Wall of a music room

Designed and manufactured by
Charles Spindler (1865–1938)
Cabinet-maker: J.J. Graff,
Guebwiller
Alsatian: Saint Léonard; c.1897
Poplar, oak, and walnut, with
marquetry of various woods,
upholstered in green cloth
h 330 cm (10 ft 10 in.); w 389 cm
(12 ft 9 in.); d 71 cm (2 ft 4 in.)
2004–2007–1900
Given by Sir George Donaldson

Literature
*Charles Spindler, Jugenstil im
Elsass*, Darmstadt, 1983

This *tour de force* formed part of the music room shown by Charles Spindler at the Paris Exhibition of 1900 for which he won a German Grand Prix and a French silver medal. The opposite and end walls, both now destroyed, were acquired by the applied art museums in Berlin and Strasbourg respectively, and other elements or copies entered the museums in Darmstadt and Aachen.

Charles Spindler was a small child when, in 1871, Alsace was annexed by Germany. Although he studied painting in Düsseldorf, Munich, and Berlin, he remained a fervent Alsatian patriot. This wall bears three inscriptions: in the centre, '*Les sujets des panneaux en marqueterie de le salon sont tirés des légendes alsaciennes*' (The subjects of the marquetry panels in this salon are taken from alsatian legends); to the left, '*Aux nuits de l'esté la blanche dame de Plixbourg descend dans la vallée et attend son chevalier qui jamais ne vient*' (On summer nights the white lady of Plixbourg goes down into the valley and waits for her knight, who never comes'); and to the right, '*Saincte Odile patronne de L'Alsace*' (Saint Odile, patron of Alsace).

In 1890 Spindler founded an artistic associ-ation in Saint Léonard, the hamlet near his birthplace, Boersch, where he settled on his return from Germany in 1889, and he sub-sequently helped to found two bilingual Alsatian journals, *Images Alsaciennes* (1893–6) and the *Revue Alsacienne Illustrée* (1898–1914). In 1893 Spindler began to experiment with marquetry, and in 1897 he contracted to produce furniture for a Strasbourg art-dealer, Bader-Nottin. Spindler executed marquetry himself but the cabinet-work was done by J.J. Graff of Guebwiller and others.

Spindler was strongly influenced by the marquetry of Emile Gallé (1846–1904) but whereas Gallé's subject matter was exclusively Nature, in the form of leaves and flowers, Spindler's themes extended to medieval legend, landscape, and symbolic figures. Gallé, native of Nancy, on the other side of the 1871 border, was a fervent French patriot, even including anti-German slogans on his furniture; Spindler's loyalties were more local but German influence is apparent in the comparatively restrained and pointedly structural framework of his furniture, the result of contacts with advanced designers such as Bruno Paul (1874–1968) and Joseph Maria Olbrich (1867–1908) SJ

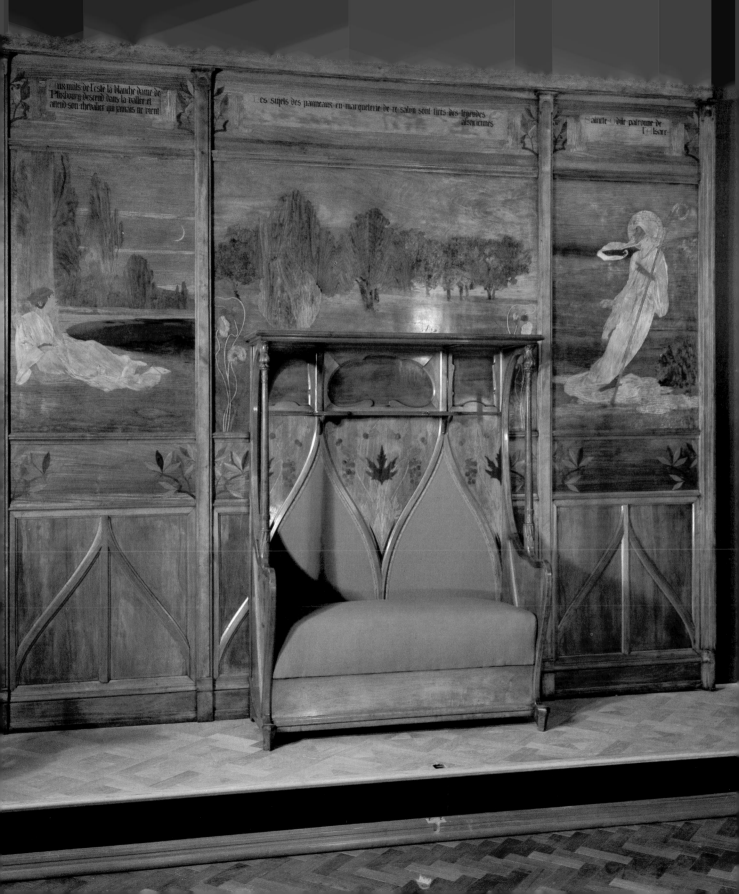

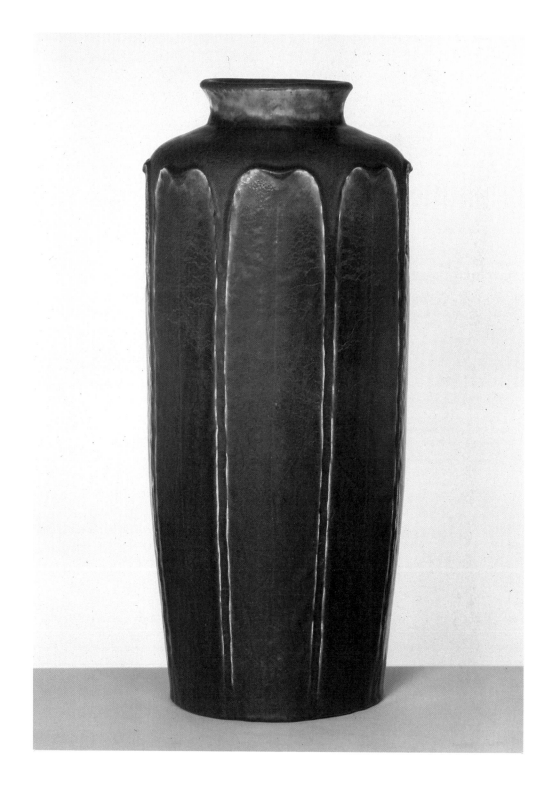

Vase

Probably designed by George Prentiss Kendrick
(dates unknown)
Possibly decorated by Wilhelmina Post (dates unknown)
Manufactured by the Grueby Faience Co.
American: Boston, 1898–9
Stoneware with semi-matt glazes
h 33.7 cm (13¼ in.)
Marks: GRUEBY FAIENCE CO. USA BOSTON around a lotus flower impressed and paper label; a cross and w.p. incised; South Kensington Museum paper label.
1685–1900

Literature

MARTIN EIDELBERG, 'The Ceramic Art of William H. Grueby', *The American Connoisseur*, 1972–3
PAUL EVANS, *Art Pottery of the United States*, New York, 1974
GABRIEL P. WEISBERG, 'Samuel Bing: patron of art nouveau', *Connoisseur*, CLXII, 1969
GABRIEL P. WEISBERG, 'Bing: international dealer of art nouveau', *Connoisseur*, CLXXVII, 1971

William Henry Grueby (1867–1925) started work in about 1880 at the Low Art Tile Works, itself founded only two years earlier in Chelsea, Massachusetts. In September 1890, after ten years' training and experience at this highly successful tile works, Grueby started his own factory at Revere, Massachusetts, for the production of architectural faience. It appears that this first enterprise was not a success for in 1891 he entered into a new arrangement with Eugene R. Atwood. Atwood & Grueby shared an address with the Boston Fire Brick Works, which were managed by Fiske, Coleman & Co. and, as their representative at the Chicago Exposition of 1893, Grueby met other ceramists and saw the work of Ernest Chaplet (1835–1909) and Auguste Delaherche (1857–1940), a significant factor in the light of Grueby's later direction.

In 1894 he and Atwood parted and the Grueby Faience Company was set up, at the same address, continuing the production of bricks, tiles, and architectural terracotta. Grueby himself was responsible for the development of glazes and served as general manager. William Hagerman Graves, a wealthy young architect, acted as business manager and George Prentiss Kendrick, already well known as a designer in brass and silverware, became designer to the pottery until 1901.

The new partnership's first display of art pottery was probably that shown at the first exhibition of the Society of Arts & Crafts in Boston in 1897 and it was an instant success. Three years later they were awarded one silver and two gold medals in Paris. By this time their production of pottery had been taken up by Siegfried Bing (1838–1905) as their sales agent in Europe. It was through Bing that the South Kensington Museum purchased this green-glazed example and one other, with a brown glaze (1684–1900).

In 1901 the pottery won a gold medal at St Petersburg and, in the same year, the Highest Award at the pan-American Exposition, Buffalo, in which they contributed to rooms designed by Gustav Stickley (1857–1946), a pioneer of Arts & Crafts style furniture in the USA. These successes were followed by the Highest Award at Turin in 1902 and the Grand Prize, St Louis, 1904.

The clay used in the architectural faience production was also used in the pottery-making. The wares tended to be massively contoured, almost sculptural, a style which may, to some extent, have been dictated by the clay. Further, a known influence at an early stage for Grueby was his encounter with the French ceramists in 1893 in Chicago. Delaherche, in particular, appears to have been a significant inspiration and the similarity in form between this vase and the classic Delaherche example (*see* page 155) need hardly be emphasized. Grueby also took note of the matt and semi-matt glazes in which the continental potters excelled, particularly those fired at higher temperatures. His own experiments in glaze recipes resulted in a rich repertoire of blues, yellows, browns, greys, and an ivory-white crackle, but the most famous and successful was the semi-matt green. Almost overnight this became the most sought-after and most imitated colour. It was copied by eight or ten other potteries including Rookwood and was so well known that the name 'Grueby green' was a recognized standard.

Most modelling and decoration was done by hand by the women students from Boston's Museum of Fine Arts School, the Massachusetts Normal School, and the Cowels Art School. Common flowers and leaves were the chief inspiration and the raised leaves and flowers were applied in thin rolls which were pressed on to the basic form around the sketch outline and the edges modelled flat or raised. Both this vase and the one other Grueby vase in the Victoria & Albert Museum's collections are based on leaf forms.

In 1907 the Grueby Pottery was independently incorporated, with Grueby as president. Two years later the production of art-wares was taken over by Karl Langenbeck who had previously been associated with Rookwood. William Hagerman Graves, the business manager, and Grueby himself returned full time to architectural faience.

The art-ware pottery closed in 1911 while the tileworks continued production, surviving a fire in 1913.

JHO

Vase

By Emile Gallé (1846–1904)
French: Nancy, 1900
Coloured glass with carved,
etched, and engraved decoration
and enamelling
h 47 cm (18½ in.)
Marks: 'Gallé Exposition 1900'
within the decoration, in enamel
1622–1900

Literature
F-T. CHARPENTIER in *Gallé*,
Musee de Luxembourg Nov
1985–Feb 1986, Paris
EMILE GALLÉ, *Ecrits pour l'Art*,
Paris, 1908 (published
posthumously)
PHILIPPE GARNIER, *Emile Gallé*,
London, 1976
LEON ROSENTHAL, *Gazette des
Beaux Arts* XV, 1927
SIEGFRIED WICHMANN,
Japonisme, London, 1981

Emile Gallé's first ceramic designs were produced for his father's faience factory at Saint-Clément in 1865. After being taught design, botany, and minerology in Weimar, he studied glass chemistry at the Burgin Schwerer & Co. glassworks in Alsace-Lorraine. He was thus well-prepared when, in 1874, he took over his father's ceramic concern and set up his own glassworks in Nancy.

As the glassworks expanded Gallé was able to fund technical research. He never ceased to develop and extend his repertoire of techniques. At first he concentrated on discovering new colourings for the glass itself, using rare and expensive metals such as iridium and thallium as well as copper, silver, and sulphur.

Gallé gave the same unstinting attention to the development of surface decoration, enriching his range of enamel colours. By 1889 he was able to write, 'There is no nuance, however fleeting, that the palette of enamels for glass doesn't reflect.' He also used wheel engraving to cut through flashed glass to an opaque or transparent layer beneath, a technique similar to that used on the semi-precious stones which he sought to emulate.

Gallé produced vases of gently-tinted transparent glass with engraved and enamelled decoration inspired by historical and exotic styles which he had studied in the Louvre and the South Kensington Museum. However, from the 1880s he began to develop his own style. He turned his attention to decoration within the body of the glass, colouring it intensely, injecting it with metallic oxides or with leaves of gold or silver, applying *cabochons* or deliberately introducing bubbles of air. In about 1897 Gallé also succeeded in embedding in the body pieces of glass or enamel of other colours and textures, forming a type of *marquetrie de verre*.

Gallé used this battery of techniques to embody his theories of art and beauty, about which he wrote profusely: 'in art as in life, truth is best and light the most beautiful.

Yes—materials, shapes, colouring and truthful ornament are the results of the contemplation of the realities of nature, marvellously evocative of things one doesn't see … New works are born from new needs of expression … They are flowers, hungry for light and direction; the analogy is also a floral one.'

As a trained botanist Gallé turned again and again to flowers for inspiration. His vases became increasingly loaded with symbolism, and this particular example was no doubt full of meaning for him. Its shape, colour, and chrysanthemum motif reflect his perpetual fascination with Far Eastern art. Like the other glassworkers of Nancy, Gallé was entranced by the shimmering surface and subtle refraction of light in Chinese jade carvings. He shared too their use of at least 400 identifiable floral decorative motifs from the Far East. In this vase the chrysanthemums probably carry both their Japanese significance as the Imperial flower, and their French association with funerals and death.

Towards the end of his life, Gallé was caught in the conflict between maintaining artistic standards and selling enough pieces to finance the expensive modelling and handwork that this implied. His output was too great for him to use new techniques and designs in every vase. Motivated also by a desire to provide art for all, Gallé introduced a series of vases decorated with old designs. These were simplified so that they could be produced by means of acid etching, a process which Gallé had previously condemned.

This vase may well be one of these series, bought as it was from the Paris Exhibition of 1900 where Gallé certainly showed such pieces. Much of the success of the enamelled, etched, and engraved decoration is due to the fact that it has been used both inside and outside the body. Gallé won prizes at the exhibition for furniture, ceramics, and glass, the results of years of patient research combined with artistry and determination. HB

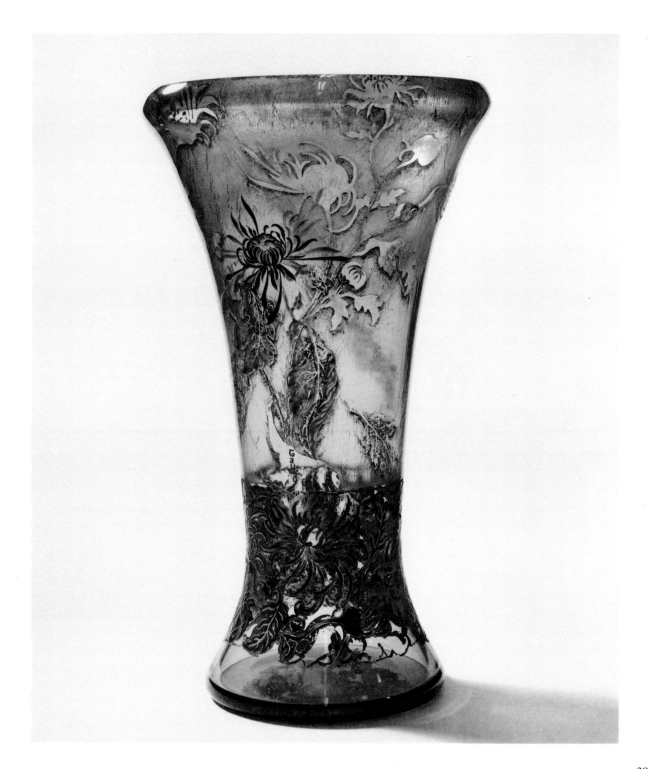

Bowl on foot

By Eugène Feuillâtre (1870–1916)
French: Paris, c.1900
Silver-gilt; blue, green, violet,
yellow, and colourless *plique-à-
jour* enamel
h 7.9 cm (3⅛ in); diam 11.6 cm
(4½ in.)
Punched mark: 'FEUILLÂTRE'
958–1901

Literature

H. FRANTZ, 'E. Feuillâtre,
Émailleur', *L'Art décoratif*, III,
1900–1
F. MINKUS, 'Die
Edelschmiedekunst auf der
Pariser Weltausstellung', *Kunst
und Kunsthandwerk*, IV, 1901
S. BARTEN, *René Lalique*,
Munich, 1977
C. GERE, J. RUDOE, H. TAIT.
and T. WILSON, *The Art of the
Jeweller, A Catalogue of the Hull
Grundy Gift to the British
Museum*, 2 vols, London, 1984

Eugène Feuillâtre was born in Dunkirk in 1870.
He worked for other artists until about 1897,
but it is uncertain whether these included
René Lalique (1860–1945). He had a successful
exhibition with Fouquet and Lalique in London
in 1898 at the New Gallery. He specialized
in cloisonné and *plique-à-jour* enamels. This
Poppy Bowl (*Coupe Pavot*) is associated with
a description by Feuillâtre of how such a
bowl was made. The notepaper is headed
'EUGÈNE FEUILLATRE/Emaux d'Art/Translucides
et Cloisonnés' beside a stamped addition record-
ing the award of a gold medal to Feuillâtre at
the Paris Exhibition of 1900.

Feuillâtre explains that the bowl is made
from silver 2 mm thick using a lathe and a
silversmith's hammer. The design is drawn
and engraved on to the bowl and then cut out
with a handsaw, leaving the skeleton of metal
which is to form the walls of the cells. A sheet
of gold leaf is used to cover the bowl. The cells
formed by the metal skeleton backed by the
gold leaf are then filled with enamel. The de-
scription appears at this point to be ambiguous
as to when the gold leaf is removed, but it
seems likely that the enamel is first fired to
produce a thin clear flux filling every cell. The
gold leaf is then removed, and the coloured
enamels fired without any further use of an
added backing. 'A piece of this importance',
writes Feuillâtre, 'passes a score of times through
the kiln'.

Whereas Feuillâtre's bowl is a self-supporting
structure because the cells are pierced out of
the metal, Fernand Thesmar's bowl (*see* page
156), is held together by the enamel itself, the
wires of the cell being unconnected. Thesmar
used as temporary backing for his *plique-à-
jour* cells either a thin sheet of copper, which
was subsequently dissolved with nitric acid,
or a sheet of mica which can be removed
easily.

This bowl was bought from the artist for
£39 14s 11d (1,000 francs) during a visit to
Paris by Thomas Armstrong in 1901. At this
high point in the flowering of French enamelling
and jewelry which took place at the end of the
nineteenth century his other purchases included
the hornet brooch by Georges Fouquet and the
peacock pendant by L. Gautrait, which are
displayed in the Victoria & Albert Museum's
Jewellery Gallery. Armstrong met René Lalique,
'an artist of extraordinary merit whose works
are so much sought after that I considered
myself very fortunate in finding two beautiful
specimens unsold'. RE

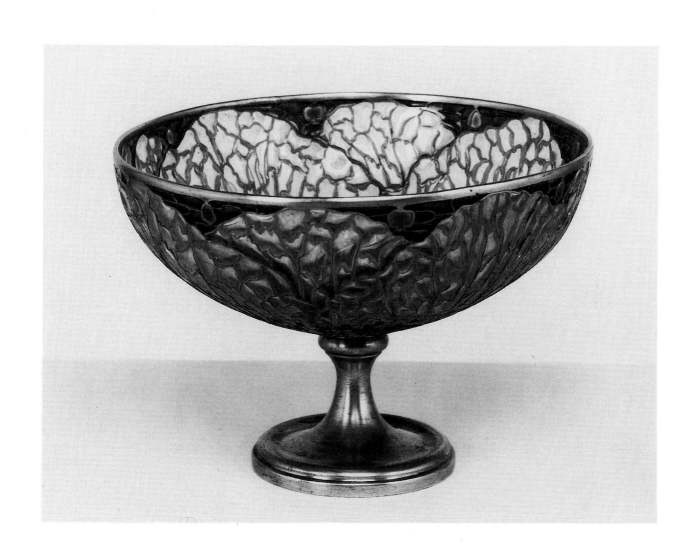

A L'Homme Armé

By Eugène Atget (1857–1927)
French: Paris, c.1900
Photograph (albumen print from
gelatin dry plate)
h 22.5 cm (8¾ in.)
w 17 cm (6½ in.)
395–1903

Literature
JOHN SZARKOWSKI and MARIA
MORRIS HAMBOURG, *The Work
of Atget*, New York and London,
1982–5.

This photograph, bought from Atget in 1903, depicts a shop sign, *At the Sign of the Armed Man*, at 25 Rue des Blancs Manteaux, Paris. Atget stands at the end of the early topographical tradition and at the beginning of twentieth-century ideas about photography. Like earlier photographers he made views of Parisian streets and artefacts for sale to archives and museums. He was later collected by Man Ray and published by the Surrealists. Atget simultaneously recorded the traditional but changing city and suggested the strangeness of modern life.

The street trades and then the shop signs of Paris were among the earliest subjects pursued by Atget, in about 1900. He sold sets of such photographs to his early customers like the Bibliothèque Historique de la Ville de Paris and in London the South Kensington Museum. This Museum collected photographs as adjuncts to the collection of printed books, a reference for art historians and art students. This particular photograph was filed with others on the theme of 'Decorative Ironwork'. The ironwork which embellished the hostelry known as *A L'Homme Armé* was, by the way, a legal requirement. The authority on Atget, Maria Morris Hambourg, has noted: 'Because they served alcohol and were open at night, the bistros, cabarets, and inns of Old Paris had been required by law to be fenced round with strong iron grills. The only unbarred opening was the door through which clients entered or else handed in a container to be filled'. Such signs as this, part of a decorative scheme in metal, tended to survive where others — by the late nineteenth century — had been removed. To record such picturesque attributes of an earlier Paris was at the heart of Atget's photographic project, at least initially. His photographs have been turned to many other uses, however, and in the twentieth century they became an inspiration both for the photography of documentary purism and also for the photography of nuance, irony, and scepticism concerning appearances and the way these may be constructed. His work has left a major impression on the *oeuvres* of such later masters of photography as Bill Brandt (1904–83) and Lee Friedlander (born 1934). MH-B

Firescreen

Designed and manufactured by
Emile Gallé (1846–1904)
French: Nancy, before 1900
Ash, with applied and marquetry
decoration in oak, zebra-wood,
sabicu, amboyna, and walnut
h 107.3 cm (3 ft 6¼ in.); w 55.3 cm
(1 ft 9¾ in.); d 34.7 cm
(1 ft 1⅝ in.)
1985–1900
Given by Sir George Donaldson

See colour plate on page 212

Literature

Gallé. Catalogue of an exhibition
held at the Musée du
Luxembourg, Paris, November
1985–February 1986, Paris
PHILLIPPE GARNER, *Emile Gallé*,
London, 1976

This firescreen was shown by Emile Gallé as part of a group of furniture at the Paris Exhibition in 1900. For Gallé's firm the exhibition was to be a triumph. Gallé was awarded prizes for both furniture and glass, and his collaborators on the furniture, Louis Hestaux, Paul Holderbach, and Auguste Herbst, were awarded silver and bronze medals.

The screen was purchased at the exhibition by George Donaldson, a jury member, who had served in the same capacity at the Paris Exhibition of 1889. Donaldson also bought other pieces of Gallé furniture, including the 'Ipomea' commode, a work table, and a tea table, in addition to pieces by Majorelle, Darras, Gaillard, and several others. These, together with a variety of ceramics, glass, textiles, and metalwork, also purchased at the exhibition, were presented by Donaldson to the Victoria & Albert Museum.

The firescreen is decorated with carving in the form of wild clematis, which reflects Gallé's training in botany, and his belief in nature as an endless source of inspiration for design. He first studied botany under Dominique Alexandre Gordon at the university in Nancy. This was to be the beginning of a life-long interest, on which Gallé published widely and for which he received honours from international horticultural societies.

While he had long applied vegetal decoration to ceramics and glass (*see* page 202) it was not until the mid 1880s that Gallé was inspired to apply it to furniture. While searching for suitable materials for an exhibition stand, Gallé had visited a timber merchant and had been astonished by the variety and beauty of timber and veneers. Soon afterwards he established a cabinet-making workshop, and in 1886 exhibited in Limoges, for the first time in three mediums: ceramics, glass, and wood. The first show of furniture from the Gallé workshops was in Copenhagen in 1888.

To enable his workmen to have direct contact with accurate examples, Gallé installed a botanical library and a collection of natural history specimens in the factory. He also ensured that appropriate plants were grown around the workshops. His manifesto on the application of botanic forms to furniture was published in the *Revue de l'Art* in 1900. In two articles entitled 'Modern Furniture Decorated According to Nature', he not only proposed nature as the major inspiration for design, but overlaid this with a rich layer of symbolism.

Establishing these workshops had meant hiring local cabinet-makers, and the help of two men experienced in furniture design, Victor Prouve and Louis Hestaux. Progress was rapid, and for his entries in the Paris Exhibition of 1889 Gallé won a silver medal.

This furniture, often based on traditional forms but with applied vegetal decoration, produced a mixed response from contemporary critics. None doubted the beauty and quality of the materials, nor the craftsmanship of their execution, but several had doubts about the application of plant forms to furniture, as opposed to glass. Gallé, undaunted, stepped up production. Timber supplies of enormous variety were used, all meticulously catalogued. In 1889 almost 600 different veneers were stocked. More machinery was installed. Gallé had always been ready to use machines for the initial stages of work, followed by hand finishing, because this kept costs down.

By 1900, when the firescreen was shown, Gallé's furniture designs had become lighter and more elegant. The plant forms flow from being an inlay flush with the surface to being a raised textured form, and sometimes into applied leaves. The signature 'Gallé' on the lower left is raised above the surface in this way.

This firescreen remains one of the best examples of Gallé's belief in the suitability, almost the necessity, of the application of plant forms to furniture. Few, however, followed him, and in 1901 the ageing Havard voiced the opinion of many on Gallé's furniture when he wrote of the return to Nature being simply insufficient to meet the challenge of designing for the industrial age. SA

Tapestry hanging for a doorway

Designed by Frida Hansen (1855–1931) and woven under her instruction at the Norwegian Weaving Society (Det Norske Billedvoeveri)
Norwegian: Kristiania, 1900
Tapestry-woven, hand-spun and hand-dyed wools
h 376 cm (12 ft 4 in.); w 129.5 cm (4 ft 3 in.)
Inscribed: 'DNB1900XIV'
1683–1900

See colour plate on page 213

Literature
M. JARRY, *La Tappisserie: art du XXeme siècle*, Fribourg, 1974

The display of Det Norske Billedvoeveri at the Paris International Exhibition of 1900 included a group of translucent, double-sided tapestry hangings which caught the attention of the jurors. They described them as 'a real innovation', awarding DNB a gold medal. The jurors' high opinion was shared by the curators at South Kensington who acquired this example from the exhibition. The jurors found the colours of the hangings attractive and the designs modern but not without charm; but most striking of all to them was the technique, in which the design is woven without a background. Because of danger that the structure of the weaving may become weakened or unbalanced, unusual technical skill is required of the designer, and the jury gave special praise to Frida Hansen, tapestry-weaver and designer, and head of DNB.

The jurors were mildly surprised at the advances made by Norwegians in tapestry-weaving since 1889, a success which they attributed to the new Schools of Industrial Art and to certain talented individuals such as Gerhard Munthe (1849–1929), a painter who had created, in the jury's words, 'a truly national style in the modern art of Norway', drawing his inspiration from Norwegian national history and the Norse Sagas. From about 1880 three new decorative arts museums in Norway—Oslo, Bergen, and Trondheim—began to circulate exhibitions of historic textiles; at the same time they funded courses in weaving, and published training material and books illustrating medieval Norwegian tapestries and other traditional crafts.

Amid this regeneration of Norwegian arts, Frida Hansen began work as an embroiderer in 1882, soon turning to tapestry-weaving. Having trained as an artist, she was able to supply her own cartoons for weaving, but she also conducted research on technical questions from which she came to recommend the use of vegetable dyes and Norwegian wools. In 1893 she was in touch with Gerhard Munthe, the leading Norwegian artist. On a visit to Paris two years later she encountered at first hand modern art from the rest of Europe. The products of her tapestry workshop, founded in 1897, reflect these varied influences, and DNB's display at the International Exhibition in 1900 included historical and mythological pieces after designs by both Munthe and Hansen, as well as the group of door-hangings. DNB's success was short-lived: the workshop closed in 1906, but until her death in 1931, Hansen continued to make tapestries, combining traditional skills with an imaginative approach to design. PH

Cloisonné Artistic Glass

By Adolf Hohenstein (born 1854)
Italian poster advertising stained
glass made by Luigi Fontana &
Co., Milan, 1899
Colour lithograph
Size of sheet 92.8 × 63.6 cm
(36½ × 25 in.)
Signed and dated *Hohenstein 99*
Lettered *G. Ricordi & C. Milano*
E.282–1982

Literature
LUIGI MENEGAZZI, *Il Manifesto
Italiano, 1882–1925*, Milan, 1974
Milan Palazzo Reale, *70 Anni di
Manifesti Italiani*, Milan, 1972

Of German origin, Adolf Hohenstein was a genre, landscape, and portrait painter, as well as a designer and lithographer, who was born in St Petersburg in 1854. He moved to Italy in about 1889, where he was asked to take over the artistic direction of part of the publishing company G. Ricordi & Co. of Milan, a firm that specialized in the publication of operatic and other music. With the backing of Giulio Ricordi, Hohenstein was here able to establish an artistic centre for the design and printing of posters which attracted some of Italy's most famous poster artists—such as Aleardo Villa, Giovanni Mataloni, and Leopoldo Metlicovitz —to work on a great variety of commissions given to the company.

Italy, for various political and economic reasons, had been a late entrant to the field of pictorial poster design, but, appropriately enough, some of the first Italian posters in this new art form were advertisements for performances of opera. Hohenstein's poster for Ricordi, publicizing a performance of Puccini's *Edgar* in 1889, was an early landmark, although its anecdotal style, faithfully recording a scene from the opera, is far removed from his subsequent work. Influenced by the decorative aspects of French Art Nouveau, Hohenstein's later designs were characterized by their boldness of composition and richness of colouring. This poster, printed by Ricordi and advertising decorative cloisonné glass made in the Art Nouveau style by Luigi Fontana & Co. of Milan, is a classic example of his style.

During his years at Ricordi, Hohenstein achieved a prodigious output of over a hundred posters, one of the most famous being that for the première of Puccini's *La Bohème* at the Theatre Royal, Turin, in 1896. His last datable poster for Ricordi was made in 1906, Hohenstein later moving to Germany and exhibiting from 1911–17 in Düsseldorf. It is uncertain when he died. MWT

Tapestry hanging for a doorway (detail) designed by Frida Hansen (*see* page 209)

Firescreen designed and manufactured by Emile Gallé (*see* page 208)

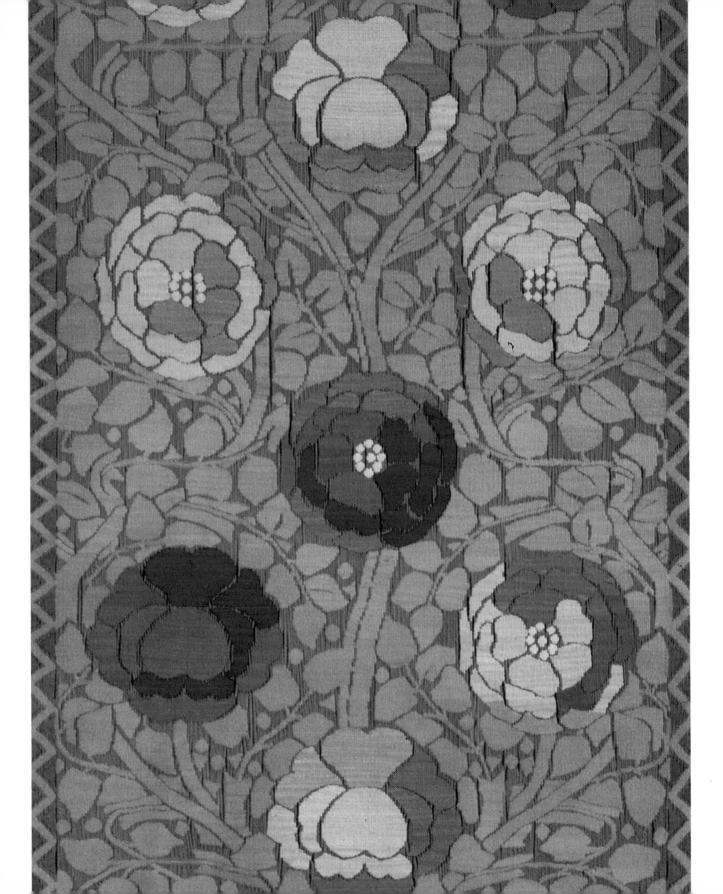

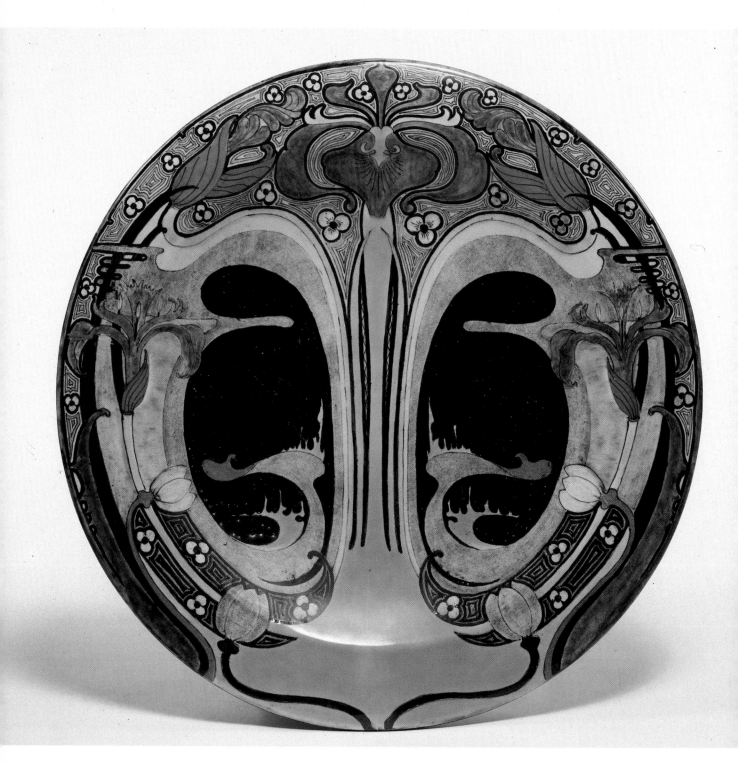

Dish

Manufactured by Weduwe
N.S.A. Brantjes & Co.
Dutch: Purmerend, Holland,
c.1900
Earthenware with painted
decoration
diam 44.7 cm (17½ in.)
Marks: a sabot, NB in monogram,
FAIENCE DE PURMERENDE
HOLLANDE DECORE A 1095 and an
unidentified monogram, painted
c.100–1967
Given by Stuart Durant

Literature
'Jugendstil uit Purmerend',
*Mededelingenblad Vrienden van de
Nederlandse ceramiek*, 90/91, 1978
'Aardewerknijverheid in
Nederland 1876–1940',
*Mededelingenblad Vrienden van de
Nederlandse ceramiek*, 94/95, 1979

The town of Purmerend has historic associations with the pottery industry. In the seventeenth century it boasted the only tileworks in the Netherlands. Towards the end of the nineteenth century Holland was enjoying a flourishing arts movement in which ceramics played an important part. Potteries proliferated around The Hague, Gouda, and Amsterdam, as well as Purmerend. For most of these newer factories the first and most obvious course was to embark on production based on Holland's traditional blue-and-white Delftware. Brantjes, not among the first of the new-wave factories, began production at a time when the presence of a contemporary ceramics industry was established and the way was open to experiment with the latest fashionable styles. The spadework in establishing the industry had been done by Rozenburg, in production at The Hague since 1885, and De Porcelayne Fles, founded at Delft in 1876.

The Brantjes factory was established in 1895 by Petronella Eleonora Maria Clementine van Rijn (1849–1917), widow of Nicolaas Brantjes. As wealthy Roman Catholics, the family's financial security was based on forests they owned in Russia. Nicolaas Brantjes, the third son, began a fireproof-brick-making factory. After his death the Widow (Weduwe) Brantjes started production of decorative earthenware at the Purmerend works in association with Egbert Estié (1865–1910). Estié, apparently a man of considerable charm, inspired enthusiasm, but it was not until his departure in 1897 to begin the Zuid-Holland factory at Gouda that the Widow Brantjes' factory was organized on a business-like and practical footing. A glaze kiln was built and forty-six workers were employed in the factory.

Brantjes' earliest production was of blue-and-white ware but it quickly progressed to making pieces with an individual and characteristic polychrome floral decoration combined, sometimes, with strong, original forms. These were sold with success through family contacts and with help of goodwill already generated by Rozenburg's impressive, coloured earthenware. J. Romijn's researches suggest that many of the designs at this period are taken from Maurice Pillard Verneuil's pattern books. Verneuil (1869–1942) was a pupil of Eugène Grasset (1841–1917), himself occasionally involved with ceramics and one-time friend and collaborator of Jean Carriès, the French stoneware potter whose work is included in the Victoria & Albert Museum's collections. Verneuil published a number of pattern books of designs based on natural forms, plants, and animals in Art Nouveau style, he collaborated with Alphonse Mucha (1860–1939), and wrote for the design and art journal *Art et Décoration*.

Despite what should have been a successful formula, the Widow Brantjes was in financial difficulties shortly after 1900 and by 1904 the pottery was merged with or taken over by a combination of Brantjes & Co and the Haga factory in The Hague, established in 1903 by Jan ten Brink and Isaac Raphael Arrias. The factory's name was changed first to N.V. Haga and, in 1905, to Plateelbakkerij Haga. It survived only until 1907 despite further improvements to kilns and other equipment and the advent of the important ceramist Chris J. Lanooy (1881–1948) who added to the repertoire of forms, decorations, and glazes.

This dish is one of at least three based on the same design and shape. Brantjes' pieces are usually marked with a decorator's monogram but unfortunately most, including this example, are unidentified.

Brantjes production represents one aspect of the Dutch art movement at this time: the richly decorative based on opulent colouring and floral ornament. A parallel development was the strict, simple, and geometric manner which, when combined with social theories, led the applied arts into basic functionalism with minimal decoration. This was considered to be more appropriate to the social responsibility of producing useful wares with what was regarded as the proper respect for the materials used. JHO

216

Chest of drawers

Designed by Adolf Loos
(1870–1933)
Austrian: Vienna, c.1900
Maple, the carcass of deal with
oak panels, brass handles, the
base covered in brass sheet
h 134.5 cm (4 ft 5 in.); *w* 100 cm
(3 ft 3½ in.); *d* 57 cm (1 ft 10½ in.)
W.19–1982

This chest of drawers was designed for the apartments of Gustav and Marie Turnowsky at 19 Wohllebengasse, Vienna 4. In about 1915 it was removed to their new apartment at 20 Gusshausstrasse, Vienna 4, where Loos designed an ante-room. Marie Turnowsky was the favourite sister of the writer Karl Kraus (1874–1936), whose friendship with Loos is first documented in March 1900.

Handles similar to those on this chest of drawers were used by Loos on a bedside cupboard designed in 1897 for the art historian Dr Hugo Haberfeld, who wrote on Austrian art in *The Studio* (1906) and in 1913 delivered a lecture on Loos in Vienna. Exactly the same handles were used by Loos on a great sideboard of dark-stained oak designed in 1900 for the apartment of the essayist Dr Otto Stoessl (1875–1936), also a friend of Karl Kraus. A light maple was used by Loos in his first bedroom design, executed for Eugen Stössler in 1898. The bedroom in the Turnowsky apartment also contained a room divider, a cupboard, a dressing table, and a wardrobe *en suite* with this chest of drawers.

In 1931 Heinrich Kulka (1900–74), pupil, friend, and colleague of Loos, drew attention to Loos's revival of traditional panelled construction in these pieces, in contrast not only to the spacious designs of Josef Hoffmann (1870–1956) and Henri Van de Velde (1863–1957), but also to the furniture shown in an exhibition held in 1924 by the German industrial design organization, the Werkbund, called *Die Form ohne Ornament*, a misleading title, according to Kulka.

Who made this Turnowsky furniture cannot be established. Josef Veillich, Loos's favourite craftsman, to whom he devoted a touching obituary in 1929, supplied a copy of a Chippendale chair to the apartment. However, he was a chair specialist and the more probable maker is the firm of Friedrich Otto Schmidt, who showed furniture from the Turnowsky apartment at the 1900/1901 Winter Exhibition of the Österreichisches museum für Kunst und Industrie (Austrian Museum for Art and Industry). Loos was friendly with Max Schmidt, the son of the firm, from the late 1890s, and is reputed to have spent a year with the firm. In 1902 he gave their firm's address as his own. The Turnowsky apartment was the first occasion on which Loos used their 'elephant trunk' table, designed by Max Schmidt, detailed and executed by a cabinet-maker named Berka. Kulka dated the furniture to 1899, but it cannot be that much earlier than 1902 when the Turnowskys moved into their new apartment.

Loos felt strongly that furniture forms should be evolved by the craftsman rather than invented and imposed by the architect-designer. Such furniture as he did design tends to be rectilinear, solid, simple, and unornamented. However, as this chest of drawers, with its massive but delicately reeded framework and sturdy proportions, demonstrates, this apparently straightforward approach did not rule out refinement and nobility. SJ

Teapot and creamer

Designed by Paul Follot
(1877–1941)
French: Paris, c.1900
Electroplate
Teapot
h 16.2 cm (6⅜ in.); l 28 cm (11 in.);
w 13 cm (5⅛ in.)
Creamer
h 10 cm (4 in.); l 14.5 cm (5¾ in.)
Inscribed with the designer's
signature 'Follot' in the lower
sections of the fluted decoration
on both teapot and creamer
Stamped on the base with a
maker's mark (unidentified)
M.105&a. 1978

Literature

MAUREEN BATKIN, 'Wedgwood
Ware designed by Paul Follot, *The
Journal of the Decorative Arts
Society*, 1982
YVONNE BRUNHAMMER, *Art
Nouveau Belgium France*,
Chicago, 1976
JESSICA RUTHERFORD, 'Paul
Follot' *The Connoisseur*, June,
1980

This teapot and creamer originally formed part of a service which included a hot water jug, sugar basin, and tray. Several examples are known to have been made and it is possible that it was one of the metalwork designs commissioned from Follot by Meier-Graefe for his shop La Maison Moderne.

Follot was the son of a successful wallpaper manufacturer, Felix Follot, who regularly contributed to major exhibitions including the Paris Exhibition of 1900. Felix Follot was a foundation member of the Société d'Encouragement à l'Art et à l'Industrie and certainly influenced his son's decision to become a professional designer and *ensemblier*.

Paul Follot studied under Eugene Grasset (1841–1917), the celebrated poster designer who also became an influential teacher at Ecole Normal d'Enseignement du Dessin founded by M.A. Guerin in 1881. Follot was his most successful pupil who later succeeded him as Professor of the advanced course in Decorative Arts. After leaving Grasset he devoted himself to the study of sculpture for he believed that contemporary designers were only educated to work in two dimensions. He sought to rectify this in his own case by embarking on a self-imposed course in three-dimensional modelling, which had a lasting influence on his subsequent work.

Art Nouveau was at the peak of its popularity while Follot was still a student and inevitably it influenced his early designs. This tea service is possibly his most accomplished work in this style. It was displayed as part of an assemblage of furniture in the Salon of the Société des Artistes-Decorateurs in 1904 which included a sequence of panels, side board, desk, *étagère*, and chairs, all Art Nouveau in style, and was the first interior by Follot to be publicly exhibited.

In spite of his success with Art Nouveau,

Follot's personal style matured over the next ten years into a formal language, heavily drawn from French neo-classicism of the eighteenth century. He was later to regard his Art Nouveau period as a relatively insignificant stage in his artistic development and condemned the style itself as a highly artificial distortion of natural forms, often inappropriately expressed by the material used.

By the outbreak of World War I, Follot was highly regarded as a de-luxe designer. His output was prolific and included furniture for Laurent Malchlès and Guénot, fabrics for Corneille et Cie, carpets for Marcel Coupé and Savonnerie and tapestries for Aubusson. He designed ceramics for Limoges and in 1911 was commissioned to design a range of ceramic services for Wedgwood, but it was not until after the war that these were put into production. He exhibited at the Turin 1911 and Munich 1913 Exhibitions and designed the Pavilion Pomone for the Paris Exhibition of 1925. In 1923 Follot was appointed the head of the design studio named the Atelier Pomone, of the Parisian department store Le Bon Marché, and in 1928, he was appointed by Serge Chermayeff to design furniture and interiors for the London department store, Waring and Gillow.

Follot in style remained consistent throughout, resisting equally the systematized Germanic approach or the austere modernism of his contemporaries such as Le Corbusier. He believed firmly in decoration and his motifs were mainly drawn from botanical sources, in particular flowers, fruit and garlands, sufficiently abstracted to be appropriate for the material. The result was a decorative style which was consistently elegant and sumptuous and which made Follot one of the most fashionable French designers of the early twentieth century. ET

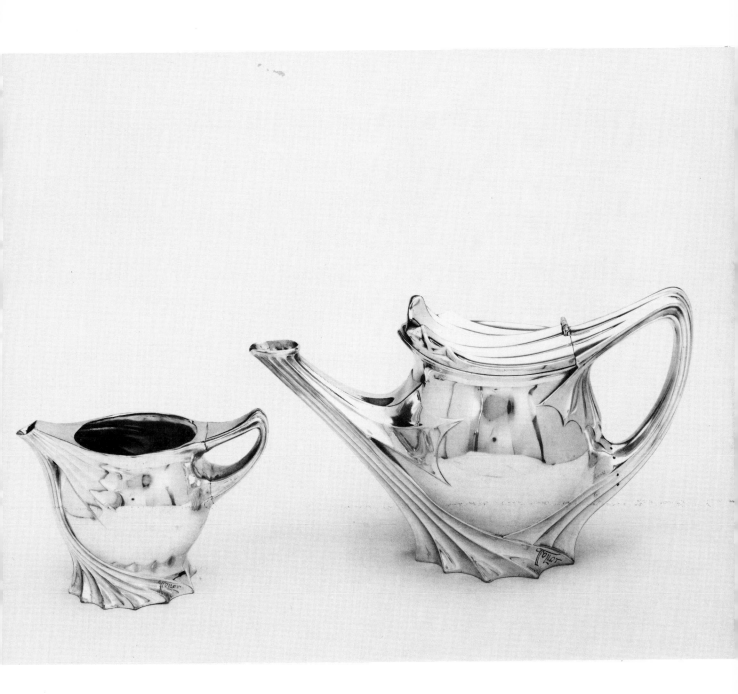

Bibliography

This is not a comprehensive reading list, but includes works which have been used in more than one entry, distinguished by asterisks, together with a selection of more general works.

General

STUART DURANT, *Ornament*, London and Shawnee Mission, 1986

*FRANCIS HASKELL AND NICHOLAS PENNY, *Taste and the Antique*, New Haven and London, 1981

*SIMON JERVIS, *Penguin Dictionary of Design and Designers*, Harmondsworth and New York, 1984

*BARBARA MUNDT, *Historismus*, Kunstgewerbemuseum Berlin, 1973

*ULRICH THIEME AND FELIX BECKER, *Allgemeines Lexikon der Bildenden Künstler*, Leipzig, 1907–1950

PETER THORNTON, *Authentic Decor*, London and New York, 1984

Art Nouveau and Arts & Crafts

MARIO AMAYA, *Art nouveau*, London and New York, 1966 (reissued 1985)

ISABELLA ANSCOMBE AND CHARLOTTE GERE, *Arts & Crafts in Britain and America*, London and New York, 1978

LIONEL LAMBOURNE, *Utopian Craftsmen*, London and New York, 1980

ROBERT SCHMUTZLER, *Art Nouveau*, London and New York, 1978

STEPHAN TSCHUDI MADSEN, *Sources of Art Nouveau*, Oslo and New York, 1956

*STEPHAN TSCHUDI MADSEN, *Art Nouveau*, London and New York, 1967

America

ROBERT JUDSON CLARK (ed.), *The Arts and Crafts Movement in America 1876–1916*, Princeton, 1972

Metropolitan Museum of Art, *19th Century America, Furniture and other Decorative Arts*, New York, 1970

*Metropolitan Museum of Art, *In pursuit of Beauty, Americans and the Aesthetic Movement*, New York, 1986

Austria

Historisches Museum der Stadt Wien, *Traum und Wirklichkeit*, Vienna, 1985

Österreichisches Museum für angewandte Kunst, *100 Jahre, Kunstgewerbe des Historismus*, Vienna, 1964

KIRK VARNEDOE, *Vienna 1900*, The Museum of Modern Art, New York, 1986

England

SIMON JERVIS, *High Victorian Design*, Woodbridge, 1983

GILLIAN NAYLOR, *The Arts & Crafts Movement*, London and Cambridge (Mass), 1971

Royal Academy, *Victorian and Edwardian Decorative Art, The Handley-Read Collection*, London, 1972

Victoria & Albert Museum, *Victorian and Edwardian Decorative Arts*, London, 1952

Victoria & Albert Museum, *Victorian Church Art*, London, 1971

France

*ELIZABETH ASLIN, *French Exhibition Pieces 1844–78*, Victoria & Albert Museum, London, 1973

*Philadelphia Museum of Art, *The Second Empire, Art in France under Napoleon III*, Philadelphia, 1978

Germany

WILHELM ARENHOVEL (ed.), *Berlin und Die Antike*, Deutsches Archäologisches Institut, Berlin, 1979

Museum für Kunst und Gewerbe, Hamburg, *Historismus*, Hamburg, 1977

Holland

STEDELIJK MUSEUM, AMSTERDAM, *Industry & Design in the Netherlands, 1850–1950*, Amsterdam, 1986

Hungary

HUNGARIAN NATIONAL GALLERY, *Lélek és forma*, Budapest, 1986

Magyar Müvészet 1890–1919, Budapest, 1981

Scandinavia

DAVID MACFADDEN (ed.), *Scandinavian Modern Design 1880–1980*, Cooper-Hewitt Museum, New York, 1982

Ceramics

JEAN D'ALBRIS, CÉLESTE ROMANET, *La Porcelaine de Limoges*, Paris, 1980

KARL BERLING, *Meissen Festive Publication*, Meissen, 1910

*RICHARD BORRMANN, *Moderne Keramik*, Leipzig, 1902

*ELIZABETH CAMERON, *Encyclopedia of Pottery and Porcelain*, New York, 1985; London, 1986

R.J. CHARLESTON (ed.), *World Ceramics*, London and New York, 1968

*R.J. CHARLESTON, *Meissen and other European Porcelain* (Catalogue of the James A. de Rothschild Collection at Waddesdon Manor), Fribourg, 1971

*GAVEN CLARK, MARGIE HUGHTO, *A Century of Ceramics in the United States 1878–1978*, New York, 1979

*PAUL EVANS, *Art Pottery of the United States*, New York, 1974

*A. FAY-HALLÉ, B. MUNDT, *Nineteenth-Century European Porcelain*, London, 1986

*HENRY-PIERRE FOUREST, *L'Art de la Poterie en France de Rodin à Dufy*, Sèvres, 1971

MARCEL ERNOULD GANDUET, *La Céramique en France au XIXe siècle*, Paris, 1969

*GEOFFREY GODDEN, *Victorian Porcelain*, London, 1961; New York, 1962

HERMANN JEDDING, *Meissner Porzellan des 19. und 20. Jahrhunderts*, Munich, 1981

ERICH KÖLLMANN, *Berliner Porzellan*, Brunswick, 1966

AURELIO MINGHETTI, *Ceramisti*, Milan, 1939

*REGINE DE PLINVAL DE GUILLEBON, *Paris Porcelain 1770–1850*, London, 1972

IRENE VON TRESKOW, *Die Jugendstil-Porzellane der K.P.M. Berlin*, Munich, 1971

OTTO WALCHA, *Meissner Porzellan*, Dresden, 1973

Furniture

VERA BEHAL, *Möbel des Jugendstils*, Munich, 1981

ALISTAIR DUNCAN, *Art Nouveau Furniture*, London and New York, 1982

SERGE GRANDJEAN, *Empire Furniture*, London, 1968

DAVID A. HANKS, *Innovative Furniture in America*, New York, 1981

GEORG HIMMELHEBER, *Klassizismus/Historismus/Jugendstil* (vol. III of Heinrich Kreisel, *Die Kunst des deutschen Möbels*), Munich, 1973

*SIMON JERVIS, *Furniture of about 1900 from Austria and Hungary in the Victoria & Albert Museum*, London, 1986
*DENISE LEDOUX-LEBARD, *Les Ébènistes du XIXe Siècle*, Paris, 1984
*MARY JEAN MADIGAN (ed.), *Nineteenth Century Furniture, Innovation, Revival and Reform*, New York, 1982
CHRISTOPHER PAYNE, *The Price Guide to 19th Century European Furniture*, Woodbridge, 1981; New York, 1985
CHRISTOPHER WILK, *Thonet: 150 Years of Furniture*, New York, 1980

Glass

*J. BROŽOVÁ, *Ceské Sklo 1800/1860*, Prague, 1979
*M. KOVACEK, *Glass of Four Centuries*, Vienna, 1985
WALTRAUD NEUWIRTH, *Orientalisierende Gläser J & L Lobmeyr*, Vienna, 1981
*G.E. PAZAUREK AND E. VON PHILIPPOVICH, *Gläser der Empire-und Biedermeierzeit*, Brunswick, 1976
ADA POLAK, *Glass, its makers and its public*, London, 1975
WALTER SPIEGEL, *Glas des Historismus*, Brunswick, 1980
*WALTER SPIEGEL, *Biedermeier-Gläser*, Munich and Cincinatti, 1981

Metalwork

*L. CARRÉ, *A Guide to Old French Plate*, London, 1971
*SERGE GRANDJEAN, *L'Orfèvrerie du XIXe Siècle en Europe*, Paris, 1962

*RONALD LIGHTBOWN, *Catalogue of Scandinavian and Baltic Silver*, Victoria & Albert Museum, London, 1975
*RONALD LIGHTBOWN, *Catalogue of French Silver*, Victoria & Albert Museum, London, 1978
HANS OTTOMEYER, PETER PRÖSCHEL (ed.), *Vergoldete Bronzen*, Munich, 1986

Photographs

HELMUT AND ALISON GERNSHEIM, *The History of Photography*, London and New York, 1969

Posters

*JANE ABDY, *The French Poster, Chéret to Capiello*, London, 1969
Das frühe Plakat in Europa und den U.S.A., II, *Frankreich und Belgien*, Berlin, 1977, III, *Deutschland*, Berlin, 1980

Sculpture

CHARLES AVERY, 'From David d'Angers to Rodin', in *Studies in European Sculpture*, London, 1981
SUSAN BEATTIE, *The New Sculpture*, London and New Haven, 1983
JEREMY COOPER *19th Century Romantic Bronzes*, Newton Abbot, 1975
*P. FUSCO AND H.W. JANSON (ed.), *The Romantics to Rodin*, Los Angeles, 1980
*H.W. JANSON, *Nineteenth-Century Sculpture*, London and New York, 1985
La Sculpture Française au XIXe Siècle, Paris 1986
J.B. SPEED ART MUSEUM, *Nineteenth Century French Sculpture*, Louisville, 1981

Textiles

RUTH GRÖNWOLDT, *Art Nouveau Textil-Dekor um 1900*, Württembergisches Landesmuseum, Stuttgart, 1980
*HENRI HAVARD AND MARIUS VACHON, *Les Manufactures Nationales*, Paris, 1885
Textilmuseum Krefeld, *Stoffe um 1900*, Krefeld, 1977

Wallpapers

JEAN HAMILTON AND CHARLES C. OMAN, *Wallpapers*, Victoria & Albert Museum and Sotheby Publications, London and New York, 1982

Contemporary Sources

*R.N. WORNUM, 'The Exhibition as a Lesson in Taste', *Art Journal Illustrated Catalogue of the 1851 Great Exhibition*, London, 1851
SIR M.D. WYATT, *The Industrial Arts of the Nineteenth Century*, London, 1851–1853
Catalogue of the Articles of Ornamental Art, London, 1852
*J.C. ROBINSON, *Treasury of Ornamental Art*, London, 1857
J.B. WARING, *Masterpieces of industrial art & sculpture at the International Exhibition 1862*, London, 1863

Index

Figures in italics refer to illustrations.